The French Portrait
1550–1850

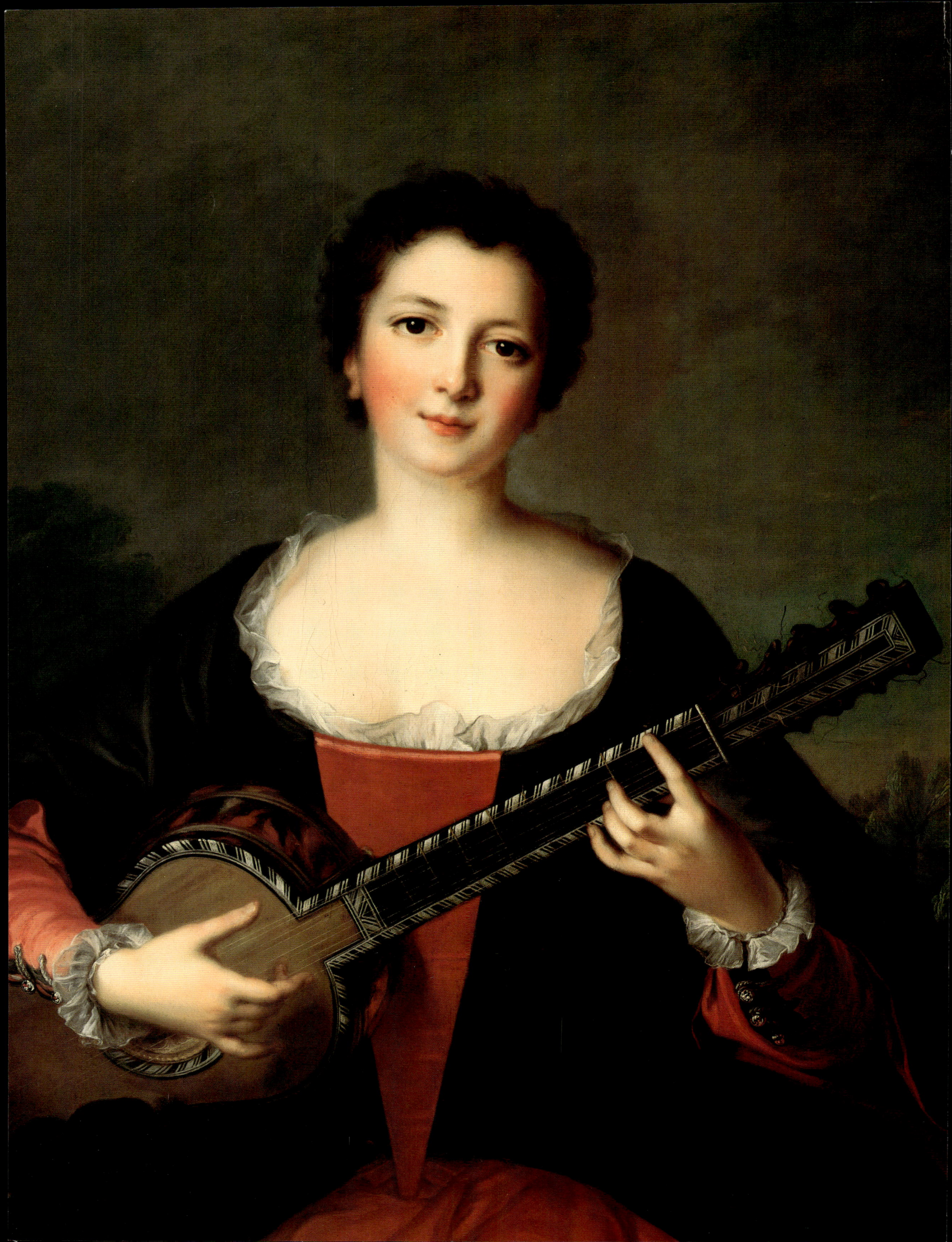

The French Portrait
1550–1850

By
Alan Wintermute

Catalogue by
Donald Garstang

Foreword by
Charles Ryskamp
DIRECTOR, THE FRICK COLLECTION

COLNAGHI
NEW YORK

Frontispiece:
JEAN-MARC NATTIER
Louise-Anne de Bourbon-Condé called Mlle. de Charolais, 1731
(detail, PLATE 8)

This catalogue accompanies an
exhibition held at Colnaghi, New York,
from January 10 to February 10, 1996.

Colnaghi USA Ltd.
21 East 67th Street New York, NY 10021
Telephone (212) 772-2266
Fax (212) 737-8325
E-mail: NYColnaghi@aol.com

P & D Colnaghi & Co.
14 Old Bond Street London W1X 4JL
Telephone (171) 491-7408
Fax (171) 491-8851

© 1996 Colnaghi USA Ltd.
Library of Congress Catalogue No. 95-83512

Design: Lawrence Sunden, Inc.
Printing: Thorner Press

INTRODUCTION

Colnaghi's most recent thematic exhibition in New York was a survey of French Landscape painting from Claude to Corot and by contrast this exhibition is devoted to the development of French Portraiture. Alexander Pope's celebrated maxim that "The proper study of Mankind is Man" could not be better illustrated than by the profound humanity and vibrant intelligence which touched French portraiture throughout its history: This is a tradition whose variety we have been able to explore with examples by less well-known artists such as Frans Pourbus the Younger, represented here with a portrait study of unusual vigor, to a portrait of exceptional charm and warmth painted by Largillierre, a great artist who made his living through the genre, to a painting by David a multi-faceted genius who executed this extraordinarily moving likeness of a fellow exile in the very last years of his life. This tide swept into the nineteenth century embracing Ingres, Delacroix, Courbet and on into Impressionism, one of whose greatest exponents, Monet is represented here with a particularly sensitive full-length of Jongkind painted in 1864.

We would like to extend our gratitude to those private collectors who have generously allowed us to exhibit masterpieces by Fragonard, David and Ingres, the latter two exhibited publicly for the first time—undoubtedly the most important French artists of their day. On this occasion we have presented the pictures in conjunction with an illustrated history of French portraiture as opposed to the more conventional catalogue usually associated with a dealer's exhibition. Such a survey highlights the inevitable lacunae in what is primarily an exhibition drawn from stock, however we hope that it will also illustrate the quality and diversity of what has passed through Colnaghi, featuring as it does such great works as David's *Portrait of Vicomtesse Vilain XIIII* acquired by the National Gallery in London, and the *Portrait of Caroline Murat and her Family* by Baron Gérard, privately acquired a few years ago.

The format of this catalogue is also intended to emphasize our continuing commitment to make a contribution to art history. We are therefore pleased to make over all proceeds from the catalogue to the Frick Art Reference Library, the finest art historical resource of its kind in the country, and one to which we are continually indebted.

Finally, we would like to thank all those who have worked so hard to make this exhibition and catalogue possible, most notably Alan Wintermute and Donald Garstang who wrote the catalogue with the able assistance of Kristin Gary and Selina Woodruff. We would like to join the author in extending our sincere thanks to Dr. Colin Bailey, Chief Curator of The National Gallery of Canada, for his advice and assistance in the editing of the principal essay.

Nicholas H. J. Hall
Richard Knight

FOREWORD

Once again Colnaghi is presenting an exhibition and an extensive study of an aspect of French art. The firm is not only one of the oldest galleries in the world (it was founded in London two hundred thirty-five years ago), but it also has a very long and distinguished tradition of scholarly research and publication. Throughout my own life, from my student days on, I have been personally indebted to Colnaghi for an important part of my education in art. The scholarship and connoisseurship of the late James Byam Shaw and some of his colleagues in the firm in London were of inestimable value to me. So it is a pleasure for me to pay tribute to these years of outstanding service to art history and to welcome another study and exhibition prepared by Colnaghi, New York.

Five years ago the firm held a remarkable exhibition in New York, *Claude to Corot,* concerning the development of landscape painting in France. Now another exhibition, which any museum would be proud to show, explores the evolution of French portraiture. The works, from François Quesnel to Courbet and Monet, are of exceptional beauty, frequently of great rarity, and all together illustrate the particular genius of French painting.

Much of the study of these paintings has been carried on in the Frick Art Reference Library. Not only is the staff of Colnaghi among the most devoted users of the Library, but the firm has also been one of its most ardent supporters. During the past few years, which have been very difficult for the Library financially, Colnaghi has again and again worked hard to help the Library. We are happy to announce that the endowment campaign for the Library which began five years ago has been successfully completed. This exhibition and the book accompanying it help to celebrate this occasion. The endowment fund for the Frick Art Reference Library should provide seventy percent of the money needed to run the Library in future years. The additional money required each year will come from the annual donations of its Associates, from grants and foundations, from benefits, and from the proceeds of publications like this one. We are deeply grateful to Colnaghi for their commitment to art history and to art libraries, and for again being a leader in helping to make the Frick Art Reference Library a vital place for the study of art.

Charles Ryskamp
DIRECTOR, THE FRICK COLLECTION

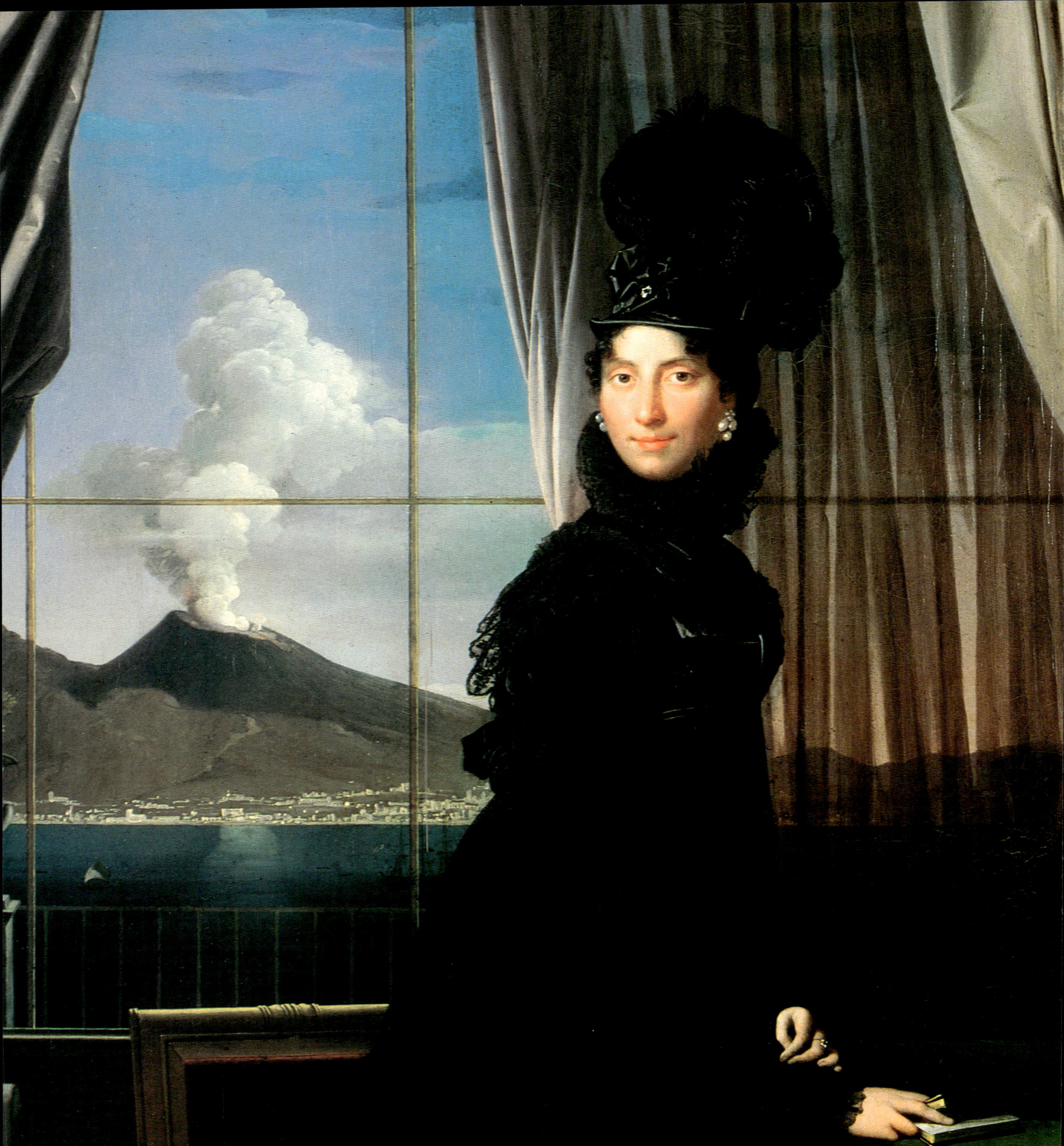

The French Portrait: 1550–1850

VOLTAIRE, extravagantly credited by Madame du Deffand with "inventing History", once cautioned that "the secret of being a bore is to tell everything." The essay that follows is much too short to exhaust a topic as vast as French portraiture from the High Renaissance to the eve of Impressionism. Rather, it aims to provide a brief survey of the most original and influential practitioners of the painted portrait in France between the reign of François I and the end of the Second Empire, and to offer a brief discussion of the institutions, theories and pedagogies which determined the acceptable boundaries for the making of portraits.

Although there are several dedicated, career portraitists in this survey—Corneille de Lyon, Pourbus, Largillierre, Rigaud, Quentin de La Tour, Nattier, Vigée-Le Brun—many of the figures were only quondam portraitists who were regarded primarily as specialists in other fields. During the period encompassed by this essay there were literally thousands of professional portrait painters plying their trade in Paris and in dozens of provincial centers around France, and today most of them are completely forgotten. Occasionally one of these shadowy figures is disinterred when a yellowed canvas is brought down from a dark stairwell in a Burgundian château or carried up from basement storage in a cantonal museum and cleaned, revealing a heretofore undetected signature and allowing a name to be put to the face, so to speak. Still, it is important to remember that only a fraction of the portraits produced in the *Ancien Régime* have survived, and that we are left to judge a glorious banquet by the crumbs that remain. Portraiture was, for obvious reasons, one of the most popular and patronized genres of painting until well into our own century, and if we accept Jacques Thuillier's estimation that in the seventeenth century alone between four and five million paintings were produced in France, it would be no exaggeration to claim that over half a million were portraits. Today, fewer than 20,000 of these survive and the majority are of little artistic merit. Survival figures are only slightly better for the eighteenth century and far smaller for the sixteenth century.

Inevitably certain questions arise: What characteristics of French portrait painting are uniquely French? And what qualities link artists of succeeding generations and distinguish their works from those emerging from the other European schools? These are questions best addressed through a close examination of selected examples which, building one on the next, will help us to understand the development of the genre in France, and from which should emerge a picture of its particular qualities.

ALTHOUGH PORTRAITS of princes, clerics and donors could be found in illuminated manuscripts from the early Middle Ages, the independent painted portrait in France is of much more recent origin. Donor portraits were often incorporated into private or ecclesiastical altarpieces, stained glass windows, tapestries, and tomb sculpture, yet portraiture for its own sake was rare. The famous profile of *John the Good* (FIG. 1, Paris, Musée du Louvre) by an unknown hand dating from approximately 1360, may be the earliest independent portrait still extant. It is such a skillful and engaging work that it must have been one of a series of similar portraits, but it remains the sole survivor, and the better part of a century would pass before the appearance of works from the next significant artistic personality in the field of French portraiture, Jean Fouquet (c. 1420–1480).

Fouquet was from Tours and probably trained with a follower of the manuscript illuminators, the Limbourg Brothers, before he traveled in 1447 to Rome and was commissioned to paint the portrait of Pope Eugenius IV (lost). While in the Eternal City he studied the works of Fra Angelico, who was then painting the chapel of Nicholas V in the Vatican, and the experience proved decisive for the young Frenchman. However, it is influence from the North—in particular the art of Jan Van Eyck—that is most in evidence in Fouquet's few portraits of his

AT LEFT: Jean-Auguste-Dominique Ingres. *Caroline Murat*, 1814 (detail, PLATE 19).

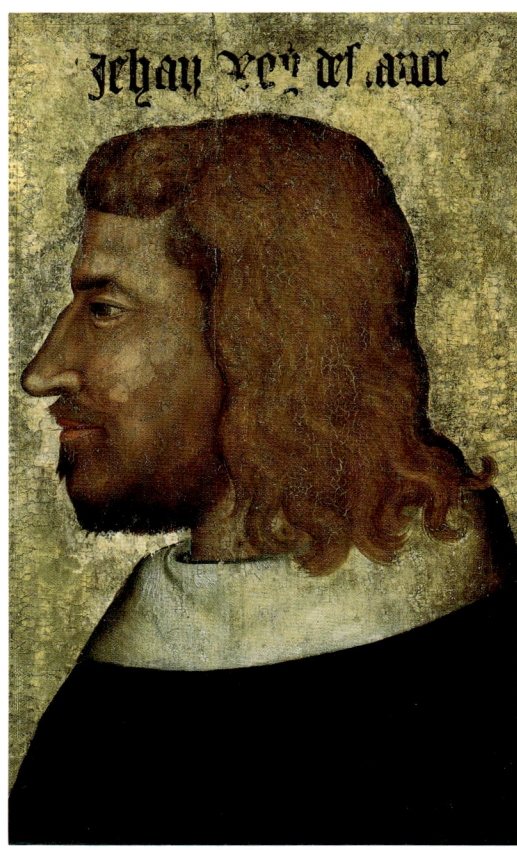

FIG 1. Anonymous. *John II the Good, King of France*, c. 1360. Oil on panel. 24 × 16⅛ inches. Paris, Musée du Louvre.

was not French by birth: he probably arrived from the Low Countries, before entering the service of François I (reigned 1515–1547), first in Tours, then Paris. François I encouraged the fashion, which had been steadily growing since the time of Fouquet, of collecting secular portrait drawings, miniatures and small panel paintings, and both he and the next queen, Catherine de' Medicis, formed substantial galleries of such likenesses of their family, friends, courtiers and allies. Portraits for the royal family or other members of the court might be copied many times, given away as diplomatic gifts or sent as mementoes to rarely seen friends or distant family members. No other artist working in France was capable of providing such an accurate likeness as eloquently as Jean Clouet. Although we know that he also painted altarpieces and made decorative designs, it is exclusively as a portrait painter that Clouet's name appears in the royal accounts; indeed, he is the first such specialist recorded. His corpus of paintings and drawings—along with portraits by Jean Perréal, the Dumoustiers and his own son and successor, François—provide a lively and convincing visual record of the Valois court to equal Holbein's pantheon of the Tudor court, with which they are exactly contemporary.

Clouet's drawings—astringent, intensely focused sheets in *trois crayons* that study the sitter's face to the

contemporaries, with their beautiful, delicate drawing, clear and directed light, keen observation and plastic modeling of gravely attentive faces.

Aside from that brief trip to Rome, Fouquet lived, married, and worked his entire life in Tours — where he fathered two son, both painters—in the employ of Charles VII and his successor, Louis XI. While a remarkable group of portrait drawings have survived, his few extant paintings, including *Etienne Chevalier with Saint Stephen* (FIG. 2, c. 1450-1460), are fragments of devotional diptychs. Indeed, Fouquet's main efforts went to painting altarpieces, making book illuminations, designing tombs, tapestries and stained glass windows, and orchestrating court festivals. Portraiture was not his principal occupation as Painter to the King, the role he had assumed by 1475.

Following the death of Fouquet (around 1480), no great portrait painter with an identifiable oeuvre emerged in France until the second decade of the Renaissance, when Jean Clouet's name first appears in the royal accounts (1516).

Clouet (c. 1485/90–1541), like many of the best artists working in France in the sixteenth century,

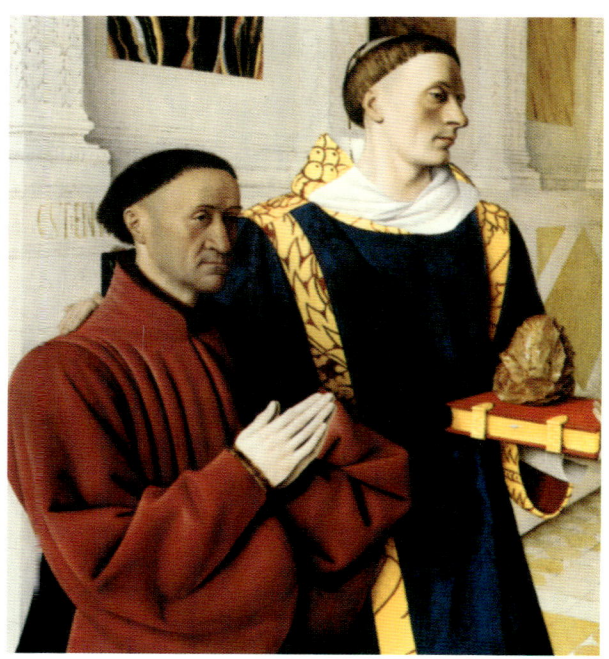

FIG. 2. Jean Fouquet. *Melun Diptych: Etienne Chevalier with Saint Stephen*, c. 1450–1460. Oil on panel. 37¾ × 34½ inches. Berlin, Gemäldegalerie, Staatliche Museen.

FIG 3. Jean Clouet. *François I*, c. 1535. Oil on panel. 37¾ × 29¼ inches. Paris, Musée du Louvre.

exclusion of all else—are often compared to Holbein's, but with their geometrical modeling and sculptural form they are closer to Italian models, in particular drawings by Leonardo. Clouet's celebrated portrait of *François I* (FIG. 3) also betrays the influence of Leonardo—in the enigmatic expression on the king's face and his extraordinarily elegant tapering hands—at the same time that it displays a stylish mannerism akin to that of the new School of Fontainebleau. Clouet probably never meet Leonardo, but he certainly was familiar with the master's works from the royal collection.

When Clouet came to paint the king's portrait he imbued it with all the rarefied elegance of design just then being employed by Rosso and Primaticcio at the Galerie François I. Uncharacteristically, Clouet employed a larger format than was standard and emphasized the trappings and power of absolute authority. A fantastically detailed profusion of brocades, silk, satin, and gold embroidery, and a rich but narrow range of colors enhance the stylized combination of arch self-confidence and complete authority with which Clouet endows his royal subject. The portrait looks to many sources: back to Fouquet's portrait of *Charles VII* (c. 1450; Paris, Musée du Louvre), north to Joos van Cleves' naturalistic rendering of the king (c. 1525; Philadelphia Museum of Art), and south to Leonardo's other-worldly elegance and Primaticcio's decorative richness. In this painting's stylistic complexity Clouet created the greatest "Fontainebleau" portrait and the most enduring image of François I.

When Jean Clouet died in 1541, his son, François, succeeded him as "peintre et varlet de chambre" at the same substantial salary (240 *livres*). Little more is known about François's life than about Jean's. Like his father, he executed various paintings and ceremonial designs, but was essentially a portraitist who left behind a substantial body of chalk drawings (his technique is drier and more severe than his father's), and a small number of paintings that are extensions of his and his father's work in that medium. François' paintings, like Jean's, are, in effect, chalk portraits translated into oil paint. Almost all are small, elegant panels with a meticulous attention to detail, fidelity to appearances and a translucent, glazed technique; the polished portrait of *Françoise Brézé, Duchesse de Bouillon* is a fine, typical example (PLATE 1). Françoise was the daughter of Louis Brézé, Grand Sénéchal of Normandy, and the legendary Diane de Poiters, Duchesse de Valentinois and favorite of François I. The painting is based on a drawing in Chantilly inscribed with the sitter's name and color notations that correspond to the colors used in the painting. The chain which runs across the Duchesse's shoulders has the letter "F" worked into the design, possibly alluding to the first name of the painter, but more likely to that of the sitter herself.

Only two of Clouet's painting are signed, the most spectacular of which is the celebrated *Portrait of a Lady in Her Bath* in Washington (FIG. 4). This remarkable image—a modern Venus rising from the waves—has lost none of its power to startle, but it was not unprecedented in its genre. Both Giulio Romano and Titian had produced compositions whose status as portraits or genre subjects remains unclear but which employed the same elements as Clouet's *Lady in her Bath*. And the most direct prototype—which Clouet certainly knew—is the so-called *Nude Gioconda* (at Chantilly) by Leonardo or his assistants, where the model has both a similar pose and similarly enigmatic expression. The icy eroticism of Clouet's magisterial panel has for decades fueled spec-

FIG 4. François Clouet. *Portrait of a Lady in her Bath*, c. 1570. Oil on panel. 36¼ × 32 inches. Washington, National Gallery of Art.

tulation that the painting depicts a royal mistress—either Diane de Poitiers or Marie Touchet—and was intended for the king's private delectation. Yet other elements in the painting—the sinister looking wet-nurse, the boy reaching for a bunch of grapes, the distant unicorn—all indicate that the portrait had an allegorical function, now forgotten, and which, if understood, might explain the sitter's state of undress. Recent research has suggested that the sitter might be Mary Stuart, François II's widow—unicorns and grapes are among her emblems—but whatever her identity, it is clear that, for the first time, portraiture is being extended through a web of allusive allegorical signifiers, and is being used to convey a more complex personal history of the sitter than we have previously seen. As his father had done, François Clouet has turned to northern and Italian prototypes for both style and subject, and has seamlessly amalgamated them into an original image at once classical and naturalistic, elegant and coarse. This work triggered a 30-year vogue for enigmatic "bath" portraits which culminated in the notorious *Gabrielle d'Estrées and Her Sister* (1594) in the Louvre.

Although the Clouets dominated French portraiture during the sixteenth century, Corneille de Lyon (active 1540-1574) distinguished himself in its middle decades. Of Dutch ancestry and born in The Hague, he is first recorded as working in Lyon in 1540,

before being naturalized French in 1547. By 1551 Corneille de Lyon is identified as "painter of the king" and that same year the Venetian ambassador described a visit to his studio: "We paid a call on an excellent painter who, in addition to other fine paintings he let us see, showed us the whole court of France, both gentlemen and ladies, depicted with the utmost lifelikeness on a great many small panels." In 1569, following a wave of religious persecution, Corneille de Lyon abjured Protestantism and, with his family, joined the Catholic Church. He is last mentioned in the tax registries of Lyon in 1574, the probable year of his death. Like the portrait of François I's powerful advisor, *Anne de Montmorency* (FIG. 5), all of Corneille de Lyon's portraits are characterized by their small size, sensitive and naturalistic modeling in thin glazes which give a variety of light and texture rather than plasticity, and by their plain green backgrounds. Focus falls almost entirely on the delicately painted face—hands rarely appear—and costume, even when it is luxurious, is usually summary.

The court's interest in small-scale, refined portrait drawings and paintings survived well into the seventeenth century, but its final flowering came in the 1580s and 1590s in the works of two families: the Dumoustiers (trained at Fontainebleau) and the Quesnels. The most interesting painter among them was François Quesnel the Elder (1543–1619), who

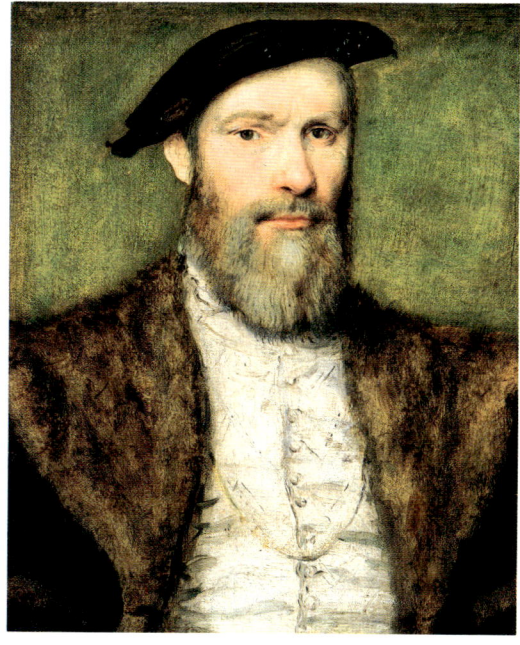

FIG 5 Corneille de Lyon. *The Connétable Anne de Montmorency*, c. 1550. Oil on panel. 7½ × 5½ inches. Private Collection. Acquired from Colnaghi, 1993.

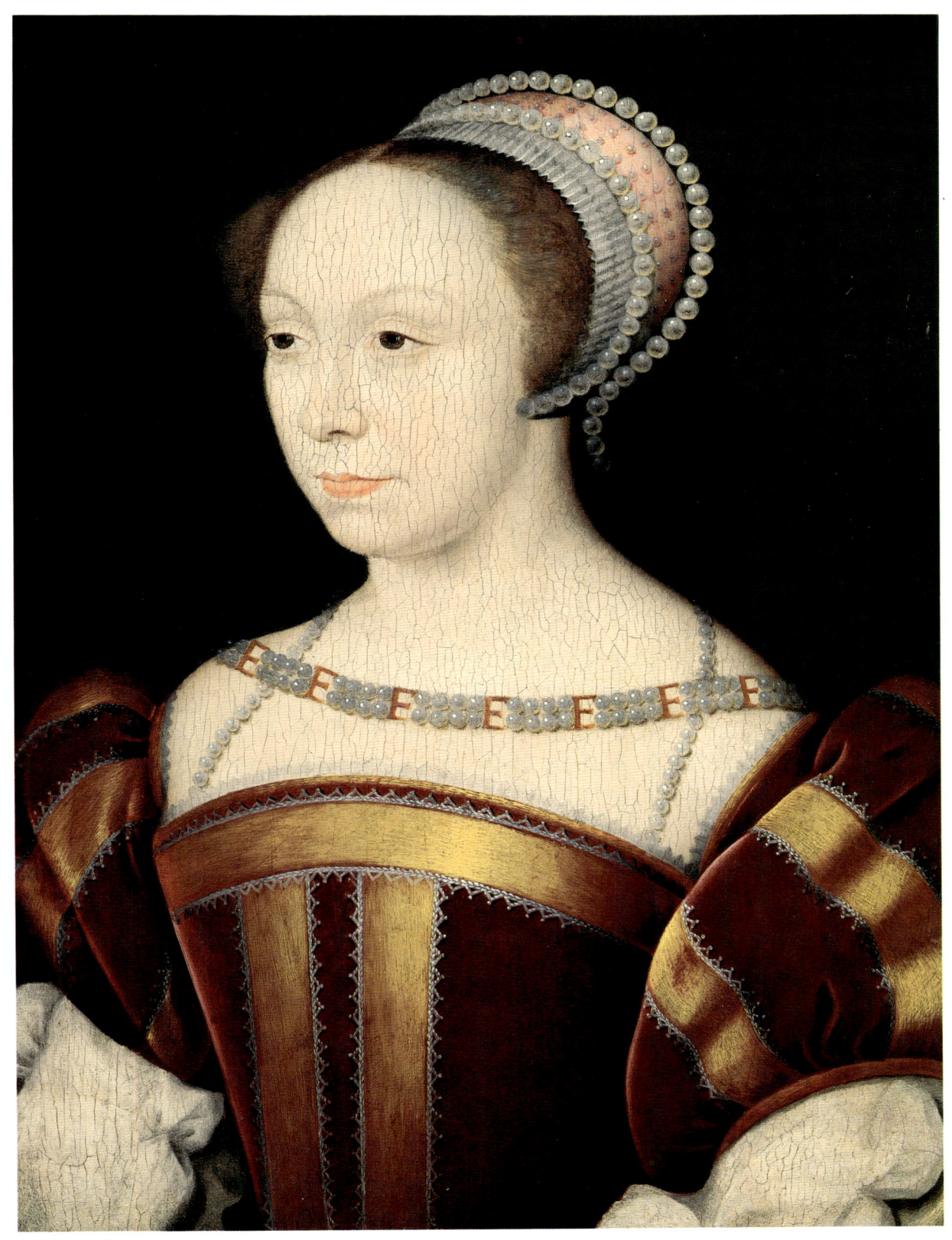

PLATE 1. FRANÇOIS CLOUET. *Françoise Brézé, Duchesse de Bouillon*, c. 1550. Oil on panel. 12¼ × 9¼ inches.

was born in Edinburgh where his father Pierre was court painter to James V of Scotland. His name first appears in the French royal accounts in 1572, where he seems to have been primarily a draftsman specializing in the popular genre of *trois crayons* portraits, a substantial group of which is preserved in the Bibliothèque Nationale. Very few painted portraits from his hand have survived, but the newly discovered *Portrait of a Lady* (PLATE 2) is a characteristic example. While the sitter's head and hands are exquisitely drawn and modeled, her body—tightly encased in a stylish black gown—is insubstantial, reduced to little more than a patterned silhouette. Almost naive when compared to the realism of the Clouets and Corneille de Lyon, Quesnel's method of disembodied stylization found great success at court as the century came to an end. Using a severely restricted palette of brown, black and white, his astringent Mannerism was well suited to construct a persona of masculine strength for the neurotic and self-indulgent Henri III (his portrait c. 1582–1586; Paris, Musée du Louvre), or to evoke the graceful delicacy of the unknown sitter of the *Lady* or Mary Ann Waltham (portrait signed and dated 1572; Althorp, Northhamptonshire, Earls Spencer).

FOLLOWING the upheaval caused by the Wars of Religion (1560–1598), painting found itself on the brink of a revival. The somewhat anemic Mannerism of the Second School of Fontainebleau favored by Henry IV would soon be replaced by vigorous new painting styles forged by a generation of native-born painters that would give Paris an international cultural eminence equal to its new found political, economic, and military prestige.

Among the last of a long line of Flemish artists to have achieved their greatest success in France, Frans Pourbus the Younger (1569–1622) worked at court at the start of this renewal. Born in Antwerp, Pourbus was trained by his father and achieved a rapid success. By 1591 he held the rank of Master at Antwerp and built a European reputation as a court portrait painter, first in Brussels and then, from 1600, in the service of the Gonzaga of Mantua. At the invitation of Henri IV's queen, Marie de' Medicis, Pourbus moved to Paris in 1609. His French career was short—appointed Painter to the King in 1618, he was dead by 1622—but his dozen years in Paris had a disproportionate impact on the development of French painting. As Anthony Blunt observed, Pourbus entirely dominated portraiture during the reign of Henri IV and regency of Marie de' Medicis.

Pourbus's most important commissions were grand state portraits such as the austere full-length *Marie de'Medicis* (c. 1609; Paris, Musée du Louvre) made to be incorporated into the monumental decorative scheme of the Petite Galerie (now the Galerie d'Apollon) in the Louvre. Probably painted shortly before the assassination of her husband, it shows the queen with a confrontational gaze, opulently dressed and bejeweled, standing against a massive architectural backdrop hung with huge swags of silk damask. Pourbus's portrait certainly succeeds in asserting the grandeur and power of the monarchy in the person of the queen, despite the fact that Marie de' Médicis' four year regency would prove notoriously indecisive. It is, of course, in the nature of court portraiture to present its subject as superhuman and, therefore, beyond our sympathy, but once Pourbus moved outside the royal family, a touch of humanity could warm his brush. His masterpiece is the portrait of the *Duc de Chevreuse* (FIG. 6, 1610; Althorp, Northamptonshire, Earls Spencer), reminiscent of François Clouet's portrait of *Charles IX*. Here Pourbus's art comes closest to the other masters of the golden age

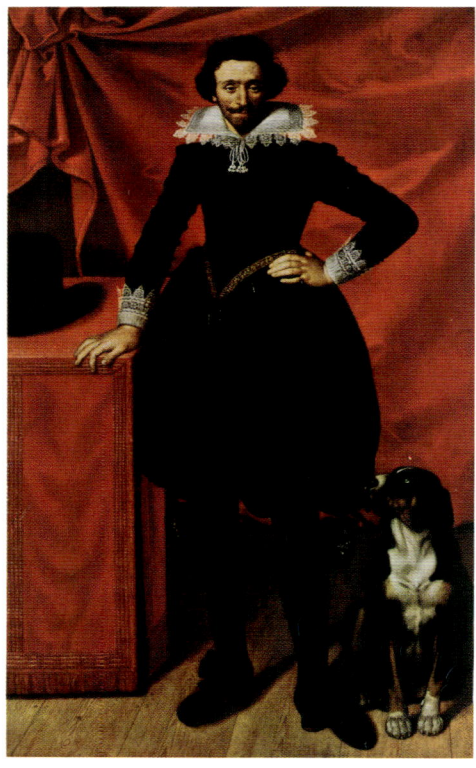

FIG 6 Frans Pourbus the Younger. *The Duc de Chevreuse*, 1612 Oil on canvas. 78 × 48½ inches. Althorp, Northamptonshire, The Earls Spencer.

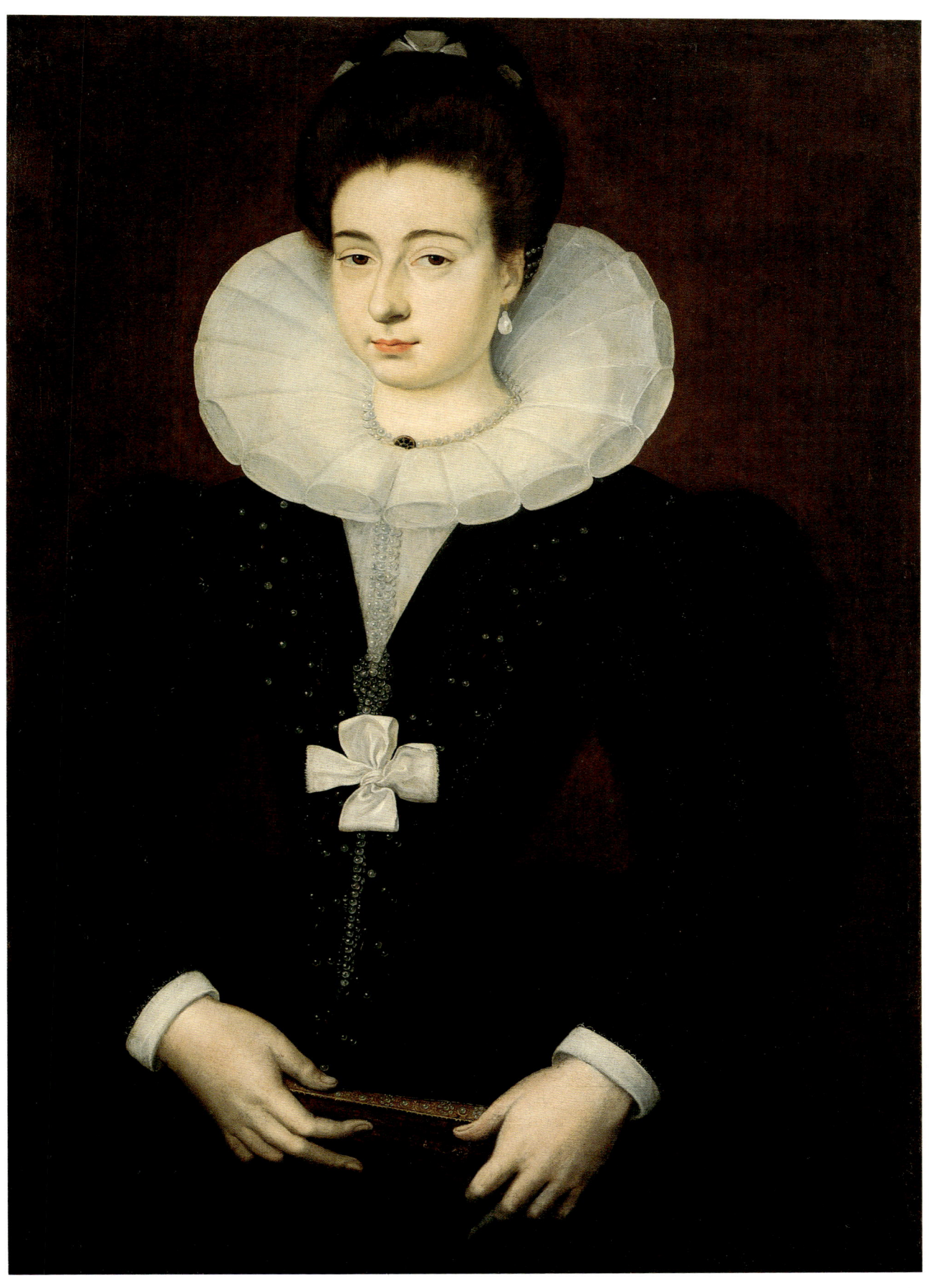

PLATE 2. FRANÇOIS QUESNEL. *Portrait of a Lady*, c. 1580. Oil on canvas. 33¾ × 24 inches.

of international court portraiture—Antonio Mor, Rubens and Van Dyck. Against a magnificiently and precisely recreated red silk drape and beside a red table, the black pantalooned Duke poses with his hound. In a setting impressive for its simple, powerful geometry, and painted with a palette reduced to a heraldic contrast of two colors, the Duke's face emerges with an intense naturalism and looks to us with profound humanity.

Pourbus also made group portraits such as the large canvas commissioned by the municipal authority of Paris commemorating "provosts of the guilds and magistrates of this town kneeling at the feet of the infant Louis XIII who is seated on a throne." Dézallier d'Argenville remarked that the painting displayed a "truth to nature and beautiful coloring with a noble simplicity in the treatment of draperies, ravishing expressions and perfect likenesses," making the loss of the picture all the more regrettable. A marvelous oil study for the painting showing the heads of three of the Magistrates has recently reemerged, however (PLATE 3). The meticulous, almost sculptural, rendering of each head, the dramatic lighting, and the variety of mood and expression captured in the world-weary faces were skills that Pourbus had first learned in the service of the Gonzaga. It is difficult to believe that such a study was not the model for Philippe de Champaigne's famous *Triple Portrait of Cardinal Richelieu* (c. 1640; London, The National Gallery).

During his stay in France, Pourbus made only a few religious paintings but *The Last Supper* (c. 1618; Paris, Musée du Louvre) prompted the young Poussin to comment that it was one of the finest pictures he had ever set eyes on. In its interplay of figures with vivid, readable expressions, its sober mood and symmetrical and severe composition, the painting prefigures the high classicism of Poussin's *Sacraments*, just as Pourbus's *Duc de Chevreuse* would prove a model for Philippe de Champaigne's most severe and classical portraits a half a century later.

ARTISTIC TRADITION in Paris in the first half of the seventeenth century is inseparable from developments in Rome, where a lively market existed, invigorated by competing schools of painting—the new classicism inaugurated by Annibale Carracci, and the bold naturalist vein of the followers of Carravaggio.

Thus, Simon Vouet (1590–1649), son of a master painter, arrived in Rome in 1614, supported by a royal pension, and quickly found himself the leading painter of a brilliant expatriate colony that included Valentin de Boulogne (1591–1632), Nicolas Régnier (1591–1667), Nicolas Tournier (1590–1639?) Claude Vignon (1593–1670) and Jacques de Létin (1597–1661). All of them worked in a variety of genres—they made altarpieces, painted scenes of everyday life and portraits—and all of them embraced Caravaggism early on.

Vouet's probable *Self Portrait* (FIG. 7) displays his particular brand of Caravaggism. With a vividness, immediacy, and startling naturalism worthy of Caravaggio—the portrait was attributed to the Italian until 1946—Vouet's *Self Portrait* nevertheless reveals a lyricism typical of the entire French colony. Portraying himself as a cavalier—the butt of his sword rises from the bottom of the canvas—this dreamy image is a paean to romantic youth and the bohemian life of

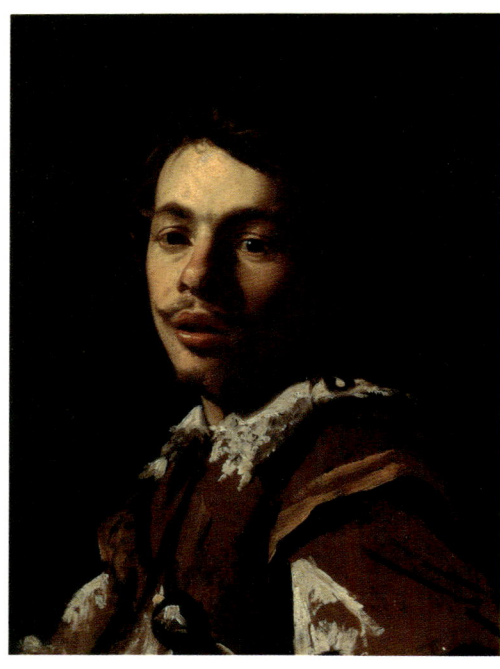

FIG 7. Simon Vouet. *Self Portrait*, c. 1615–18. Oil on canvas. 25¼ × 19 inches. Arles, Musée Réattu.

Rome, where a Parisian craftsman could metamorphose into a noble practitioner of one of the Liberal Arts. Freed from the constraints imposed in a commissioned likeness, Vouet endows his portrait with a fleeting mood, and an informality of pose and characterization. The sitter's parted lips seem about to speak and his shaded eyes sound a note of youthful uncer-

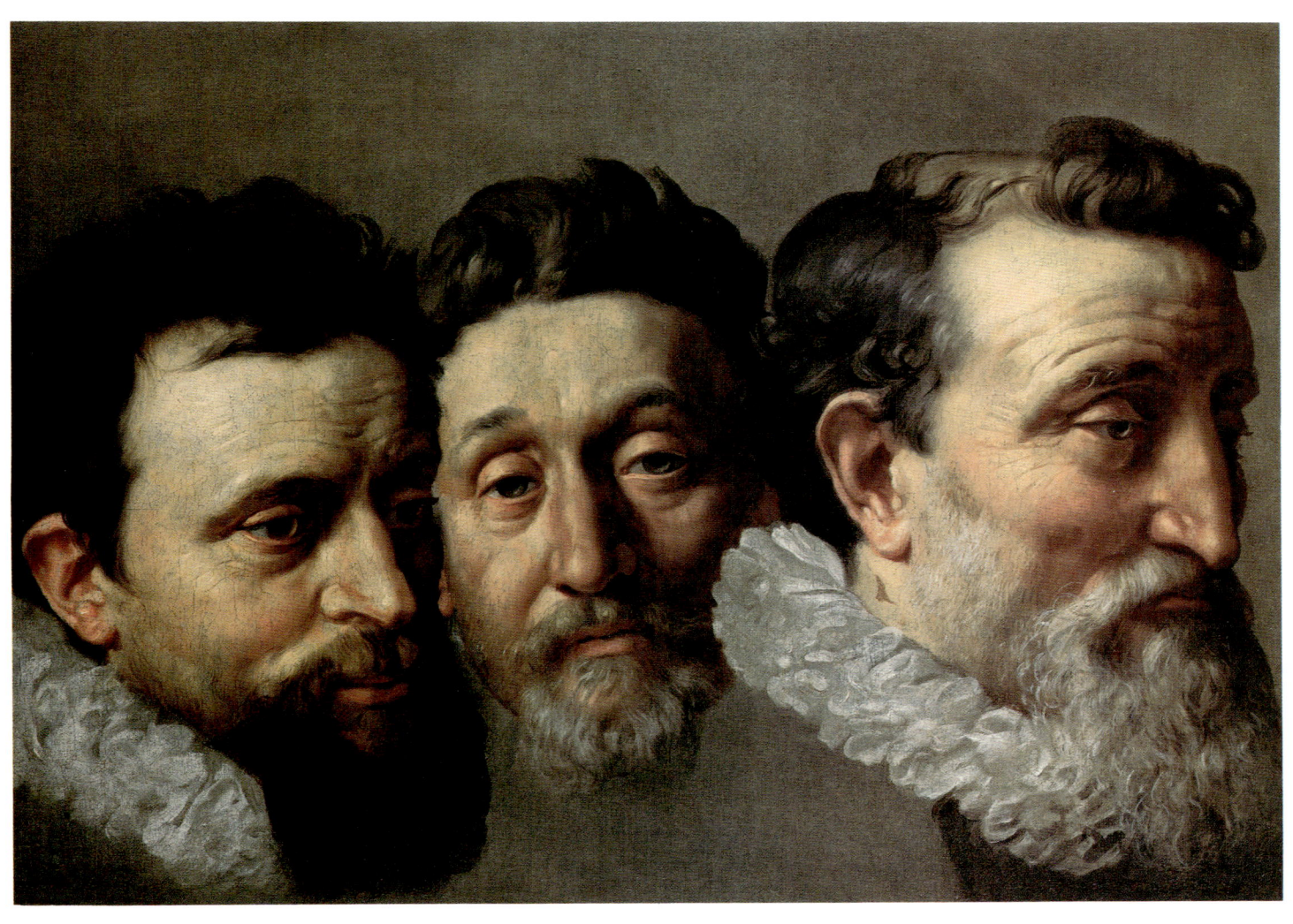

PLATE 3. FRANS POURBUS THE YOUNGER. *Head Studies of Three French Magistrates*, c. 1610. Oil on canvas. 15 × 22⅝ inches.

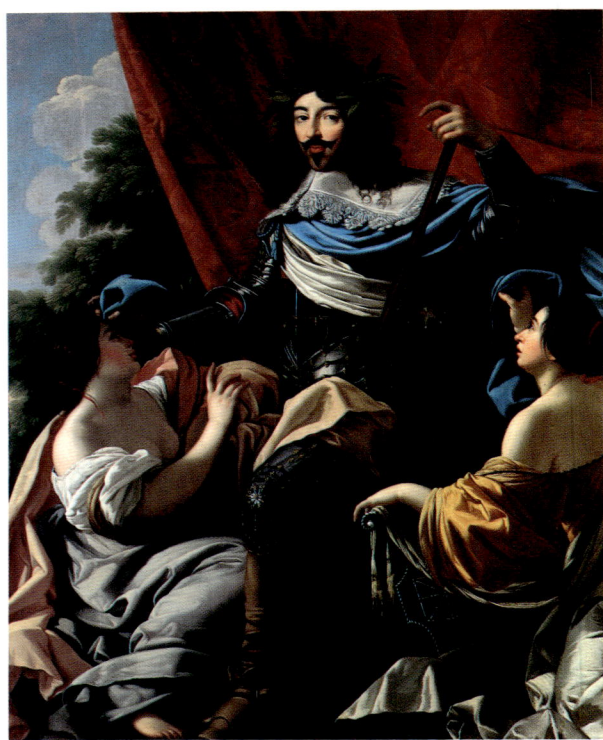

FIG 8. Simon Vouet. *Louis XIII, King of France and Navarre*, c. 1635. Oil on canvas. 64¼ × 61½ inches. Paris, Musée du Louvre.

tainty that is in contrast to his bold glance. Its bravura technique—the thin layer of his brown coat is enlivened by rapidly impasted slashes of white and black—would have been unthinkable in the restrained and dignified portrait tradition that still dominated the Parisian art world.

While in Italy, Vouet executed other portraits in oils (*Giancarlo Doria*, painted in Genoa in 1621; Paris, Musée du Louvre) and pastel (private collection), and painted a series of important altarpieces in Naples and Genoa, culminating in the commission to fresco St. Peter's in Rome. In 1624 he was elected President of the Roman Academia di San Luca, a testament to the remarkable esteem in which this young foreigner was held, and among his private patrons could be counted the poet Marino, Cassiano dal Pozzo and Cardinal Barberini, all of whom would switch their allegiances to Poussin after Vouet's return to France.

Early in 1627, Louis XIII instructed his ambassador to recall Vouet to Paris, where his illustrious reputation had preceded him. He was immediately innundated with commissions, many for the Crown, and is known to have painted many portraits of members of the court.

One portrait that survives attests to the tremendous shift in style that Vouet's painting underwent by the time of his return. *Louis XIII between France and Navarre* (FIG. 8,), commissioned by the king and probably dating from around 1635, symbolized Louis XIII's role as military protector of the two domains united under his rule. The title "King of France and Navarre" was first used by Louis's father, Henri IV, who had been Henry of Navarre, once an independent state along the Pyrenées. Louis stands, looking directly at us, poised between two female figures—personifications of the two Kingdoms—who kneel in submission on either side of the monarch. Though the painting suffers conspicuously from the constraints imposed on all state portraiture—it is stiff and rather unconvincing (and one might here acknowledge the possibility, despite its provenance, that it is largely a shop piece)—it nevertheless displays Vouet's new palette and facture. His arrival in Paris—a city where the brooding, brutal realism of the Caravaggisti had never won much favor—certainly hastened the adoption of a lighter palette which Vouet now applied to the gracefully gyrating figures that fill his canvases. Such figures define the space and structure of his pictures and infuse his compositions with a Baroque vigor that is always held in check by a certain classical restraint. The visit to Paris by Orazio Gentileschi (who worked for the king's mother from 1624 to 1626) and the recent arrival of several of Guido Reni's most refined and luminous canvases, helped prepare the public acceptance of Vouet's new Bolognese-inspired colors.

The onslaught of commissions, many of them large-scale decorative schemes, necessitated Vouet's reliance on an active workshop. "There are hardly any churches, palaces, or large houses in Paris which are not adorned with works by Vouet", Felibién would note. During his 18-year career in the capital, most of the significant French painters of the midcentury would pass through Vouet's studio, which became the *de facto* French Academy. Because so few of his portrait commissions have survived, Vouet's impact in this genre may best be considered through his former assistants, many of whose work bore the unmistakable marks of his style until the 1660s.

Among his greatest pupils was Eustache Le Sueur (1616–1655), who never traveled outside France and worked in Vouet's shop for a decade—from roughly 1633–1643/44. His early works show such a complete dependence on the manner of his master that, until recently, many of them carried an attribution to

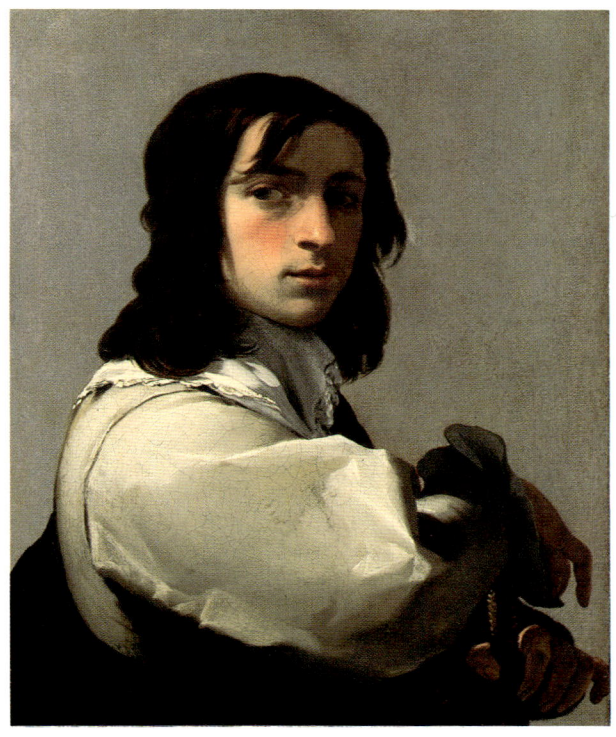

FIG 9. Eustache Le Sueur. *Young Man with a Sword*, c. 1640–45. Oil on canvas. 25¼ × 20½ inches. Hartford, Wadsworth Atheneum, The Ella Sumner and Mary Catlin Sumner Collection.

Vouet. Le Sueur's ravishing *Young Man with a Sword* (FIG. 9), whose attribution has recently been doubted—to my mind unjustifiably—reveals a full understanding of both Vouet's Roman and Parisian careers, combining as it does the bohemian romanticism of Vouet's Arles *Self Portrait* with the fine drawing, clear color and suave handling of his mature works. The sophisticated fall of light across the right side of the unidentified sitter's face and silk sleeve—which itself appears to emerge from the picture plane with uncanny conviction—as well as the graceful, boneless fingers and the extreme refinement of a palette more subtle than Vouet's, make this one of the century's more urbane portraits. Vouet's style could not be employed to greater or more comic contrast than in the endearingly dignified full-length portrait of a mountainous subject said to be the Tuscan general Alessandro del Boro (FIG. 10), only recently and quite convincingly given to Charles Mellin (?1597–1649), a painter from Lorraine who was in Vouet's orbit in Rome but seems, remarkably, to have also absorbed his post-Roman style.

BY THE EARLY 1640s the French art market had recovered enough that young painters no longer needed to leave the country in order to work and those lucky enough to be apprenticed in Vouet's workshop could find there the comprehensive training previously unavailable in Paris. In consequence, the formerly *de rigueur* Roman sojourn was now much shortened or, as in the examples of Le Sueur and La Hyre, eliminated altogether.

Nonetheless, even at mid-century, Rome remained a pilgrimage point for many French painters, as much because it was now the permanent home of the French school's most revered painter, Nicolas Poussin (1594–1665), as for its reputation as the cradle of Antiquity. Poussin had arrived in Rome in 1624, after a number of delays, aged 30. He voraciously absorbed the visual culture of antiquity as well as contemporary Roman painting and created a sensual series of mythological landscapes, modeled on the Venetian colorism of Titian's *Bacchanals*. The unfolding of Poussin's career is too well-known to require retelling here, but it is worth pointing out that, shortly after his arrival in Italy, he was well-patronized by a small, sophisticated group of *cognoscenti* including the poet Marino, Cardinal Barberini and the Cardinal's secretary, the antiquarian

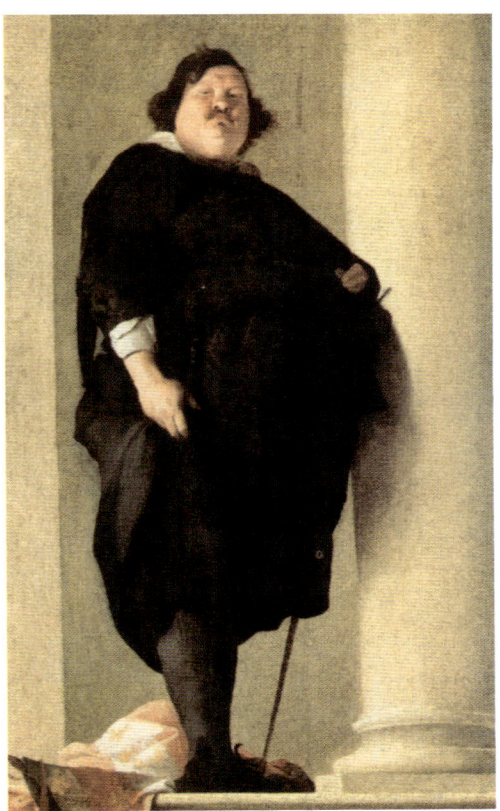

FIG 10. Attributed to Charles Mellin. *Portrait of a Man, said to be Alessandro del Boro*, c. 1650. Oil on canvas. 80 × 47¾ inches. Berlin, Gemäldegalerie, Staatliche Museen.

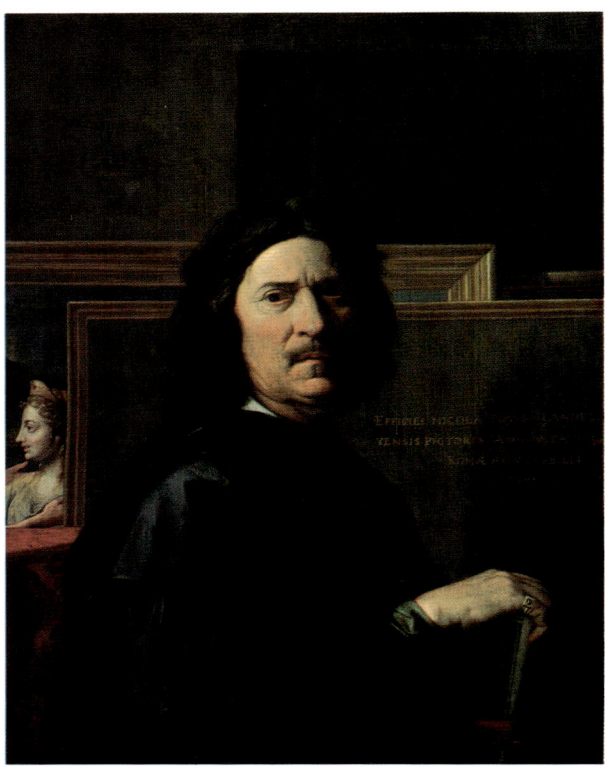

FIG 11. Nicolas Poussin. *Self Portrait*, 1650. Oil on canvas. 38½ × 28 inches. Paris, Musée du Louvre.

and collector Cassiano dal Pozzo, and that, as the decade of the 1630s progressed, the artist found himself painting increasingly for export to French patrons who had heard of his remarkable talent. When Louis XIII's minister, Cardinal Richelieu, turned his attention to reviving the arts in France, he called upon Poussin, from whom he had previously commissioned a pair of *Bacchanals* for his own collection. Officially summoned back to France, Poussin's brief tenure as Louis XIII's *Premier Peintre* (1640–1642) was an unhappy period for the artist, by nature an independent figure who preferred to pursue his personal vision of art in small easel paintings destined for like-minded friends. Once back in Paris, Poussin found himself in charge of teams of assistants and entrusted with creating vast decorative schemes for the Louvre for which his talents were ill-suited. He soon found a pretext to return to Rome, and never left it again.

Nevertheless, his Parisian experience was critical to Poussin's career because during that trip he formed strong attachments to a new circle of wealthy *bourgeois* who would be his chief patrons for the remainder of his career, in particular, the banker Pointel and Paul Fréart de Chantelou, assistant to the *Surintendant des Bâtiments*. It was these two men who would commission from Poussin his only existing portraits, the self portraits in Berlin and Paris (FIG. 11).

As early as 1647, both Chantelou and Pointel expressed the wish of having portraits of the artist. Poussin tried unsuccessfully to satisfy their wishes by finding another painter skilled in portraiture, a genre in which "he took no great pleasure and had little experience." Yet, as Poussin wrote to Chantelou, "...I cannot bring myself to spend a dozen *pistoles* to have my head coldly pummelled and painted by the likes of M. Mignard, who—although he is the best practitioner I know—is as untalented as he is undisciplined," and, challenged with repeated requests, he relented and took on the job himself. He set to work in 1649 and the first *Self Portrait*, originally intended for Chantelou, was finished in June. He confided in a letter to his patron that he was about to begin a second portrait and would wait until it was finished before sending him the better of the two: "But please, you must not breathe a word of it, so as to avoid any jealousy."

The second portrait, regarded by Poussin as "the better painting and the better likeness," was completed in May 1650 and went to Chantelou. The first, which was sent to Pointel, is a melancholic and elegiac portrayal, more gentle and plaintive. The Chantelou portrait (in the Louvre since 1797) "epitomizes those qualities one associates with the master: severity, authority and unflinching determination," as Richard Verdi has recently noted: it seems to illustrate the painter's dictum that "painting should appeal to the mind and not the eye." In it Poussin observes us, his brow furrowed with the fixity of his gaze. He wears a toga in the manner of the ancients and stands before framed paintings stacked against a doorway, which give the portrait a rigorous, geometric design. Seen at the left is a fragment of a painting—a young woman embraced—which Bellori, who probably got the interpretation from Poussin himself, explained as follows: "The head of a woman in profile with an eye at the top of her diadem symbolizes painting; the two hands which appear and enfold her represent both the Lover of Painting and Friendship to whom the painting pays tribute." Poussin wears on his finger a diamond ring cut in the shape of a pyramid, its form a well-known Stoic symbol of constancy. His hand rests on a portfolio, as many critics have observed, like Moses gripping the tablets of the Law.

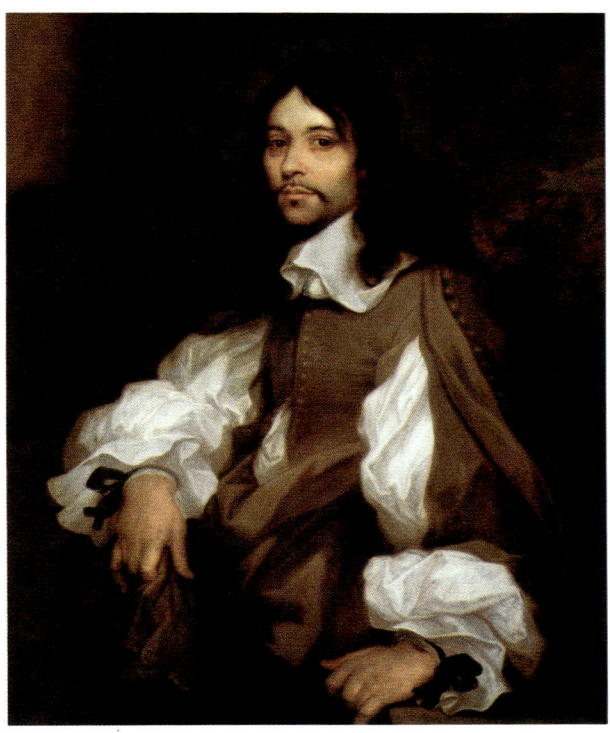

FIG 12. Sébastien Bourdon. *Man Wearing Black Ribbons*, c. 1657. Oil on canvas. 42½ × 35 inches. Montpellier, Musée Fabre.

As Vouet's youthful *Self Portrait* (FIG. 7) had offered a new model for the painter's image of himself, Poussin's *Self Portrait* offers another: the Painter as Intellectual, Philosopher and heir to the legacy of the Renaissance. It is also a tribute to the Art of Painting and to those individuals—both painters and patrons—who love it.

Poussin's rigorous classicism had a profound influence on the art of the next generation of French painters—partly because it offered such a marked alternative to the decorative Baroque of Vouet—but in portraiture its impact would be seen most vividly in the revival of classicism led by Jacques-Louis David and Ingres a century and a half later. Unlike the elder Poussin, Sébastien Bourdon (1616–1671) seems to have enjoyed portrait painting and specialized in it at several points in his career. A native of Montpellier and an exact contemporary of Le Sueur, Bourdon traveled extensively in his youth, arriving in Rome in 1634 where he developed a specialty in *bambocciate* genre scenes. Born a Protestant, he left Rome in 1637 to escape the Inquisition, and painted several ambitious Baroque altarpieces and history subjects back in Paris. The early 1640s were a turning point in Bourdon's career: inspired by Poussin—"Think like Poussin" he would later exhort students—Bourdon created monumental geometrical compositions with rigorously defined planes, Poussinesque figures and fresh color. But when he went to Sweden in 1652 to assume the role of court painter to Queen Christina (a welcome opportunity to escape the unrest of the Fronde), he made pictures modeled not on the severe classicism of Poussin but on the aristocratic ease of Europe's most sought after court portraitist, Anthony Van Dyck, who had himself worked in Paris in 1641. In portraits such as the *Man Wearing Black Ribbons* (FIG. 12), made during his brief return to Montpellier (1656–1658), Bourdon's inspiration is clear. The Flemish master's casual elegance informs this masterpiece of what has been termed the "the Louis XIII Romantic Style," but the very French note of reserve, and Bourdon's extraordinarily gentle *sfumato*, are quite alien to the more robust Van Dyck. Nor is Bourdon's preoccupation with form—so evident in his Poussinist subject pictures—missing here. Always a notable colorist, his reduced palette of ivory, cocoa and black is a perfect foil to set off the sitter's firmly modeled face and hands.

IN THE SAME year that the Fronde (1648–1653) erupted, the Académie Royale de Peinture was established in Paris. Among its original twelve members were Charles Le Brun, Laurent de La Hyre, Le Sueur, Bourdon, and Philippe de Champaigne. The founders of the Académie—known as the "Ancients"—were mostly young men of the generation born after 1600, and neither Vouet, whose domination of the Paris art world was beginning to look restrictive if not insidious, nor Poussin, whose role as painter-philosopher had largely inspired the Ancients in their undertaking, were invited to join. The choice of the name "Académie" suggests that they were modeling it not only on the Academia di San Luca, but also the Académie Française, founded by Richelieu in 1635. In establishing the Académie its members sought to free themselves from the control of the Maîtrise, with its feudal mentality and strictures, to achieve recognition for its members as practitioners of an intellectual and not merely mechanical art, and to provide the training and education necessary for the highest achievements in the visual arts.

From the very beginning, Charles Le Brun (1619–1690) assumed a leading role within the

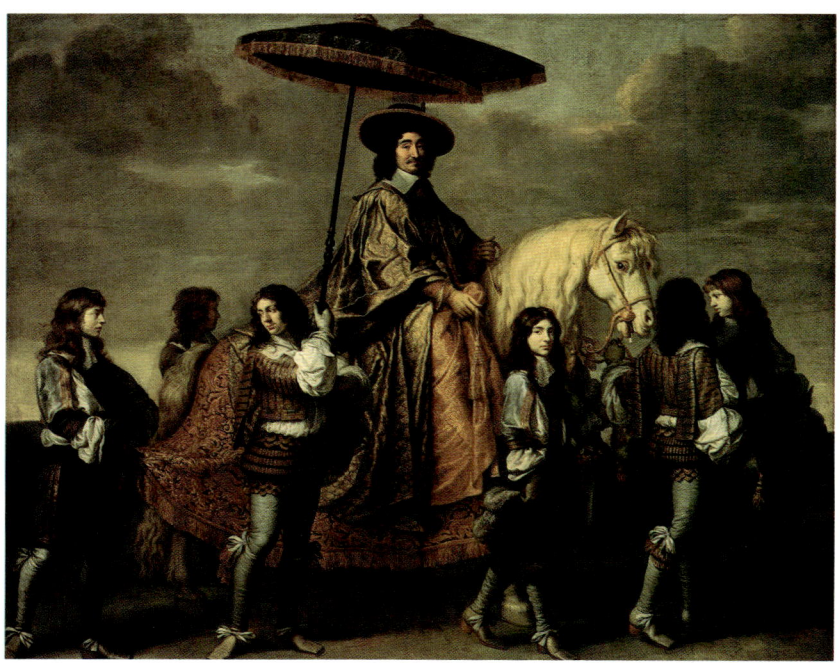

FIG 13. Charles Le Brun. *Chancellor Séguier*, c.1653-57. Oil on canvas. 116 × 140 inches. Paris, Musée du Louvre.

Académie and on several occasions early in its history, his first and most important private patron, the powerful Chancellor Pierre Séguier (1588–1672), intervened to save it. Séguier, the subject of Le Brun's most remarkable portrait (FIG. 13), had been identified as a likely protector by the artist's father, himself a sculptor in the Chancellor's employ. Séguier, who had commissioned Vouet to decorate his townhouse, placed his new protégé in Vouet's studio, where the boy received the most comprehensive apprenticeship available in Paris. Later Séguier provided the funds for Le Brun to study in Italy—the young painter departed for Rome in 1642 in the company of Poussin—and insisted that he remain there and work when the homesick student wanted to return to Paris after only six months. Most significantly for Le Brun's career, it was probably Séguier's maneuvering that enabled Le Brun to take the reins of the fledgling Académie in the early 1650s (Séguier was himself Protector of the Académie Française), and the Chancellor's unwavering support that secured Le Brun's relationship with Colbert in the critical months that followed Fouquet's downfall.

Le Brun's huge portrait of the Chancellor, which probably dates from the mid-1650s, is a fitting tribute to the devoted patron to whom he owed so much. The Chancellor is depicted in gloriously shimmering silk robes astride a white horse, surrounded by page-boys like a Chinese Mandarin, and escorted beneath paired parasols, which themselves might allude to his role as a protector of the arts. His brimmed hat is the one traditionally worn by French chancellors and the ribbon of the order of the Holy Spirit rests against his chest. It was suggested in the eighteenth century that Le Brun represented his own features in the face of the parasol-carrying equerry.

Although life-sized equestrian portraits were popular throughout the courts of Europe in the seventeenth century, they were unusual in France. Le Brun's genius was to create a French rejoinder to the challenge of Rubens's *Duke of Buckingham*, Van Dyck's *Charles I* and Velasquez's *Count-Duke of Olivares*. Le Brun abjures the Baroque vigor of these works replacing their swirling movement with the magisterial simplicity of an ancient frieze, unrivaled in the grandeur and nobility of its effect.

It was not until the following decades, when Le Brun was made *Premier Peintre du Roi* (1664), Director of the Gobelins factory (1663) and Chancellor for life of the Académie (1664) that his control over the artistic tradition in France was consolidated. To carry out the massive decorative schemes planned by Louis XIV and Colbert for Versailles, the Louvre, and the other royal palaces required teams of artists with a perfect command of human anatomy and expression who were master draftsmen and colorists, familiar moreover with poetry, mythology, and the Bible. To educate them would require that the Académie be more than an association and school for artists: it had to codify the rules—in the same way that the Académie Française was responsible for codifying the rules of language—and with this in mind, under Le Brun's direction, the newly reconstituted Académie (1663) hammered out the systematized doctrine that would dominate artistic production in France for the next two centuries. Lecture series were instituted, Salon exhibitions organized, competitions arranged, prizes awarded, scholarships funded and an outpost of the

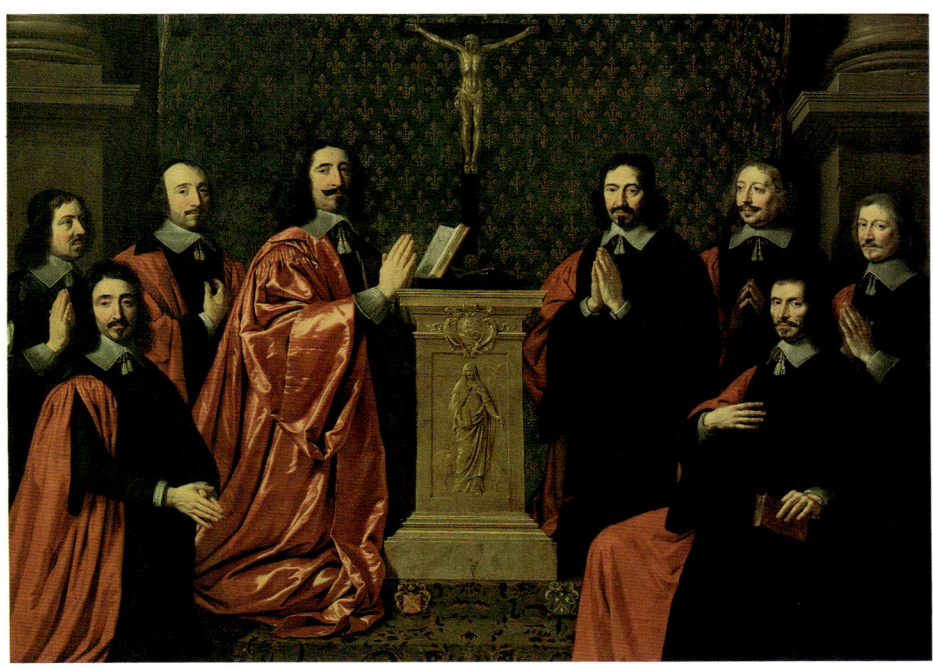

FIG 14. Philippe de Champaigne. *The Aldermen of the City of Paris*, 1648. Oil on canvas. 78¾ × 107 inches. Paris, Musée du Louvre.

Académie founded in Rome. Membership in the Académie itself became a social distinction and permission to work on royal commissions was restricted to members.

At the core of academic pedagogy was the hierarchy of genres. Portraiture was ranked high, second only to history painting. While it depicted Man, the measure of all things, it merely aped nature, whereas history painting portrayed an idealized Man enacting stories from history and the Bible, and required all the skill and knowledge at a painter's disposal. Still, several portrait specialists were founding members of the Académie—the Beaubrun cousins, Louis Elle, and the Testelin brothers, as well as the versatile Bourdon and Philippe de Champaigne, the latter a religious painter but also one of the great portraitist of the age. It is to him that much of the credit for portraiture's growing esteem within the Académie is due.

Born in Brussels, Philippe de Champaigne (1602–1674) arrived in Paris in 1621 and entered the studio of Lallemand. Together with the young Poussin, he worked for Marie de' Medicis at the Luxembourg Palace, eventually becoming her official painter. Champaigne was patronized extensively by both Church and court and was granted a pension and lodgings in the palace. He curried favor with Louis XIII, for whom he painted a portrait (in the Louvre) showing the king crowned by Victory at the Siege of La Rochelle (1628). He also worked extensively for Richelieu, and made the celebrated full-length portrait of the Cardinal (c.1635–1640; London, The National Gallery). In a pose reminiscent of those found in Van Dyck's Genoese portraits, the minister is seen from a low vantage point, encased in massive, sculptural robes and standing before swags of drapery and a high marble arcade. Like Champaigne's great portrait of Omer II Talon (Washington, National Gallery of Art), it looks back to Pourbus's state and court portraiture, which also gained dignity from the shrewd use of physically imposing, nearly empty stage settings.

On three occasions, Champaigne was commissioned to paint the official group portrait of the aldermen of Paris, portraits traditionally ordered every two years when a new provost was elected. The one that has survived was made for the Hôtel de Ville in 1648 and displays both Champaigne's phenomenal naturalism, especially evident in the faces, and the archaic formality of his compositions (FIG. 14). Painted in his familiar palette of red and black, the figures kneel around a crucifix which stands on a small altar carved with the image of St Geneviève, the patron saint of Paris, in hieratic poses reminiscent of early Netherlandish paintings by Van Eyck and Memling . As is traditional with such corporate portraits—think of the many similar groups by Rembrandt and Hals—there is little interaction among the sitters, but this static quality of physical and emotional isolation characterizes all aspects of Champaigne's art.

The artist's most moving work, and a painting with an intense spiritual if not physical communion between the sitters, is the *Ex-Voto* (FIG. 15) in the Louvre. In the 1640s, shaken by the deaths of his wife and two of his children, Champaigne was drawn

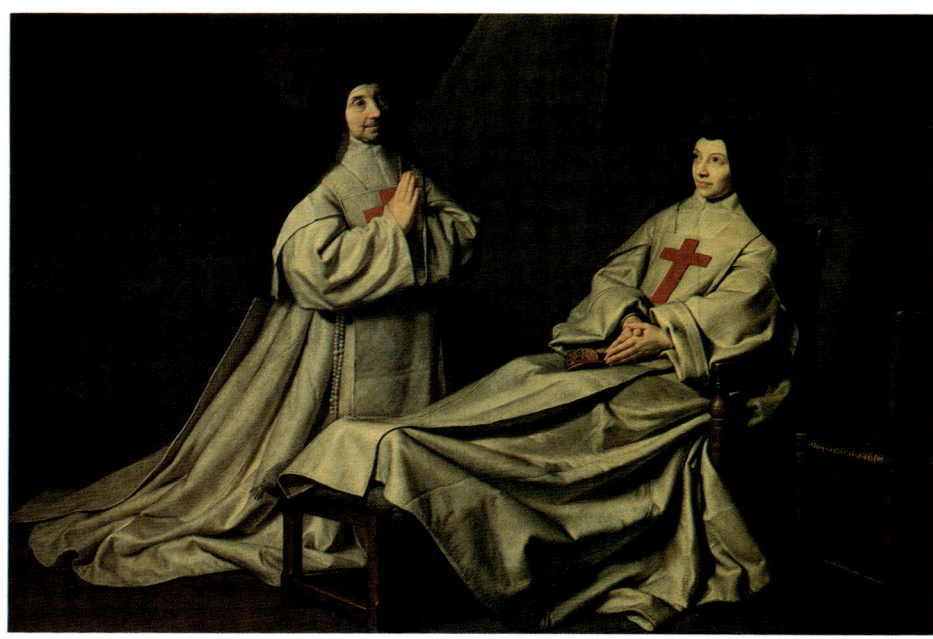

FIG 15. Philippe de Champaigne. *'Ex-Voto': Mother Catherine-Agnès Arnauld and Sister Catherine de Sainte-Suzanne Champaigne*, c. 1662. Oil on canvas. 65 × 90¼ inches. Paris, Musée du Louvre.

to the austere and unyielding doctrine of strict morality propounded by the Jansenists, a Gallican Catholic sect centered at Port-Royal, not far from Versailles. Because the self is detestable for the Jansenists, Champaigne's numerous portraits of the priests and nuns of Port-Royal were made without their knowledge or executed posthumously from death masks. In October 1660, Champaigne's only daughter Catherine, a sister at Port-Royal, was stricken with a paralysis of the legs which by the following year had left her unable to walk. The prioress, *Mère* Catherine-Agnès Arnauld declared a *novena* in the hope that the girl might be cured, and on the 7th January 1662 Catherine's health was restored and she suddenly regained the ability to walk. In thanksgiving for her recovery, Champaigne painted the miracle and made a gift of the picture to the monastery.

The *Ex-Voto* is a masterpiece of classical restraint, in keeping with both the theology and aesthetics of the sect. In a room bare of all furnishings except for two wooden chairs and a footrest, Catherine reclines beneath a wooden cross, her bible behind her. *Mère* Agnès kneels at her feet in prayer. Positioning the prioress and the empty chair at a right angle to his outstretched daughter, Champaigne configures the participants themselves in a rough cruciform and colors his composition in a muted harmony of black, brown, white and ivory—a restricted palette similar to the one Bourdon was experimenting with at the same moment—enlivening it only with the brilliant red of their scapulars. The composition is sober and timeless, like a piece of medieval tomb sculpture, and the single sourceless shaft of light is the sole allusion to the miraculous event that is witnessed. Although, characteristically, the women silently gaze heavenward rather than look at each other, they are spiritually bound by the intensity of their devotion. In its visual austerity and compositional rigor, the *Ex-Voto* is a monument of French classicism equalled only by the late paintings of Poussin.

It was the 70-year-old Philippe de Champaigne who inadvertently launched the quarrel about the comparative importance of color versus drawing to the art of painting which divided the Académie until the end of the century. In a lecture in 1671, Champaigne criticized a painting by Titian for the brilliance of its colors and invoked the example of Poussin as a corrective. A battle broke out as one by one members identified themselves with the 'Poussinistes' or the 'Rubenistes'. Le Brun's conception of the art of painting, which held Raphael and Poussin as models, was that painting should address the mind rather than appeal to the senses and it should accomplish this through clarity—'readability'—of form and expression. This literary, as opposed to sensual, emphasis inevitably stressed the primacy of drawing and through Le Brun's efforts became the cornerstone of academic pedagogy. Mignard, Le Brun's most admired and bitter rival, naturally sided with the Rubenistes.

A pupil of the Bourges painter Jean Boucher, then of Vouet, Mignard moved to Italy in 1635, and might well never have left had he not been recalled by the king in 1657. That he was successful and prominent

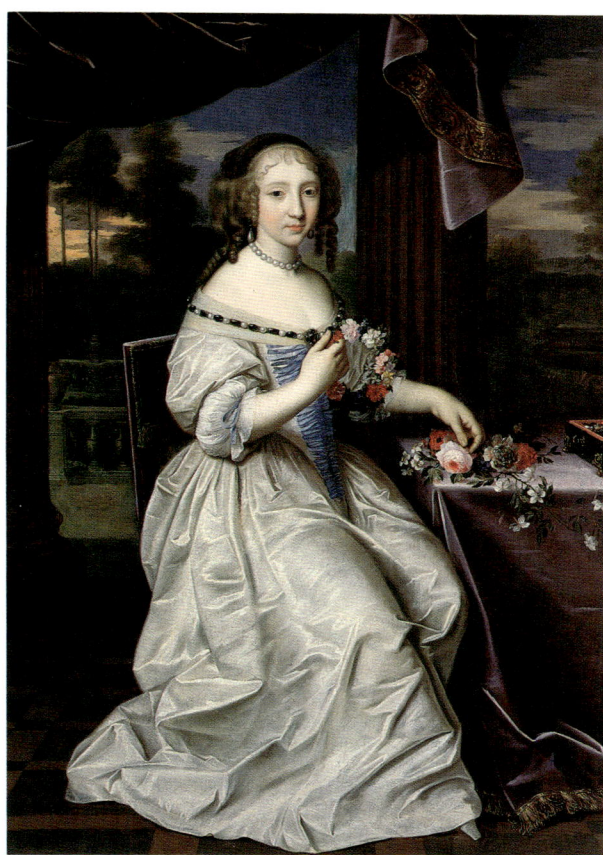

FIG 16. Pierre Mignard. *Portrait of a Young Lady*, c. 1680. Oil on canvas. 63¾ × 44½ inches. Private Collection.

is all that is known of his two decades in Rome, from which little work survives. Once back in France he prospered decorating private houses and painting society portraits. From the start, Mignard and Le Brun seemed locked in conflict for leadership of the French school. When Le Brun championed the Académie Royale Mignard broke with it and took refuge in the alternative Académie de Saint-Luc. Unfortunately for Mignard, the alliance between Colbert and Le Brun ensured his eclipse, and it would not be until his own principal supporter, Louvois, succeeded to the position of *Contrôleur-Général* following Colbert's death in 1683, that Le Brun's dictatorship of the arts would come to an end. On the death of Le Brun in 1690, Mignard was appointed to the posts of *Premier Peintre,* Director and Chancellor of the Académie all in one day. He would have only five years to enjoy this much-delayed triumph.

Although a history painter and grand-scale decorator, Mignard was most admired, then as now, for his portraits—Poussin's disparaging remarks aside—and in particular for his very flattering depictions of women (FIG. 16). No painter of his time was more skilled at softening the contours of a lady's form or bringing forth the milkiness of her skin. Molière, a great admirer of Mignard who sat to him more than once, observed that the time had come when women asked painters to give them complexions "all lilies and roses, a shapely nose, small mouth, big sparkling, finely slotted eyes and most important of all, a face no longer than a fist, even if in reality it was a good foot wide." Mignard himself seemed to concur when he told his biographer, the Abbé de Monville, that he would rather have painted great decorations for less money than "women [who] do not know what it is to be painted as they are; they have an idea of beauty which they would like to resemble; it is this that they want copied, not their faces."

And it was this that Mignard gave them, despite his complaints. Returning to the Fontainebleau School's idealized facial types, drained of all character, he specialized in icy renderings of sullen beauties whom he painted in a palette of frosty blues and silvery whites that derive from Bolognese masters such as Reni and Albani. His rigid classicism and chill palette make one wonder how he could have theoretically embraced Rubens while learning so little from him. In the portrait of an unknown lady holding a crown of flowers, which probably dates from the 1680s, the marmoreal sitter is posed in a portico that opens onto an extensive garden. The setting of the picture is almost identical to that in Mignard's *Little Girl Blowing Soap Bubbles* at Versailles, and in both, the sitters' activities—weaving a floral wreath beside an open jewel box, and blowing bubbles next to a prominently placed timepiece—are probably intended to evoke a *Vanitas* theme. It was Mignard, more than anyone else, who was responsible for reviving the Renaissance tradition of the allegorical portrait and introducing it into the domestic portraiture of Louis XIV's reign.

Undoubtedly the brittle self-consciousness and imposing artificiality of so many of his paintings were compatible with the vast decors created by Mignard and Le Brun contemporaneously; nevertheless (and remembering how much of his oeuvre is lost) it is difficult fully to appreciate the tremendous reputation that Mignard had in his lifetime. His oversized equestrian portrait of *Louis XIV at the Siege of Maastricht* (1673; Turin) pales beside Le Brun's *Séguier* or any of the Baroque models—Bernini included—that he

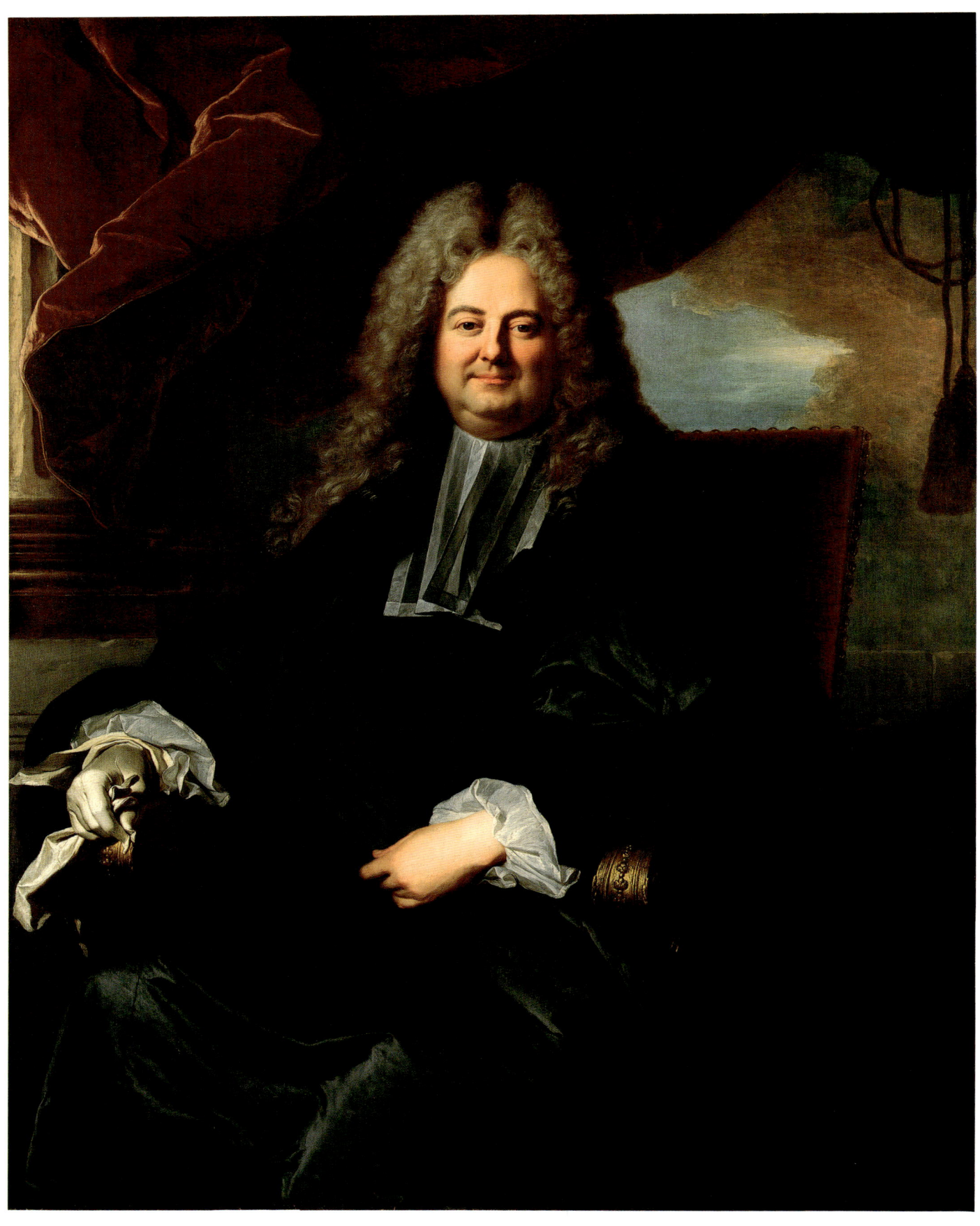

PLATE 4. HYACINTHE RIGAUD. *Portrait of a Parisian Alderman*, c. 1700. Oil on canvas. 55¾ × 44½ inches.

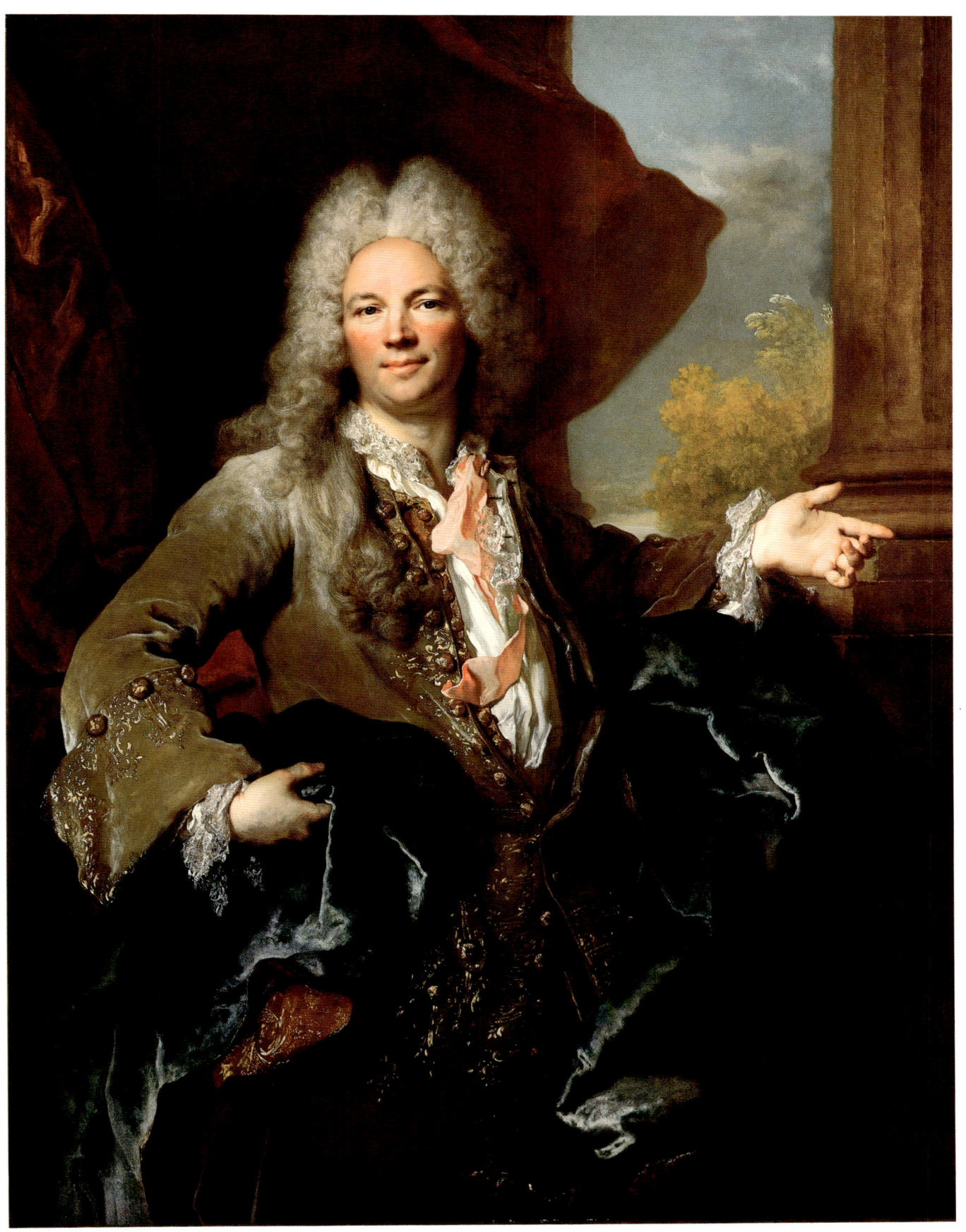

PLATE 5. NICOLAS DE LARGILLIERRE. *Portrait of a Gentleman*, c. 1720. Oil on canvas. 54 × 41½ inches.

directly challenged. Stiff, mannered and faintly ridiculous, his painting seems carved from stone, lacking both the fluency of the Baroque and the sober dignity inherent in Le Brun's classical solution. Mignard does better in his few informal portraits of men, such as the powerful *Man in a Fur Hat* (1654; Prague, Narodni Gallery), and it may be these that inspired the acclaim and loyalty of Racine, Molière and Madame de Sévigné.

Le Brun and Mignard close an era in French art. Both were made rich by their profession, both were ennobled by the king, both traveled in exalted circles and were employed—and befriended—by some of the most illustrious men in the Kingdom; Le Brun in particular was recognized as having personal power as great as many royal minsters. Mignard, the only artist mentioned by name in the memoirs of Saint-Simon, left an enormous estate at the time of his death (550,000 *livres*) and his daughter became a countess. The Académie that each had led brought prestige to all of its members.

At the same time, the *grand goût* of Versailles could not easily be excelled by a younger generation of painters and a certain weariness—even flatulence—of style threatened to set in. It was probably inevitable that in the dispute over color versus line, color would win, since color offered a new direction as yet to be fully explored and one that is more democratic in its vision of an art accessible through the senses rather than comprehensible only by the mind. With the election to the Académie in 1699 of Roger de Piles, the leading theorist of the Rubenistes, a page in the history of French painting had turned and a new chapter begun.

THE UNDISPUTED LEADERS of the new era in portraiture were Hyacinthe Rigaud (1659–1743) and Nicolas de Largillierre (1656–1746). They are invariably spoken of together as two sides of the same coin: Rigaud, the court painter *par excellence* to whom every great noble of Versailles sat; Largillierre, the unrivaled portrait painter to the rich bourgeois aldermen, lawyers, and financiers of Paris. Between them a whole society seems to have been recorded over the better part of a century. The splendor of Rigaud's achievement can be illustrated with a single work: his great portrait of Louis XIV in the Louvre (FIG. 17), painted in 1701, the most celebrated and indelible image of the *Roi soleil*. Probably no royal portrait

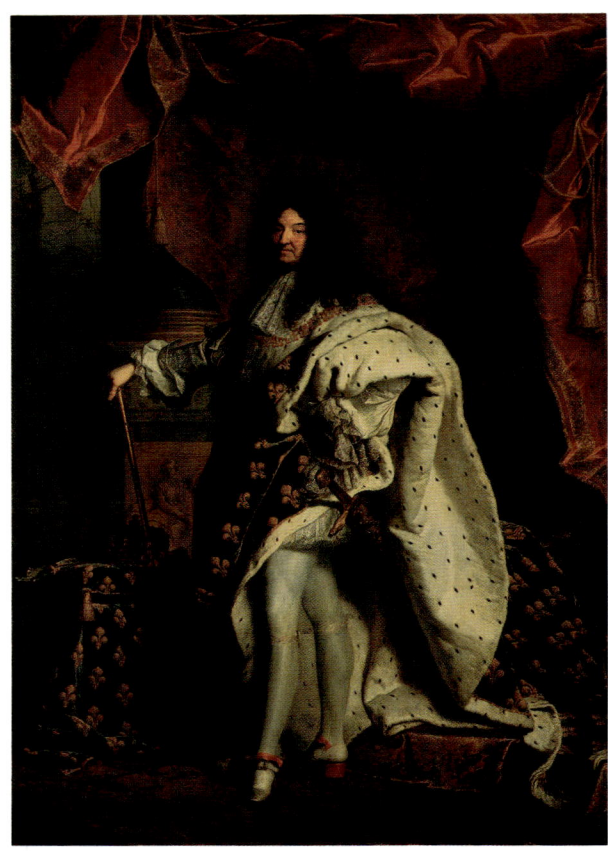

FIG 17. Hyacinthe Rigaud. *Louis XIV,* 1701. Oil on canvas. 107 × 76½ inches. Paris, Musée du Louvre.

since Clouet's *François I* (FIG. 3), and certainly none again until Ingres' portrait of *Napoleon I on the Imperial Throne* (1805; Paris, Musée de l'Armée, Palais des Invalides), has so effectively conveyed the authority of the French sovereign. His pose loosely modeled on that of *Charles I Hunting* by Van Dyck (Musée du Louvre), Louis XIV is depicted, aged 63, in his coronation robes, the order of the Holy Spirit around his shoulders, scarlet heels of the nobility beneath his feet, sword of the military hero at his waist, crown, scepter and "hand of Charlemane" at his side—the very model of the just and powerful king appointed by God. If no monarch after him seemed so convincingly to embody these qualities, no other king was lucky enough to have been painted by Rigaud at the height of his powers. The rigid stiffness of the monarch is counterbalanced by the suffocating swirl of red silk curtains and cascades of ermine lined, fleur-de-lys-embroidered velvet which create a breathtaking sense of swagger and luxury to rival the most bravura Baroque portrait. Rigaud is one of the rare painters for whom drapery is an essential ingredient of drama.

Louis XIV's head is painted on a separate piece of canvas which was subsequently sown into the larger one. No doubt this was because Rigaud had to travel to Versailles with the small canvas under his arm, had only a few brief sessions with the king during which he rendered the face, and then returned to complete the painting in his studio with stand-ins or mannequins. Nevertheless, it reflects his general practice of painting only the sitter's head and hands. It was his numerous studio assistants—often with specialized skills in painting drapery, fur, flowers, battle scenes—who finished the paintings from oil sketches provided by the master. As a royal commission might sometimes require that as many as twenty copies be sent out as family or diplomatic gifts, such a huge enterprise was essential.

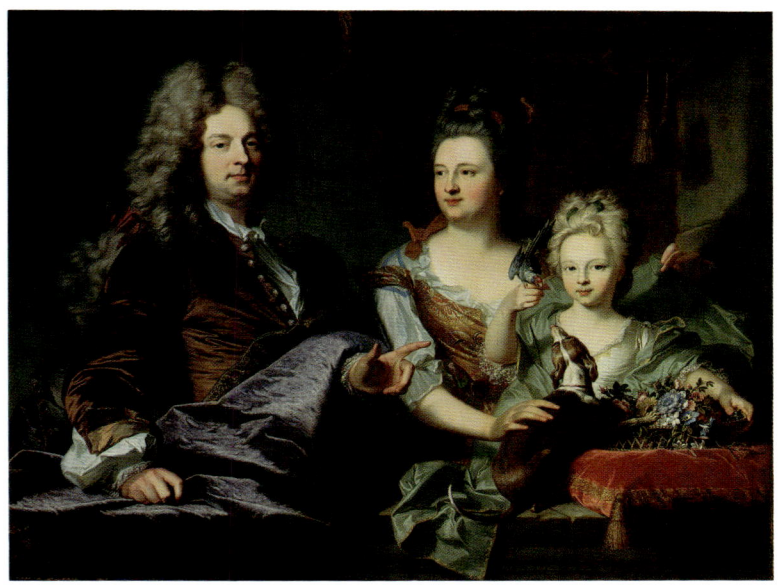

FIG 18. Hyacinthe Rigaud. *Jean Le Juge, his Wife Elisabeth de Gouy, and their Daughter Marguerite-Charlotte Le Juge*, 1699. Oil on canvas. 45 × 58 inches. Ottawa, National Gallery of Canada. Acquired from Colnaghi, 1938.

It should be obvious from the warm, rich palette of the king's portrait, that Rigaud was in the camp of the Colorists. Born in Perpignan in 1659, he studied under minor masters first in Montpellier and then in Lyon. In 1681 he arrived at the capital and found immediate success. He was awarded the *Prix de Rome* in 1682 and would have gone to Rome but, following the advice of Le Brun, he decided to stay in Paris and begin his professional career without delay. Rigaud was admitted to the Académie in 1684 and officially received as a full member in 1700 with the submission of his *morceau de réception*, a portrait of the sculptor Desjardins (Paris, Musée du Louvre). In 1688, Rigaud's career was made when he was commissioned to paint the portrait of Monsieur, the King's brother; his portrait was well received, and henceforth all of the court sat to him, including generals, foreign princes, and most of the French royal family.

Rigaud rarely painted women—"If I paint them as they are" he said, "they don't feel that I've made them handsome enough; if I try to flatter them, they are unrecognizable"—though the famous double portrait of his mother in the Louvre (1695) has a spare, poignant sincerity worthy of Philippe de Champaigne. Despite court patronage, Rigaud also painted some of the bourgeois clients—men of the city rather than the court—who normally took their business to Largillierre. Between 1700 and 1715, Rigaud charged 240 *livres* for a standard waist-length single figure portrait; by 1730 he was able to command 600 *livres*. During this same period Largillierre would be paid just over half of Rigaud's going rate for the same type of picture. Nevertheless, as Dézallier d'Argenville remarked, "Largillierre preferred to cater to the public" than the Crown, "for the work was less demanding and the payment more prompt." An analysis of the similarities and differences between the styles of Rigaud and Largillierre can be made by comparing two bourgeois portraits of men, one by each of them (PLATES 4 and 5).

Rigaud's portrait of an unidentified alderman probably dates, judging from his costume, to around 1700 (PLATE 4). The baroque conventions of Louis XIV's far grander state portrait—the framing devices of a marble column with a huge billowing tasseled drape—are present here in miniature, as it were. The alderman's fat, smiling face is meticulously described by Rigaud's brush and is more inviting than the king's, to be sure, and the physical relationship of the sitter to the picture space (and hence, the viewer) is much more intimate. Contrasted with Largillierre's portrait of an unknown man, probably painted fifteen or twenty years later (PLATE 5), the pose of Rigaud's alderman is almost hieratic—not stiff, for it is much too natural and convincing to be so described—but alert and reserved. Largillierre's sitter, on the other

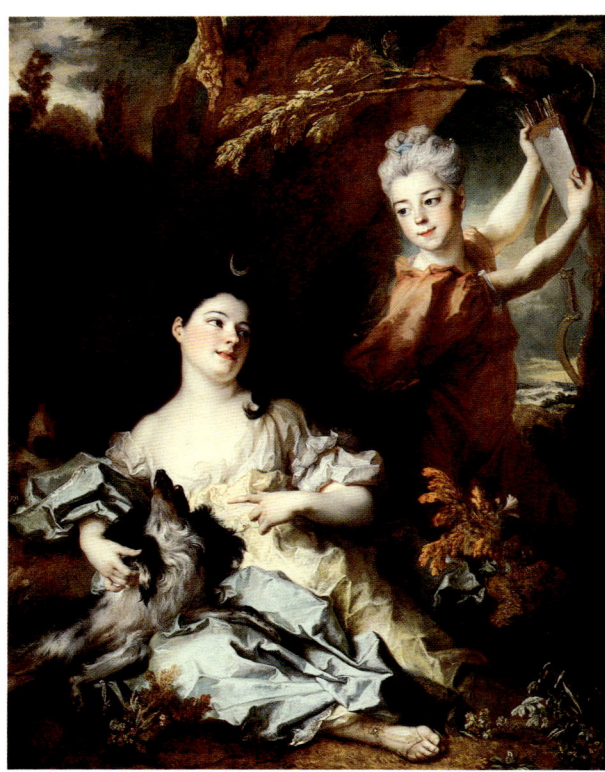

FIG 19. Nicolas de Largillierre. *Countess of Montsoreau and her Sister as Diana and an Attendant*, c. 1714. Oil on canvas. 56¾ × 44¼ inches. Dallas, Private Collection.

hand, displays a rhetorical, even conversational pose, and the extreme informality of his undone shirt front contrasts vividly with the black silk encasement of the alderman's robe. The handling of pictorial surfaces is quite different in each as well, with Rigaud's finish smoother, more polished, closer in facture to Champaigne, while Largillierre's handling is drier, more textured and velvety. Although both artists are exquisite colorists, Largillierre's color is lighter but more intense, more Rubensian; Rigaud's palette is darker and cooler with shimmering highlights that dart off fabric surfaces.

Both painters looked to Dutch and Flemish art for inspiration as did all artists who supported the party of color, but Largillierre was actually trained in the northern tradition. Born in Paris, he moved as a child to Antwerp where his father worked as a hat maker. Largillierre was apprenticed to an obscure still life painter, Antoine Goubaud, by 1668 and became a master in 1673. The artist left Antwerp for England just before his 18th birthday. He was employed doing minor work for the superintendent of the English king's buildings (which included the restoration of pictures at Windsor Castle) and was encouraged by the portrait painter Sir Peter Lely who maintained the tradition of his master, Van Dyck—though it is far from certain that Largillierre worked in Lely's workshop, as is often asserted. Largillierre seems to have left England in 1679 during a wave of anti-Catholic persecution. Many of the portraits made during his first years back in France, notably the so-called *Pierre Le Pautre* (1689; Colnaghi), strongly reflect the influence of Flemish court painting, especially as practiced by Lely in England.

Largillierre was received into the Académie in 1686 with his great portrait of *Charles Le Brun* of 1686, now in the Louvre. One of the most memorable portraits of the *Grand Siècle*, it shows Le Brun surrounded by objects symbolic of his achievement—classical casts, paintings, engravings of his most famous compositions—and with it Largillierre invented a new genre, as Anthony Blunt has noted, "the state-portrait of an artist." Here Largillierre does for Le Brun and the Académie what Rigaud would do for Louis XIV and the Monarchy fifteen years later, and following this triumph he would never lack for work.

Both Rigaud and Largillierre were masters of the group portrait. In the superb portrait of *Jean Le Juge, his Wife Elizabeth de Gouy, and their Daughter Marguerite-Charlotte Le Juge*, (FIG. 18) from 1699, relations among the sitters are reserved and decorous, yet the picture is informal and not lacking in affection and family feeling. The distinguished patriarch was an usher to the king's Grand Council; his wife Elizabeth (1668–1743), who turns her head deferentially in his direction, seems to have been acquainted with the artist for some time, as Rigaud had painted portraits of her parents, free of charge, the year before.

The family portrait amply displays the painter's mastery of various textures and fabrics and his love of opulence. Its palette becomes increasingly pastel as it moves from the rich brown jacket and purple cloak of Le Juge to the sherbet green of the little girl's shawl. Rigaud was probably looking to Dutch group portraits when designing the picture, in particular the portraits of Gaspard Netscher's son, Theodore, who worked in Paris in the 1670s.

Le Juge died in 1707 and Rigaud married his widow three years later. His affection for Elizabeth and her daughter (who died, unmarried, sometime after 1744) and the fact that he attached enough personal significance to this portrait to depict himself

painting it in a *Self Portrait* of almost thirty years later (1727; Perpignan, Musée Rigaud), suggest that he may have executed more of it himself than was his usual practice, although the basket of flowers and the animals were probably done by Pierre-Nicolas Huilliot whom he had hired as a flower painter in 1699. Ironically, considering what the future held for the participants, the dog and parrot may have been intended to convey their traditional allegorical meanings: fidelity and chance.

Largillierre, by contrast, created a family *portrait déguisé* in a delicious mythology depicting the *Comtesse de Montsoreau as Diana and her Sister as one of the Goddess's Handmaidens* (FIG. 19). By the turn of the century, academic doctrine was beginning to acknowledge that portraiture as a genre had developed since the founding of the institution, and that the best and most sophisticated examples of it—in particular those by Largillierre and Rigaud—approached the accomplishments and complexities of history painting. In 1685 Félibein had stressed that if the perfection of a Van Dyck is to be achieved, "extensive study is required and many observations are to be made;" in 1708 Roger de Piles recognized that the difficulty of representing "the man in general" as history painters do, was equal to that of faithfully representing "a particular man, different from all other men," the object of the portrait painter. Is Largillierre's portrait of the *Comtesse de Montsoreau as Diana*, after all, significantly less complex or accomplished than a mythological narrative by Charles de La Fosse, such as *Clytia Changed into a Sunflower* (1688) in the Trianon de Marbre? Did it demand fewer or less highly developed abilities or less compositional invention from its author than, say, the *Diana Resting* (1707; Tours, Musée des Beaux-Arts), painted by Louis de Boullogne for the Château de Rambouillet?

In his portrait of the *Comtesse Montsoreau as Diana,* Largillierre has completely rejuvinated a long established formula by infusing it with a good-humored intimacy. All the expected elements are present: the goddess of the hunt wears a crescent moon in her hair, her bow and arrow-filled quiver hang on a nearby tree branch, her hounds lurk in the background. But the closely observed and delicately rendered faces of the sitters, the daring diagonal movements of the composition and the witty addition of the frightened lapdog (who senses the

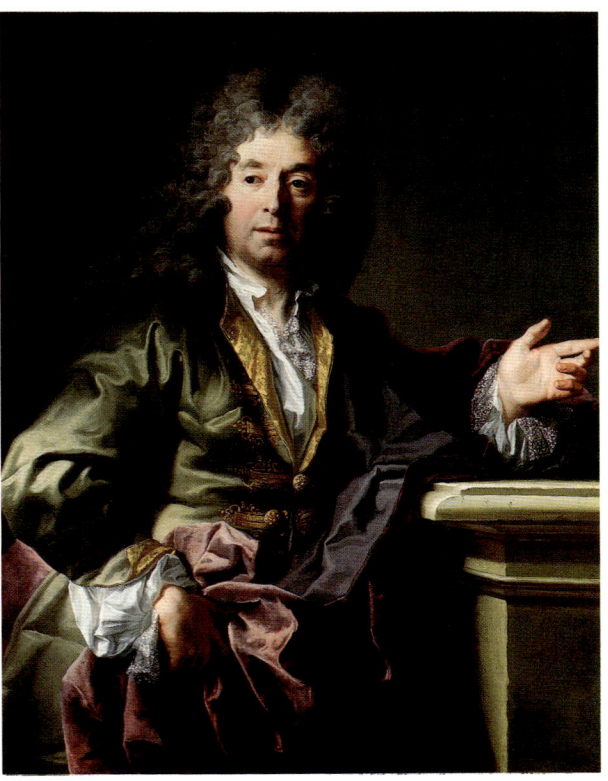

FIG 20. Jacques-François Delyen. *Portrait of a Man,* c. 1725-30. Oil on canvas. 46⅛ × 35½ inches. Private Collection. Acquired from Colnaghi, 1993.

approach of Actaeon?) all bring it vividly to life. Above all, it is Largillierre's rich Rubensian palette of autumnal russets that gives the painting atmosphere, uniting its component parts, and integrating the figures in the memorably evoked forest landscape—"*le tout ensemble.*" "Four things are necessary in order to make a perfect portrait," wrote de Piles, "air, color, attitude and their adjustment."

By the beginning of the eighteenth century a significant number of professional portrait painters had been admitted to membership in the Académie and a vast proportion of the works exhibited in the sporadic Salons were portraits; roughly forty-five percent at the Salon of 1704, where Largillierre alone showed twenty-four paintings. The tremendous critical and commercial success of Rigaud and Largillierre resulted, inevitably, in many followers and more than a few imitators. One of the Largillierre's students who managed to create vigorous, original portraits based on his lesson without being reduced to pastiche, was Jacques-François Delyen (1684–1761). A native of Ghent, he exhibited in 1722 at the *Exposition de la Jeunesse*—an alternative to the official Salon—and was

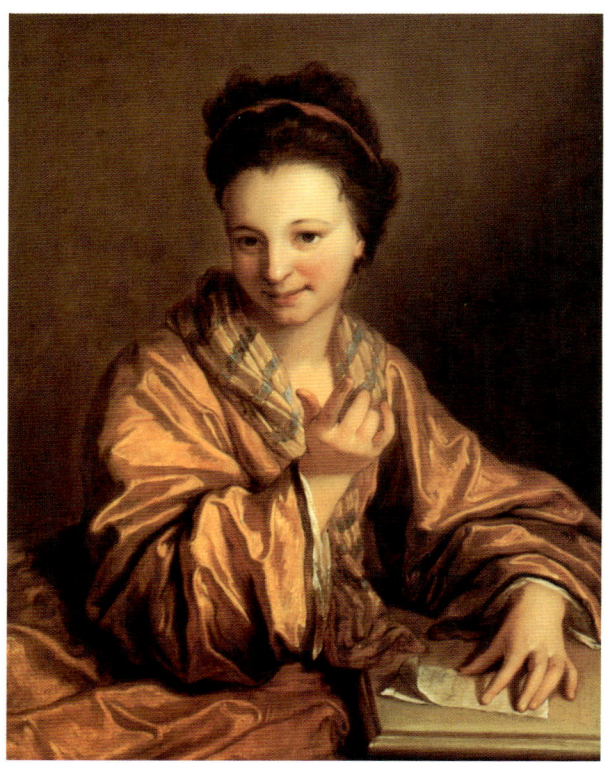 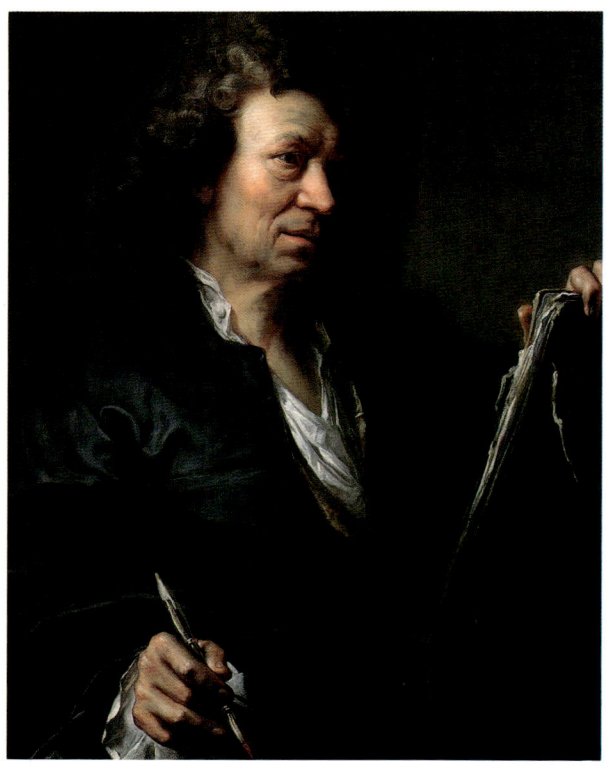

FIG 21. Jean-Baptiste Santerre. *Portrait of a Young Lady, beckoning*, c. 1703. Oil on canvas. 31¾ × 25⅝ inches. Private Collection.

FIG 22. Jean-Baptiste Santerre. *Portrait of an Artist, presumed to be Santerre himself*, c. 1710. Oil on canvas. 32 × 25½ inches.

accepted into the Académie in 1725 with the presentation of two portraits: the painter Nicolas Bertin and the sculptor Guillaume Coustou (both Versailles, Musée National de Château), the only two securely documented portraits in his small oeuvre. Another portrait of an unknown male sitter, previously attributed to Largillierre, has recently been given convincingly to Delyen (FIG. 20). It mirrors works by his teacher in its naturalistic observation, especially apparent in the face, and in its lively animation. But as in the Versailles portraits, its subject gesticulates at us, and seems to address us directly in a more spontaneous and engaged way than is customary in Largillierre's works. Delyen's portrait—a "speaking likeness" in Michael Levey's apt phrase—may have been one of the dozen portraits that he exhibited at the Salons from 1737 to 1747 that remain to be discovered.

The exploration of color that turned artists' eyes to the North resulted not only in enthusiastic 'Rubenistes' but also 'Rembranesques'—notably the portrait painters Alexis Grimou (1678–1733), François de Troy (1645–1730), Jean Raoux (1677–1734), and Robert Levrac-Tournières (1668–1752) as well as Rigaud who owned several paintings by Rembrandt.

Among the most interesting of 'Rembranesques' is the portrait and genre painter Jean-Baptiste Santerre (1658–1717). Santerre was born northwest of Paris in Magny-en-Vexin and entered Bon de Boullongne's studio upon his arrival in Paris. In 1704 he was *reçu* at the Académie as both a history and portrait painter with two diploma pieces, the famous *Susanna at the Bath* (Musée du Louvre) and a portrait of the painter Noel Coypel.

His best-known works are icy but elegant allegorical or mythological portraits of women, highly idealized and rather lifeless, with "imaginary faces with the features most agreeable to his sitter." His masterpiece is the full-length portrait of Louis XV's mother Marie-Adélaïde de Savoie, Duchess of Burgundy being handed a basket of flowers by Cupid (an allusion to her youth and beauty) in the gardens of Versailles (1709; Versailles, Musée National du Château). It embroiders on a formula for female allegorical portraiture that was revived by Mignard and would subsequently be taken up by Nattier.

But Santerre also painted more intimate, tenebrous works inspired by Rembrandt or, as in the case of the *Girl at the Window* in Orléans, directly copied from him. The fine portrait of a young woman beck-

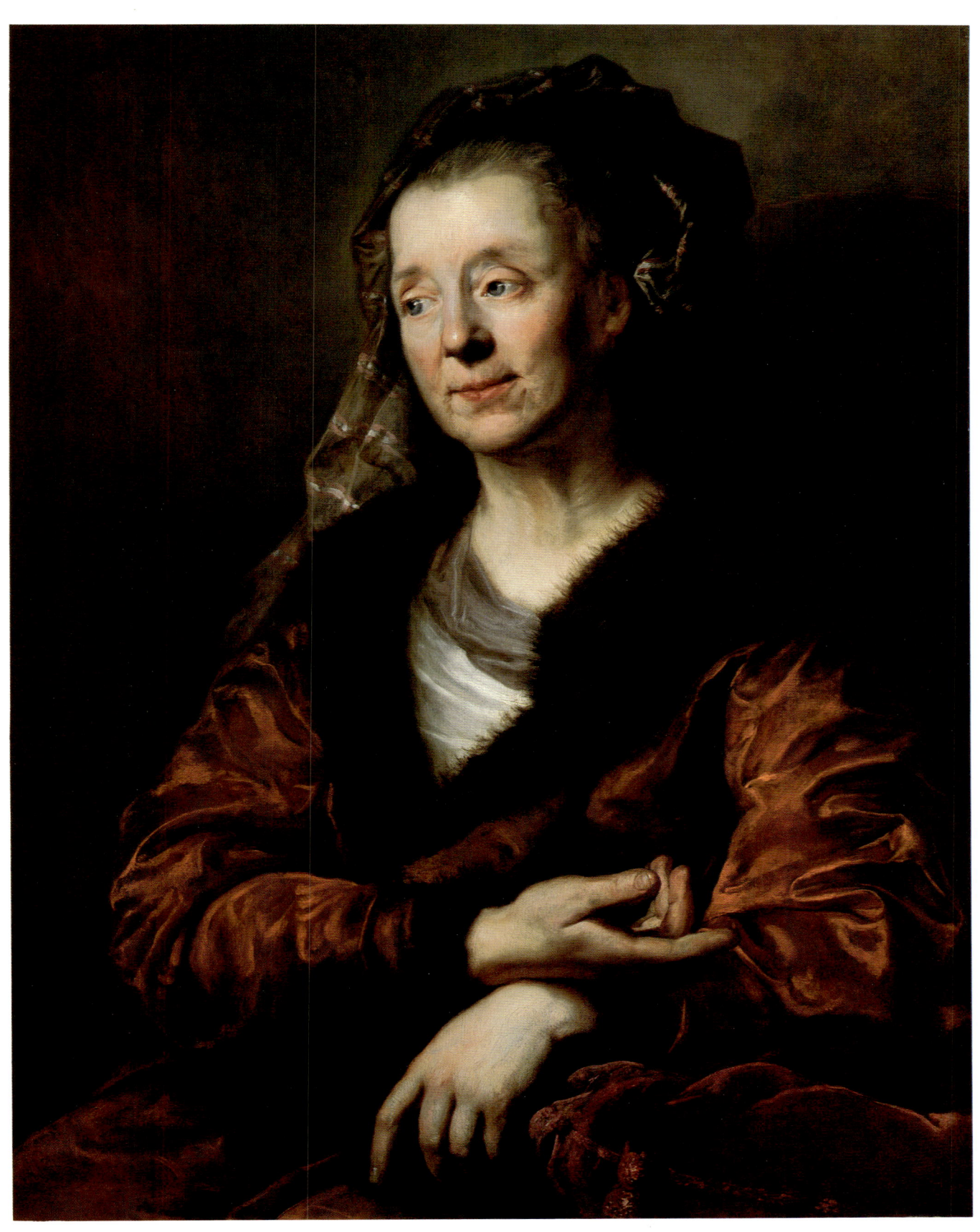

PLATE 6. JEAN-BAPTISTE SANTERRE. *Portrait of a Woman*, c. 1710. Oil on canvas. 32 × 25½ inches.

oning (FIG. 21) reveals the painter's study of the Dutch masters in its warm, and gilded palette and dramatic effects of light and shadow. A recently discoverd pair of portraits, depicting an artist—perhaps the aged Santerre himself—and his wife (FIG. 22, PLATE 6) are remarkably sensitive and humane in their treatment of an elderly couple and bring to mind pairs of portraits of old couples by Rembrandt, such as *Jacob Trip and his Wife* (London, The National Gallery). The ruddy palette of wine red, black and chocolate browns, and the delicacy and careful observation with which Santerre studies the folds of flesh in the face of the wife in particular also elicits comparison with Rigaud's Rembrandtesque double portrait of his mother (1695; Paris, Musée du Louvre).

THE FINAL DECADES of Louis XIV's long reign were marked by a series of aggressive and ruinous wars that strained the Crown's finances to near bankruptcy. With the decoration of Versailles completed by 1695, and with little left in the royal coffers, no new large-scale projects of note were undertaken by the Crown. At the same time, a small group of financiers and speculators amassed vast fortunes and, in turn, built Parisian townhouses that required decorating. In artistic matters, the first decades of the 18th century are characterized by a retreat from the oppressive world of Versailles in favor of the greater freedom, both social and intellectual, that prevailed in Paris. The movement from court to capital, from grandeur and etiquette to private and more informal opulence, created a new taste for portraits that were less imperious and hieratic, more fluent and witty, as has already been seen in Largillierre's piquant portrait of the *Comtesse de Montsoreau as Diana* (FIG. 19).

A sophisticated new style of portraiture appeared at this time, anticipating the *tableau de mode* (conversation piece) of the 1720s. One of the earliest and best examples is the amusing *Duchesse de Maine being given a Lesson in Astronomy* (1702–03; Sceaux, Musée de l'Isle de France) by François de Troy, and there are other such examples by Raoux and Tournières. Small in scale, these paintings portray real people at home engaged in their daily round of activities. Indebted to seventeenth-century Dutch painting, these cabinet pictures combine portraiture and genre; the intimacy and vivacity of the latter provided new possibilities for expression in the field of portraiture.

As an example, one might turn to *Madame de Tencin Serving Chocolate* (PLATE 7) painted sometime after 1710 by Jacques Autreau (1657–1745). This small picture shows three friends engaged in animated discussion as they prepare to take breakfast in Madame de Tencin's informally arrayed library on the rue Saint-Honoré. Reading from the left to the right we see Bernard Le Bovier de Fontenelle, one of the leading *philosophes* and poets of the age; Houdar de La Motte, a distinguished poet and librettist and close friend of the painter; and standing, Joseph Saurin, a mathematician. Entering from the rear, and carrying a tray of brioches, is Claudine de Tencin, hostess of the most illustrious salon in Regency France.

The meaning of the scene is uncertain and seems to contain at least one inside joke—the *salonniste*, among the most celebrated women in Paris, is dressed as a servant—but the painting probably refers to a spirited battle waged in 1707 by all of the sitters against the reactionary poet Jean-Baptiste Rousseau, who had attacked their collective character. The pages held by Houdar de La Motte might contain the vicious denunciation of their opponent penned by the painter Autreau, which was to have been sung by the group while standing on the Pont Neuf.

Three versions of the composition are known, and a fourth recorded, and it is likely that Autreau prepared one for each of its subjects. Fontenelle, one of the leading "Moderns", espoused a new doctrine of Progress opposed to the prevailing orthodoxy which held that the ancient world provided an immutable standard against which all was to be measured. In this argument, modern culture could aspire no higher than to exist in the shadow of the past, a belief that lay at the heart of institutions such as the Académie. In his odd pictorial hybrid, Autreau succeeded in capturing the heady atmosphere of a circle of refractory aristocrats and heretics who launched one of the first salvoes of the Enlightenment in its war against authority.

Freedom from the bombast of the *Grand Siècle* may have come as a relief to many painters and patrons, and is reflected in many of the small, colorful and informal pictures produced at the end of Louis XIV's reign and during the Regency of the Duc d'Orléans (1715–24). Jean-Antoine Watteau (1684–1721), perhaps the greatest European painter

PLATE 7. JACQUES AUTREAU. *Madame de Tencin Serving Chocolate*, c. 1710–16. Oil on canvas. 28¼ × 35⅝ inches.

FIG 23. Jean-Antoine Watteau. *Antoine de La Roque,* c. 1715. Oil on canvas. 18⅛ × 21½ inches. Tokyo Fuji Art Museum.

of the first half of the 18th century, was the most original master of *Régence* Paris, but his impact on portraiture was small.

The only documented portrait by Watteau to have survived is of *Antoine de La Roque* (FIG. 23), in which the soldier-turned-writer is depicted in an Arcadian setting with the nymphs who inspire him playing in the background. Watteau stages his painting in the manner of a scene from the *Opéra Comique*, a natural allusion to his sitter, La Roque (1672–1744), who wrote two opera libretti after his leg was shattered at the battle of Malplaquet (1709). La Roque gestures towards the upraised leg, and on the ground behind him is his cast-off armor—a reference to his former career—and a lyre, flute, book and manuscript attesting to his present occupation. A month before Watteau's death, La Roque founded a new journal, the *Mercure Galant*—later the *Mercure de France*—which would publish his obituary of the painter. An inscription on Bernard Lépicié's engraving of the painting, published in 1734, gives its meaning clearly:

> Victim of the god Mars, the muses now
> occupy his heart and mind.
> He fought for glory; now he writes for it.

La Roque's pose would have a long afterlife, reappearing years later in Gainsborough's little portrait of *John Plampin* (c. 1755 ; London, The National Gallery), as well as in conversation pieces by Francis Hayman and, more unexpectedly, in Tischbein's *Goethe in the Campagna* (1798; Frankfurt Städelisches Kunstinstitut) at the century's end.

Watteau's friend and most talented emulator, Nicolas Lancret (1690–1743), was certainly responsible for painting the merry band of muses and fauns in the background of the portrait of *Antoine de La Roque,* and he exploited and developed the wit and novelty of Watteau's innovative presentation. Following Watteau's death, and throughout the 1720s and '30s, Lancret produced a series of captivating conversation pieces which found their genesis in *La Roque:* Small, richly colored, vaguely allegorizing family portraits set in overripe parks. Closely related to these, Lancret also painted several theatrical portraits, the finest of which depicts *La Camargo Dancing* (FIG. 24) and was first recorded in the collection of Frederick II at Potsdam.

Set amid the languorous lovers in fancy dress typical of the *fête galante,* a couple dances. He may be the choreographer Laval; she is certainly Marie-Anne de Cupis de Camargo (1710–1770)—'La Camargo' to her legions of fans—the first great ballerina of the Paris Opéra, where she performed from 1726 until her retirement in 1751. Almost as notorious in her private life (she took many illustrious noblemen and intellectuals as lovers) as she was celebrated in public, Camargo was a great innovator of the dance, freeing ballet from the rigid constraints typical of the *Grand Siècle,* introducing shorter skirts and ballet slippers as well as a new athleticism of movement. It seems quite appropriate, therefore, that her most celebrated portrait should be equally innovative and unconventional.

This fluidity of the genre is typical of art during the Regency, which witnessed the breakdown of traditional distinctions between portraiture and genre painting. In Watteau's and Lancret's paintings, and in pictures by Jean-Baptiste Pater (1695–1736) and Jacques de Lajoüe (1686–1761), there appears to be an easy interchange between the real world and a theatrical—even fantastical—representation of every-

FIG 24. Nicolas Lancret. *La Camargo Dancing*, c. 1726–30. Oil on canvas 30 × 42 inches. Washington, National Gallery of Art.

day life. La Camargo's *pas-de-deux* is not performed on a stage but in a "real" setting, though the reality of the *fête galante* is of a timeless island of love which itself owes much to the theatre.

Cross-pollination among painting, the stage, and everyday life is also evident in several of the portraits of Charles-Antoine Coypel (1694–1752), notably the delightful pendants of *Monsieur Dupillé* and *Madame Dupillé with her Daughter* (FIG. 25), painted in 1733. Charles was the son of Antoine Coypel and the youngest member of a dynasty of prominent history painters. He was something of a prodigy and was accepted into the Académie aged 21 with the submission of *Jason and Medea* (1715; Berlin, Schloss Charlottenburg). Independently wealthy, Coypel also pursued a literary career, though his plays were attacked and he abandoned writing for the theatre in 1732. Nevertheless, his experience there had an effect on his history paintings, in which he made ever greater efforts to capture the wider range of emotions, gestures and expressions that he found on the stage. This, too, opened him to criticism—Mariette wrote that Coypel "was incapable of introducing either the unaffected or the natural into his art"—but in many ways Coypel's theatricality developed out of a respect for costume, readable narrative and emphatic gesture which were the staples of academic painting, handed down from Poussin and Le Brun. As his father had advised him, "If erudition is not seasoned with a certain ability to please, then it becomes dreary and dull".

Stage acting informs his portraiture as well, as is evident in the Dupillé portraits. As Thierry Lefrançois recently discovered, Coypel's sitters are probably Jacques André Dupillé (1680–1740), *reçeveur général des finances* of Lyon, his wife Marie-Anne Rollot de la Tour and their daughter. A wealthy property owner, Dupillé acquired a fashionable townhouse on the rue de Turenne by 1719. In his portrait, Dupillé is shown peering over a window ledge—a motif adapted from Dutch paintings of the previous century—and he directs our attention to his wife and daughter. The women appear at a similar *trompe l'oeil* casement, draped with a heavy velvet curtain, and gesture welcomingly to us. Both are sumptuously costumed for a masked ball. The vivid sense of arrested animation projected by the portraits is highly theatrical and, until the recent identification of the sitters, it was sometimes assumed that they were actors. It is a mark of the open-minded patronage of many members of the new class of wealthy farmer-generals and financiers

FIG 25. Charles-Antoine Coypel. *Madame Dupillé and her Daughter*, c. 1733. Oil on canvas. 57½ × 37¾. Collection of Mr. and Mrs. Stewart Resnick.

that portraits as daring and unconventional as these met with immediate approval.

A heightened sense of drama also enlivens the 'historiated portraits' of one of the most successful portrait painters of the *Ancien Régime*, Jean-Marc Nattier (1685–1766). The son of an obscure portraitist and the younger brother of a history painter, Nattier was elected to the Académie in 1718 as a history painter—his diploma piece is *Perseus Changing Phineas to Stone* in Tours—but soon turned to the practice of portraiture. In his earliest paintings he so successfully reproduced the glistening paint handling of Jean Raoux, that he was employed by the *Grand Prieur*, Jean-Philippe, chevalier d'Orléans to complete the decoration of the gallery in the Hôtel du Temple that had been left unfinished at the time of Raoux's death in 1734. But from the start, Nattier made his figures appear more fully-fleshed and convincing, less doll-like than Raoux's, notably in his portrait of *Mademoiselle de Clermont taking the Waters* (1729; Chantilly, Musée Condé) in which he daringly portrayed Marie-Anne de Bourbon, called Mlle de Clermont, fifth child of Louis III, duc de Bourbon, as a water nymph. The painting was a great success and four years later Nattier painted the sitter again, this time as a sultana, capitalizing on the fashion for things Turkish. As Albert Châtelet has remarked, Nattier's innovation lay in employing the traditional formula of the allegorical or mythological portrait to portray princesses and noblewomen in poses and costumes hitherto reserved for actresses: offering them the vicarious pleasures of dressing up—or down, as it were—and playing a role.

Doubtless, the success of the first portrait of Mlle de Clermont inspired her older sister, Mlle de Charolais, to sit to Nattier (PLATE 8). Third daughter of the duc de Bourbon, Louise-Anne de Bourbon-Condé (b. 1695) was also a famous beauty and a member of Louis XV's intimate circle. Nattier's portrait of her is less flamboyant then those of Mlle de Clermont or their other sister, Louise-Henriette, whom he painted in the guise of Hébé (1744; Stockholm, Nationalmuseum). Mlle. de Charolais is dressed in a magnificent contemporary red and black silk gown and depicted playing a guitar on a marble terrace that looks out over a garden. To her left is a blue tasseled pillow covered with fleur-de-lys, a reference to her noble birth, while to her right, Nattier introduces a single mythological element: the winged putto who holds Mlle de Charolais's sheet music and who is engaged in reading it himself. His presence—real, yet understood as symbolic—turns what seems an otherwise realistic portrait into a *portrait historique* in which the sitter assumes the musical attributes of a Muse. No artist of his time was better able to convey the delicacy and charm of feminine beauty without sacrificing the grandeur and physical presence required in portraits of great ladies. As his eldest daughter would write: "He utilized these two great genres so well in his work that the enlightened public often did not know what to admire most in him: the history painter or the portraitist."

FIG 26. Jean-Baptiste-Siméon Chardin. *Auguste-Gabriel Godefroy Spinning a Top*, c. 1738. Oil on canvas. 26½ × 30 inches. Paris, Musée du Louvre.

DESPITE THE SEDUCTIVE appeal of Nattier's mythologizing portraits for ladies of the court—and by the 1740s, he was the favored portrait painter of Versailles—Nattier was long the object of derision from critics who did not appreciate the ambition of his *portraits historiques* and found his duchesses attired as Vesta or Hébé simply pretentious. In a satirical article in the *Mercure de France*, Charles-Nicolas Cochin, posing as an art critic from the 21st century, expressed amazement that in the eighteenth centu-

PLATE 8. JEAN-MARC NATTIER. *Louise-Anne de Bourbon-Condé, called Mlle. de Charolais*, 1731. Oil on canvas. 43¾ × 57½ inches.

FIG 27. Jacques-André-Joseph Aved. *Madame Crozat*, 1741. Oil on canvas. 54 × 39¼ inches. Montpellier, Musée Fabre.

ry French women had to tame eagles in order to get a glass of wine! A sober, natural and more bourgeois alternative to Nattier's perceived aristocratic excess appeared in the contemporaneous paintings of several important artists, including Jean-Baptiste-Siméon Chardin, Joseph Aved, and somewhat surprisingly, François Boucher.

Chardin (1699–1779) did few standard portraits until he took up working in pastel at the end of his life. However, a number of his most beloved genre subjects were conceived simultaneously as portraits. The much-loved *Spinning Top* (FIG. 26) in the Louvre was first exhibited in the Salon of 1738 as a "portrait of the son of M. Godefroy, jeweler, watching a top spin." Auguste-Gabriel Godefroy (1728–1813), son of the jeweler and banker Charles Godefroy, became Controller-General of the Navy. He was an avid art collector who owned, among many works, Watteau's *La Finette* and *L'Indifférent*. Chardin seems to have been close to the family and had also painted Auguste-Gabriel's elder brother Charles-Théodose three or four years earlier (Louvre).

As a portrait, *The Spinning Top* is remarkable for the absorption of its protagonist who makes no attempt to establish a relationship with the viewer.

This self-sufficiency is both fascinating and convincing. Children are self-involved and often little aware of the activities of the outside world, and Chardin succeeds in making a picture of this particular child as if from a child's point of view.

When this portrait was engraved by Lépicié in 1742, it was published simply as *Le Toton* (The Top) with a caption that read:

> In the hands of caprice, to which he abandons himself
> Man is a top endlessly spinning;
> His fate often depends on the direction that
> the turn of Fortune gives it.

The message is clear: The boy has put aside his books and papers, quills and chalk in favor of a useless pursuit. In opposing industry and idleness, labor and imagination, Chardin raises profound existential questions.

Chardin was a close friend of Aved (1702–1766), and painted his portrait (1734; Paris, Musée de Louvre). Born in Douai, the son of an apothecary, and trained in Amsterdam under Bernard Picart, Aved arrived in Paris in 1721 to work with the fashionable portrait painter Alexis-Simon Belle. He was received into the Académie in 1734 upon presenting portraits of the painters J.F. de Troy and Cazes (both Versailles). He exhibited regularly in Salons from 1737 to 1759 and, in spite of making occasional royal portraits including those of Louis XV and William IV of Holland, he found his *métier* painting the high bourgeoisie. As a result of his training, all of his work exhibits a strong strain of Dutch realism, fully evident in his acknowledged masterpiece, the portrait of *Madame Crozat* (FIG. 27) in Montpellier. Almost obsessive in its minute attention to every detail of the sitter's heavily embroidered gown, lace collar, cuffs and cap, and to her extremely comfortable surroundings, the painting is saved from microscopic preciocity by the remarkable effect of clear, brilliant northern light flooding in from an unseen window opposite the sitter, and by the absolutely frank depiction of Madame Crozat at home. Diligently working on a tapestry, she pauses for a moment, removing her pince-nez—no vanity here!—to glance at something that has caught her eye beyond the window. As a contemporary observed, "M. Aved has the rare secret of rendering in his portraits not only the face, but also the genius, the character, the talents, the habits of

FIG 28. François Boucher. *Madame Boucher*, 1743. Oil on canvas. 22½ × 26⅞ inches. New York, The Frick Collection.

the person he paints. Pose, drapery, accessory details, nothing is arbitrary. Hide the heads of his figures and you may not be able to tell who it is from the rest of the picture, but you can tell what are his interests, his manners, his faults, and his virtues."

This splendid portrait of a supremely sensible woman was much admired when it was exhibited at the Salon of 1741, and its influence can be found in unlikely places over the following couple of decades: in Drouais's domesticated *Madame de Pompadour* at her tapestry frame (1764; London, The National Gallery), in Nattier's own subdued and naturalistic portrait of *Marie Leczinska* (1748; Versailles, Musée National du Château) and, with an *insouciant* twist, in Boucher's tiny portrait of his wife (FIG. 28).

Reclining flirtatiously on a pink chaise lounge in a white taffeta morning dress, mob cap and pink mules, Mme. Boucher is surrounded by the comfortable furnishings of her boudoir—in actuality her husband's studio—almost all of which reappear in other paintings by the artist: The gold wall fabric is seen again behind the *Blonde Odalisque* (1752; Munich, Alte Pinakothek); the Chinese screen is found in *La Toilette* (1742; Madrid, Thyssen-Bornemisza Collection); the Chinese porcelain figure recurs in *Le Déjeuner* (1739; Paris, Musée du Louvre). Messy and casual but undeniably chic, it is the appropriate setting for a fashionable middle-class painter's wife who had once been a model greatly admired for her beauty.

The demand for portraiture that offered a more recognizable likeness, one guided by nature rather than mythology, accounts for the tremendous and unlikely success of one of the greatest but most unconventional artists of the age of Louis XV: Maurice-Quentin de La Tour (1704–1788). The son of a musician who was a cantor at the Collegiate church of Saint-Quentin, La Tour ran away from home at the age of 15 to become a painter in Paris. He trained briefly in the studio Jean-Jacques Spoëd, and in 1724 traveled to the Congress of Cambrai in the hope of attracting the attention of wealthy patrons, there painting a greatly admired likeness of the Spanish ambassador's wife. His services now much in demand, he returned to Paris and was wisely counseled by Louis de Boullougne, the *Premier Peintre de Roi*, to devote himself day and night to perfecting his drawing skills. La Tour followed this advice, abandoned oil painting, and emerged two years later as one of the most assured draftsmen and greatest pastelist in France.

Although not new to France—in the previous century Robert Nanteuil (1623–1678) and Joseph Vivien (1657–1734), as well as Le Brun and Vouet, had each worked in pastel—interest in the medium was revived by the Venetian pastelist Rosalba Carriera, whose triumphant visit to Paris La Tour had witnessed in 1720–21. La Tour exhibited at the Salon to critical and popular acclaim in 1737, the year he became an associate member of the Académie, and he continued to show regularly there until 1773.

La Tour's method of working differed little from that of most portrait painters: in order not to exhaust his sitter, the artist made what was called a *préparation*—a preliminary study of the head alone, which would be used to work up the finished portrait (FIG. 29). Where La Tour is exceptional is that so many of his *préparations* have survived, including a group of more than 60, donated by his brother to the museum in Saint-Quentin. The Goncourts noted that, "the longer we look, the more our wonder increases at this creative force, this power of animation, this

FIG 29. Maurice-Quentin de La Tour. *Voltaire*, c. 1780. Pastel on paper. 14¼ × 11¼ inches. Saint-Quentin, Musée Antoine Lécuyer.

unmatched mastery of the anatomy of the human face...," and a visit to the Musée Antoine Lécuyer still elicits the same wonderment today. As you enter the great gallery hung row-upon-row with *preparations*, every eye seems to turn upon you, every face smiles. You are greeted by Voltaire, Rousseau, and D'Alembert; Mme. de Pompadour, La Camargo, and Mme. Favart; Restout, Chardin and, of course, La Tour himself, over and again.

La Tour's genius lay in his uncommon ability to evoke the vivacity and mobility of human expression with a mild exaggeration that never approaches caricature. His *Self Portrait Pointing* (FIG. 30), the painting that made his reputation in the Salon of 1737, displays his unequaled gift for creating a 'speaking likeness', as well as his remarkable wit and eccentricity. He could be capricious, did not suffer fools gladly and was competitive when a younger talent, like Perronneau, seemed to be poaching on his territory. He could be carelessly insolent, even to the king, and had no qualms about charging the highest prices of any portrait painter in France. Despite his impudence, he was received by Society and regularly attended Madame Geoffrin's Monday dinners;

Diderot reports that at the age of 55, La Tour took up Latin. Yet he always maintained close friendships with fellow artists, even those less lionized than he, many of whom, such as *Jacques Dumont le Romain* (Salon of 1742, PLATE 9) are the subject of his finest portraits. Himself a history painter and portraitist of distinction who was received into the Académie in 1728, Dumont (1701–1781) was a friend of the artist, and twice sat to him. The earlier portrait of 1742 is monumental, yet gentle and moody, and the expression on Dumont's face suggests uncertainty, even longing, as he strums the guitar strings. It was portraits like this that made François Gérard, the artistic hero of Bonaparte's Empire, exclaim admiringly, "You could crush us in a mortar, Gros, Girodet, Guérin, myself, all the G's, and you couldn't squeeze out of us a single fragment of such quality."

La Tour had no reason to feel threatened by a rival eleven years his junior since, immensely gifted though he was, Jean-Baptiste Perronneau (1715–1783), was a more somber, less flattering portraitist who tried to stake out a career for himself in a city less appreciative of such qualities. A pupil of Charles Natoire and of the engraver Laurent Cars, Perronneau soon took up portraiture in both pastel and oils. *Agréé* at the Académie in 1746, the year he made

FIG 30. Maurice-Quentin de La Tour. *Self Portrait*, c. 1737. Oil on canvas. 21¾ × 18⅛ inches. Toledo Museum of Art.

PLATE 9 MAURICE-QUENTIN DE LA TOUR. *Jacques Dumont le Romain*, c. 1742. Pastel on paper, 25½ × 21 inches.

his Salon debut, he was received as a full member in 1753 with two superb oil portraits of Oudry and Adam (both, Louvre). After first achieving a fleeting success with the sort of client who sat to La Tour, he was soon forced into a peripatetic life as he searched for patrons, traveling through the French provinces, Holland, Poland, Germany, and Spain. Still struggling to make ends meet he died, aged 78, in Amsterdam.

His portrait of the young *Antoine Le Moyne* (b. 1742), exhibited in the Salon of 1747 and formerly in the Groult collection, is exceptional in his oeuvre, not only because of its obvious high quality, but because Perronneau had so clearly set out to create a work of pure seduction (PLATE 10). Perronneau may have expected that a suave, dazzlingly accomplished portrait of a child—the five-year-old son of the sculptor J.B. Le Moyne—could not fail to please prospective Parisian clients and might well secure for him a niche in the genre as yet unexploited by La Tour: that of portraits of children. Even if the strategy seems to have failed, the result is a picture of unusual directness which, if more softly modulated and smoothly blended than many of Perronneau's pastels, lacks none of his technical bravura. Pale blue is touched in at pulse points to give a sense of living flesh, and vigorous drawing enlivens the face with rapid, unblended strokes of different colored chalks, prefiguring Chardin's pastel technique of the 1770s.

PERRONNEAU was by no means the only French artist in the middle of the century to find work outside the kingdom. For example, a number of French painters made their careers in Rome, among them Pierre-Hubert Subleyras (1699–1749), one of the most talented history painters to emerge from the eighteenth-century Académie. Moving to Rome upon winning the *Grand Prix* in 1727, Subleyras quickly established himself as one of the most successful painters in the city. During the 1730s and '40s, Subleyras received numerous commissions for altarpieces to which he brought a carefully and tenderly observed naturalism, free of the false rhetoric that sometimes diminished the works of his Académie-trained contemporaries. Though he joined Pompeo Batoni in spearheading the movement to reform Roman painting by returning it to nature, his deliberated and inward-looking art is closer in spirit to the genre painting of Chardin than to the works of his fellow history painters.

FIG 31. Pierre Subleyras. *Young Boy in Hungarian Dress*, c. 1740-45. Oil on canvas. 47 × 35½ inches. Acquired from Colnaghi, 1990.

Subleyras developed an active practice as a portrait painter and many aristocrats sat to him, among them princes, cardinals and scholars. Through the intervention of Cardinal Valente Gonzaga, an advisor to the Pope who became Subleyras's protector, the artist was chosen to paint the portrait of the newly elected Benedict XIV, a commission which sealed his reputation (1741; Chantilly, Musée Condé).

The identity of Subleyras's *Young Boy in Hungarian Dress* (FIG. 31) is unknown, though if he is not a Hungarian prince he may well be a member of the Odescalchi family, for whom Subleyras worked on several occasions, dressed in Hungarian costume. The boy wears a fashionable wig of the 1740s, a date which accords well with the picture's style, and is shown surrounded by various *vanitas* symbols such as a mirror, pocketwatch, and a shuttlecock, familiar from Chardin's allegorical portraits of children. Subleyras was famous for the virtuoso array of whites that he could employ in a single painting, a skill rarely displayed to better advantage than here, where snow-white feathers, fur, silk brocade, lace and hair punctuate and anchor the picture's powerful composition. At the same time, the artist captures the boy's child-

PLATE 10. JEAN-BAPTISTE PERRONNEAU. *J.-B. Antoine Le Moyne*, c. 1747. Pastel on paper. 17 × 13¾ inches.

FIG 32. Gabriel de Saint-Aubin. *Self Portrait,* 1750. Oil on canvas. 11½ × 8¼ inches. Private Collection. Acquired from Colnaghi, 1990.

ish demeanor yet bestows upon him all the dignity of an adult prince.

Louis-Gabriel Blanchet (1705–1772) was another Frenchman who left for Rome never to return. He began his studies at the Académie, was awarded the second prize in the *Grand Prix* competition of 1727, and is recorded the following year in Rome where he spent the next five years as pensioner at the French Academy. Blanchet had strong ties to Subleyras, with whom he shared lodgings in 1737, and their drawings in particular are close in style. While in Rome, Blanchet assumed the function of unofficial portrait painter to the Stuart court, and his work was poplar with French and British expatriates. Yet either his income was modest or he was profligate, since he was imprisoned for debt in 1752, the year inscribed on his *Portrait of a Gentleman* (PLATE 11).

The stylishly dressed sitter peers out of a *trompe l'oeil* niche, holding a volume inscribed 'Belidor' on the spine. One of the great military engineers of the 18th century, Belidor was the author of several volumes on artillery and warfare. He visited Italy in 1744, but was too old to have sat for this portrait. The inclusion of Belidor's volume and the fortress-like wall opening in Blanchet's portrait may have been intended to relate to the occupation of the unknown sitter; it is possible that he was an engineer, perhaps even a protégé of Belidor. The dry, chalky manipulation of paint is one of the most appealing characteristics of Blanchet's style, along with a bravura handling of whites, which he learned from Subleyras.

Nattier's son-in-law, Louis Tocqué (1696–1772) was a well-patronized portrait painter based predominantly in Paris, but he did make an extended journey to St. Petersburg (1756–1758), where he worked at the court of the Tsarina Elizabeth before visiting Copenhagen to paint the portraits of the King and Queen of Denmark.

His portrait of *Nikita Akimfievitch Demidoff* (PLATE 12), painted at some point during his two year appointment in Russia, is exceptional and doubtless reflects the specific wishes of the sitter. Life-sized and full-length, it may well be Tocqué's only swagger portrait and he carries it off to great effect. Despite his relationship to Nattier, it was Largillierre and Rigaud whom he most admired as portrait painters: by framing his subject between a marble column and a great swag of drapery, he consciously adopted one of their most effective devices. The almost microscopic detailing of Demidoff's elaborate costume—a grey velvet coat with gilt frogging and a Sèvres blue *gilet* embroidered with gold thread—is worthy of a state portrait by Rigaud.

Demidoff (1724–1789) was a state counselor and Court Chamberlain with a strong personal interest in the arts. An honorary member of the Academy of Fine Arts in St. Petersburg, he traveled widely, making trips to Paris and Rome, and commissioned portraits of himself and his wife from Alexandre Roslin in 1772.

The restrained range of grey, mauve and cranberry (enlivened only by the brilliant blue of Demidoff's *gilet*) is typical of Tocqué's muted palette, but the application of paint, which is more enameled than Tocqué's usual velvety touch, may indicate a conscious emulation of Pompeo Batoni whose contemporaneous Roman portraits were fashionable with travelers on the 'Grand Tour'.

By contrast, few portraits are more intimate and less calculating than the *Self Portrait* (FIG. 32) by Gabriel de Saint-Aubin (1724–1780). Tiny and delicate, it shows the artist at age 26 thumbing through a portfolio of etchings. Though it was his brother,

PLATE 11. LOUIS-GABRIEL BLANCHET. *Portrait of a Gentleman*, 1752. Oil on canvas. 29¼ × 24¼ inches.

FIG 33. François Boucher. *Madame de Pompadour*, 1756. Oil on canvas. 79 × 62 inches. Munich, Bayerische Hypotheken und WechselBank, on deposit in the Alte Pinakothek.

Augustin, who specialized in portraiture, Gabriel's *Self Portrait* is a minor masterpiece of the genre by one of the most original artists of eighteenth-century France. Remembered for his thousands of sketches and miniscule illustrations in the margins of auction catalogues, Gabriel—who was described in his obituary as "full of erudition...[but] eccentric, unsociable and untidy..."—shunned the conventional route to professional success through membership in the Académie, and thus was excluded from official commissions. His self portrait conveys the nervous sensitivity of an outsider, one destined to pursue an independent, even isolated, course. He appears intelligent and inquiring, but is touched with a melancholy unknown to earlier painters' self portraits, if familiar to us from the post-Romantic era.

Towards the end of his life, even Nattier sought to achieve a manner of portraiture in which his sitters, still beautiful young women, were presented as capable of reflection, spirituality, even intimacy. In two particularly sensitive portraits from 1757—Casanova's mistress *Manon Balletti* (London, The National Gallery), and *Mademoiselle Marsollier* (PLATE 13)—Nattier dispenses with the trappings of allegory to concentrate instead on his sitters' beauty and freshness. In both, the artist employs a standard bust-length format and depicts each sitter in the same costume—in place of Mlle Marsollier's bow, Manon wears a pink rose—but he also envelopes the women's flesh with a warm *sfumato* that heightens the creaminess of their skin. The soft atmospheric effects of *Mlle. Marsollier* function as a metaphor for the sitter's gentleness of character.

Feminine charm is evoked less poetically, though no less effectively, in Boucher's justly celebrated portrait of *Madame de Pompadour* (FIG. 33) in Munich. Of course, Boucher was principally a history painter who specialized in grand mythologies—he was known as 'Ovid's painter'—though he made the occasional portrait, usually of a beautiful young woman, or a woman made young and beautiful by his brush. However, during the years when he was regularly employed by Madame de Pompadour (between 1750 and 1764) he was commissioned to paint her likeness at least eight times.

The Munich canvas is the only portrait by Boucher of his patroness to have been exhibited in her lifetime. It was displayed at the Salon of 1757 on its own specially made dais, where it was sketched by Saint-Aubin. The exhibition of this magisterial work served publicly to consecrate Madame de Pompadour who, although she had been Louis XV's mistress since 1745, was only granted official recognition in February 1756 when she was made *Dame du Palais* to the queen.

The sheer opulence of the portrait is breathtaking—almost an embarrassment of riches—and Boucher's ability to convey the luxury of the fabrics, parquetry, gilding and marquetry is unrivaled. Although Madame de Pompadour is regally poised and silent, the painting seems in perpetual motion. Draperies billow, books fall from the B.V.R.B. *table à écrire,* and her green silk taffeta gown—among the most sumptuous ever painted—cascades in all directions carrying a garden of pink silk roses with it. Surrounding her are a clutter of objects—books, unsealed letters, scrolls, drawings, prints—intended to provide evidence of her intellectual and artistic nature and her role as a tastemaker. As Rigaud's *Louis XIV* is the quintessential state portrait, Boucher's *Madame de Pompadour* is the emblematic rococo portrait of Louis XV's reign. It may not be especially probing as a likeness, yet it is a magnificent work of art, a delight to the eye, and curiously noble. Praised by many when

PLATE 12. LOUIS TOCQUÉ. *Nikita Akimfievitch Demidoff*, c. 1756–58. Oil on canvas. 87 × 56½ inches.

FIG 34. François-Hubert Drouais. *Le Comte and Chevalier de Choiseul as Savoyards*, 1758. Oil on canvas. 54⅞ × 42 inches. New York, The Frick Collection.

it was exhibited in the Salon, it was excoriated by Grimm as in the worst possible taste. Yet its charms were not lost on Neoclassicism's great painter of feminine beauty, Ingres, in whose paintings many a graceful neck may also be glimpsed reflected in a mirror.

A pupil of both Boucher and Carle Vanloo, François-Hubert Drouais (1727–1775) was Nattier's true successor in the field of society portraiture. Received into the Académie in 1758, he had already made a name for himself the year before with his double portrait of the *Comte de Provence and Duc de Berry as Children* (1757; San Paulo, Museu de Arte), in which the hallmarks of his style are already in place: a glossy, highly finished manner coupled with a meticulous rendering of sumptuous costumes, and a complete absence of characterization in his sitters' pastily modeled faces. Drouais quickly became the favorite painter of the new royal mistress, Madame du Barry—playing Boucher to her Pompadour—producing endless portrayals of her as Flora, Vesta—even a pageboy!—all with the same lifeless, doll-like expression. An over-life-sized portrait of a naked Du Barry as a Muse caused such outrage that Drouais had to withdraw it from the Salon in 1771 and cover the sitter's body with Grecian drapery (Versailles, Chambre de Commerce et d'Industrie). Still he shamelessly flattered his sitters according to the taste of the moment and as Grimm commented, "all our women now want to be painted by Drouais".

Drouais is at his best in his numerous sentimental portraits of the children of noble families in fancy dress, such as the *Comte and Chevalier de Choiseul as Savoyards* (FIG. 34) of 1758 in the Frick Collection. Their exquisitely tailored velvet coats make it quite evident that these cousins of the duc de Choiseul, foreign minister under Louis XV, are not really gypsies from Savoy, but their disguise may allude to the popular belief that Savoyards were models of filial affection because of their devotion to family and country.

Although Diderot claimed that the boys' faces looked as if they were made of plaster, the picture exerts an undeniable, if superficial, charm as do the *Comte d'Artois and his Sister Riding a Goat* (1763; Paris, Musée du Louvre) and the *Bouillon Children as Montagnards* (1756; private collection). The success of these paintings attests to the fashionable affectation of *les grands* to espouse the virtues of the simple rustic life, which would reach its zenith in the 'petit hameau' of Marie-Antoinette.

IN THE 1760s and 1770s, the romance of village life exerted a great attraction among the aristocracy and haute bourgeoisie, a reaction in part to the extravagance and over-sophistication of Louis XV's court. The appeal of this pastoral myth is manifest in artistic styles which at first glance seem quite antithetical. Drouais' insipid confections of the royal favorite and Greuze's emotional genre scenes and sober portraits are in fact dual expressions of this new aesthetic.

Greuze's many portraits convey the same powerful and subtle command of human expression and psychology that are to be found in his domestic dramas, and are perhaps more attractive and accessible to modern sensibilities. His portrait of the *Comte d'Angiviller* (FIG. 35), exhibited in the Salon of 1763, depicts Charles-Claude de Flahaut de La Billarderie, comte d'Angiviller (1730–1809), Louis XVI's future *Surintendant des Bâtiments*. An art collector of some significance, as Directeur-Général of the King's buildings, d'Angiviller would be responsible for

PLATE 13. JEAN-MARC NATTIER. *Mademoiselle Marsollier*, 1757. Oil on canvas. 23¼ × 20 inches.

FIG 35. Jean-Baptiste Greuze. *Charles-Claude de Flahaut de La Billarderie, Comte d'Angiviller*, c. 1763. Oil on canvas. 25¼ × 21¼ inches. New York, The Metropolitan Museum of Art.

administering royal patronage and for supervising all cultural institutions, including the Académie. Successful, if dictatorial, d'Angiviller laid the foundations for a National Museum, ushered in reforms at the Académie and revitalized royal patronage of contemporary painting and sculpture, which had declined in the later years of Louis XV's reign.

When painted by Greuze in 1763, all this was still a decade in the future. Greuze shows d'Angiviller aged 32 years old, recently retired from the military career customary of a member of the ancient *noblesse d'épée*. In fact, d'Angiviller had only just arrived at court where he held the post of Gentleman of the Sleeve to the Dauphin and was responsible for supervising the education of the royal grandchildren, among whom the Duc de Berry, future Louis XVI. Dressed in a magnificent salmon-colored jacket lined in brown fur, worn over an opulent fur-lined embroidered waistcoat, proudly bearing the Order of Saint-Louis that he received during his military service, d'Angiviller cuts an impressive figure. Nevertheless, it is his obvious intelligence and commanding character, vividly embodied, that rivets our attention. His military bearing and haughty self-confidence, so efficiently conveyed by the raised eyebrows and parted lips, are traits that characterize the man destined to rule the arts in the final years of the *Ancien Régime*. It is a painting which marks its maker as the best and truest portraitist of his generation.

Greuze's most eloquent and dedicated champion—and the most influential art critic of the *Ancien Régime*—was Denis Diderot (1713–1784), portrayed by some of the greatest artists of his day—Greuze, Fragonard, Pigalle—but perhaps most faithfully by Louis-Michel Vanloo (FIG. 36). Novelist, satirist, journalist and playwrite, Diderot was also the founder of modern art criticism; he remains the most accessible philospher of the Enlightenment. His supreme achievement was as co-editor of the *Encyclopédie*, issued in 35 volumes between 1751 and 1765—arguably the single most influential publication of the modern world. Vanloo's spirited execution gives a quality of intellectual urgency to this portrait of Diderot as a genius of the Enlightenment. Seated at his writing desk, slightly disheveled and wigless, Diderot pauses—pen in hand—absorbed in a moment of creative inspiration.

In fact, the portrait was almost certainly made in Vanloo's studio. The short silk dressing gown that Diderot wears is not the famous green and lilac robe offered him by Madame Geoffrin, nor the old wrapper about which wrote so eloquently in one of his most charming essays, but a studio prop that appears in several other portraits by Vanloo, including his self portrait of 1763.

The portrait was exhibited in the Salon of 1767 and was much discussed. Bachaumont admired "this bare and smoking head onto which this author must occasionally throw some cold water to moderate the excess of a boiling genius". Of course Diderot himself commented on it, writing in the third person for the *Correspondance littéraire*:

> Very lively.... But too young, his head too small. Pretty like a woman, leering, smiling, dainty, pursing his mouth to make himself look captivating... And then clothing so luxurious as to ruin the poor man of letters should the tax collector levy payment against his dressing gown... His head is uncovered. His grey forelock, with his air of affectation, makes him seem like an old flirt still out to charm; his posture, more like a government official than a philosopher... My children, I warn you that this is not me. In the course of a single day I assumed a hundred different expressions, in accordance with the things that affected me. I was

PLATE 14. JEAN-HONORÉ FRAGONARD. *Portrait of a Singer Holding a Sheet of Music*, c. 1769. Oil on canvas. 32 × 25½ inches.

FIG 36. Louis-Michel Vanloo. *Denis Diderot*, 1767. Oil on canvas. 32 × 25½ inches. Paris, Musée du Louvre.

serene, sad, pensive, tender, violent, passionate, enthusiastic. But I was never such as you see me here.

MUSING IN HIS JOURNAL, Edmond de Goncourt noted: "Sometimes I imagine Fragonard having come out of the same mold as Diderot. In both there is the same verve, the same effervescence. Is not a painting by Fragonard just like a page of Diderot?" Although the *philosophe* admired the few works by Fragonard that he knew from the Salons - and would mention him in *Jacques le Fataliste*—there is no evidence that the two were especially close. Yet Jean-Honoré Fragonard (1732–1806) is responsible for painting the most brilliant evocation of Diderot, one of his famous *figures de fantaisie* ("imaginary portraits" in the *Encyclopédie's* definition), of which fifteen are known today. Although universally admired and recognized as one the supreme achievements of eighteenth-century European painting, the *figures de fantaisie* elicited no recorded comment from Fragonard's contemporaries, and their genesis remains a mystery. Pierre Rosenberg has ingeniously theorized that Fragonard might have painted these rapid sketches of friends and patrons to decorate his studio in the Louvre, since we know from Fragonard's grandson that "he received many distinguished foreigners, who had not seen everything if they had not seen the gallery of paintings that Honoré had made for himself..."

The known fantasy portraits are on canvases of identical dimensions (31½ × 25½ inches) and adopt a uniform format for presenting the sitter, who is posed half-length, standing or seated behind a stone balustrade, set against a plain background. All of the subjects are attired in fancy dress, in ruffs, plumed hats, swords and the like—described in the 18th century as "à l'espagnole"—and they are painted with an unrivaled freedom of handling, a dynamic, improvisational, *fa presto* brushwork of a confidence and daring unsurpassed even by Frans Hals.

The portrait of *M. de La Bretèche* (Paris, Musée du Louvre) is of particular importance in documenting the group as it alone is illegibly dated 1769 and bears on its verso an 18th-century label both identifying the sitter and stating that the portrait was painted by Fragonard in one hour. Although it is unlikely that Fragonard executed all of the fantasy portraits in the same year, they are of such stylistic consistency that they must have been made within a few years on either side of that date. The ravishing *Portrait of a Singer Holding a Sheet of Music* (PLATE 14), one the best preserved of the group, is also signed and dated, but the last two digits are unintelligible. However, a pastel copy of the picture was made in 1773 by the Comte de Brehan (1734–1813), thus providing the *terminus post quem* for its execution.

Fewer than half of Fragonard's sitters have been identified, and among these are the dancer Mlle. Guimard; Jérôme de Lalande, the astronomer who was also the subject of numerous caricatures by François-André Vincent and portraits by Houdon and Ducreux; and the Duc d'Harcourt and his younger brother. Along with the *Lady with a Dog* (New York, Metropolitan Museum of Art), the unknown lady posed as a singer is the most Rubensian of the *figures de fantaisie*. Her high starched collar and coiffure, the rope of pearls clipped to the bosom are all taken directly from Rubens's cycle *The Life of Marie de' Medicis*, then in the Luxembourg Palace, which Fragonard had copied in 1769. But Fragonard was well-versed in the history of art and had traveled widely, and the *figures de fantaisie* incorporate many of the lessons of his deep visual culture. He employs his sources so effortlessly that they become almost unde-

PLATE 15. ELIZABETH-LOUISE VIGÉE-LE BRUN. *Portrait of the Artist's Mother*, c. 1775–78. Oil on canvas. 24½ × 20½ inches.

FIG 37. Joseph-Siffred Duplessis. *Madame Freret-Déricour*, 1769. Oil on canvas. 32½ × 25 inches. Kansas City, The Nelson-Atkins Museum, Missouri. (Purchase: Nelson Trust).

tectable amid the spontaneous brilliance of his brushwork.

The *figures de fantaisie*, despite their theatrical costumes and poses, should certainly be regarded as portraits—the label on the back of *M. de La Bretèche* makes that clear—though they are certainly unconventional by eighteenth-century standards. In contrast to the liberty with which her costume is executed, Fragonard has painted the *Singer's* head with precision and delicacy, obviously laboring to capture a recognizable likeness. Yet no attempt is made to convey her personality, or her place in society. Rather the painting is a pretext for the artist's virtuosity. Nevertheless, Fragonard captures the essential spirit of a living woman with an immediacy and conviction equaled by few of the more conventional portraitists of his time. As Diderot himself wrote, "The merits of resemblance are passing; it is those of the brush which astonish in their time and make the work immortal."

A very different painter admired by Diderot is Joseph-Siffred Duplessis (1752–1802) who, after studying in Rome with Subleyras and returning for several years to his hometown of Carpentras, achieved fame with his first submissions to the Salon only in 1769 at the age of 44. Among the ten portraits he exhibited was one of a *Madame Freret-Déricour* (FIG. 37) about whom nothing is known, but whose name is given in the Salon livret beside a quick sketch of the portrait by Saint-Aubin. The portrait is elegant and colorful and exhibits, like Mme. Freret-Déricour herself, a wry sense of humor. Duplessis followed the tradition of frank and unaffected naturalism as practiced by Aved and Tocqué. At their best, Duplessis's pictures display their polished realism, expert rendering of fabrics and vitality of expression, though it must be admitted that a number of his portraits are lifeless despite their surface veracity. This did not affect his great success at court, however, where he became Louis XVI's official painter and executed the King's state portrait (1777; Versailles, Musée National du Château). Meeting the challenge of Rigaud's *Louis XIV* lay well beyond Duplessis's talents, however.

THE MOST SOUGHT after portrait painter during the reign of Louis XVI (1774–1792), and by far the most successful woman artist of the *Ancien Régime* was Elizabeth-Louise Vigée-Le Brun (1755–1842). The daughter of a minor specialist in the genre, Louis Vigée, she took up her late father's career at the age of 15. Her mother, Jeanne Maissin (1728–1800), was a fashionable hairdresser in Paris and she, her new husband—Jeanne remarried several months after Louis Vigée's death in 1767—and Etienne Vigée, the artist's younger brother, sat for their portraits on several occasions. The first of Vigée-Le Brun's portraits of her mother was a large pastel representing her as a sultana, now lost, while a second, long attributed to Watteau but recently identified by Joseph Baillio, depicts Jeanne, bust-length and in lost profile, seen from behind, the focus placed on her stylish coiffure. A third portrait, one of the artist's most graceful early works, is an oval in which the aging Jeanne is depicted wearing a luxurious white satin pelisse edged in swan's feathers (PLATE 15). The young painter, by her own admission largely self-taught, was obviously testing her skills by creating a society portrait in the manner of the most fashionable portrait painter of the moment, Duplessis. Earlier she had portrayed her brother dressed as a schoolboy in a type popularized by Drouais (1773; Saint Louis Art Museum).

"My mother was very beautiful", an elderly Vigée-Le Brun remembered in her *Memoirs*. "You

FIG 38. Elisabeth-Louise Vigée-Le Brun. *Marie Antoinette and her children*, 1787. Oil on canvas. 109½ × 75½ inches. Versailles, Musée National du Château de Versailles.

can see it for yourself if you look at the pastel of her by my father and also the oil painting that I did of her much later". The portrait is a touching example of the affection and tact with which the 20-year-old painter, herself a famous beauty, was able to convey Jeanne's fading charms, a skill she would often be called upon to employ.

Already apparent is Vigée-Le Brun's genius for capturing the character of a sitter with arresting immediacy and for reproducing both flesh and fabric with delicate, luminous glazing. The portrait of Jeanne was widely admired and helped launch Vigée-Le Brun's meteoric career. "I had only recently finished the portrait of my mother", she remembered, "and its praises were being sung in society. Soon the Duchess [de Chartres] sent for me to go paint in her home. She inspired everyone in her entourage with her interest in my talent and… from then on I received a succession of great ladies from the court…".

By the age of 24, Vigée-Le Brun had received such recognition that she was invited to paint her first official portrait of Marie-Antoinette (1778; Vienna, Kunsthistorisches Museum). More than twenty royal portraits would follow, the queen becoming Vigée-Le Brun's most ardent patron. Her career had earlier benefited from her marriage to the most astute and well-connected art dealer in Paris, J-B-P Le Brun (1748-1813), but it was the queen's advocacy that helped the painter gain admission into the Académie in 1783 against considerable opposition. For the next eight years Vigée-Le Brun exhibited to acclaim in every Salon. A whole society sat to her—royalty, aristocrats, court ministers, foreign dignitaries, art collectors and fellow artists—and it was largely through her vivid and memorable gallery of portraits that we now have an image of *mondain* Paris at the end of the Old Regime.

The high point of Mme. Vigée-Le Brun's career came with the commission to paint *Marie-Antoinette and Her Children* (FIG. 38), her largest and most important royal commission. Finished just in time to appear at the Salon of 1787, it depicts the queen seated with her children surrounding her, Madame Royale and the Dauphin flanking each side and the infant duc de Normandie on her knee. Majestic and grandiose, it is richly painted and shows the artist at the peak of her powers. Marie-Antoinette wears a glorious red velvet *robe à l'anglaise* trimmed in sable and a matching *pouf* decorated with ostrich and egret feathers, all in the ancient French royal colors of red, black and white. She is shown presenting her children to the Nation, an act which displays the continuity of the French Crown. But the portrait was also intended to place the queen—who had been the object of scurrilous attacks for several years—in a more flattering light as *mère de famille* as well as Mother of the People. In tune with the sentiments of the time, Vigée-Le Brun was unabashed at introducing a note of Greuzian *sensibilité* into state portraiture. The result was the most successful royal portrait since Rigaud's *Louis XIV* of almost ninety years earlier— "more a history painting of Her Majesty with the Princes and Princess, her children, than a portrait of Her Majesty," as d'Angiviller observed.

The portrait was received with great acclaim when it appeared at the Salon, where it hung beside David's *Death of Socrates*, but the tide was already turning against the royal family. As the artist later recounted, "The sight of the frame alone being carried in [to the Louvre] gave rise to scores of unpleasant remarks! 'So that's where our money goes!'". The portrait, which acquired the nickname 'Mme. Deficit' on the streets of Paris, was removed from the

FIG 39. Jacques-Louis David. *Antoine-Laurent Lavoisier and his Wife*, 1788. Oil on canvas. 112½ × 88¼ inches. New York, The Metropolitan Museum of Art.

walls at Versailles following the death of the Dauphin in 1789. This in fact accounts for its preservation, since as Vigée-Le Brun later realized, had the portrait still been hanging, "the ruffians and bandits who came there shortly after to hunt out their Majesties would have almost certainly destroyed it with their knives..."

PORTRAITS EXHIBITED in the public domain had always been liable to a reception based on more than their aesthetic merits: a sitter's notoriety may determine the public reception of his effigy. This was particularly true in the early years of the Revolution. If *Marie-Antoinette and her Children* was hailed in some quarters and hissed in other, the majestic double portrait of *Antoine-Laurent Lavoisier and his Wife* by Jacques-Louis David (1747–1825) did not even make it to the Salon (FIG. 39).

Antoine-Laurent Lavoisier (1743–1794) was a ground-breaking chemist who studied oxygen and respiration, described the chemical composition of water, and demonstrated the mechanisms of combustion; in 1789 he published his theories in the *Traité élémentaire de chimie*. He was also an immensely rich farmer-general who married the daughter of another farmer-general, but he was, nonetheless, a true reformer who actively favored constitutional restraints on royal power. However, when as Commissioner of Gunpowder, he had ordered the removal from Paris of a stock of old gunpowder to make way for new, he was suspected of plotting against the Revolution: an angry mob believed that the powder was being sent to assist the *émigrés* and Lavoisier barely avoided being lynched.

Several days after this event and just two weeks before the opening of the annual Salon where David's painting was to hang, d'Angiviller and Vien, president of the Académie, advised withdrawing the portrait; ironically, David's *Brutus*, was exhibited without incident in the Salon that year—it one of the most potent symbols of the Revolution in the making—while a portrait that celebrates conjugal love was censored as inflammatory.

Probably commissioned by Madame Lavoisier, who had been David's pupil, the portrait shows the chemist at home recording the chemistry experiment that takes place before him. He looks up at his Muse who affectionately rests her arm on his shoulder. One of the most sincere and convincing representations of marital companionship ever recorded, the Lavoisier portrait is also remarkable for its effortless fluency in mixing allegory, everyday life and grand manner portraiture harmoniously, and for its perfectly achieved balance between neoclassical austerity and microscopic precision of detail. Its rational, unaffected optimism in human nature and scientific progress marks it as the last great achievement of French portraiture before the Revolution.

David's most talented rival, as both a history painter and a portraitist, was François-André Vincent (1746–1816). Both painters studied with Vien at the French Academy in Rome and returned to Paris as stars of the Académie Royale. In Vincent's stylish portrait of the comic playwright and libertine memoirist Desforges (FIG. 40), shown in the Salon of 1789, one can see clearly his independence from his great contemporary. Desforges's pose obviously relies on the stock formula so often used in depicting writers: that of the sitter inspired, also seen in Vanloo's portrait of *Diderot* (FIG. 36) and in several of the *figures de fantaisie* by Vincent's old traveling companion, Fragonard. But in its highly sophisticated palette, *Desforges* stands apart: the brilliance with which the scarlet tablecloth and the

FIG 40. François-André Vincent. *Pierre-Jean-Baptiste Choudard, called Desforges*, 1789. Oil on canvas. 31⅞ × 27⅝ inches. Dallas, Private Collection. Acquired from Colnaghi, 1993.

back of the green chair frame the subtle play of ivory, chamois and pearl grey is novel and thoroughly satisfying. Vincent's portraits display a decorative elegance quite removed from the more sober, psychologically penetrating portraits of David. Their virtues are less profound, no doubt, but their chic is essentially French.

One portrait painter who stands alone at the end of the century is Joseph Ducreux (1735–1802), the spiritual heir of Maurice-Quentin de La Tour. Although he became *Premier Peintre* to Marie-Antoinette and was the author of many conventional society portraits, it is his arresting and occasionally bizarre series of expressive self portraits that constitute his real legacy (PLATE 16).

Early in 1791, after most of his aristocratic patrons had fled the country and commissions were hard to come by, Ducreux moved to London, where he exhibited at the Royal Academy and published a series of three self portrait etchings, each inscribed with the emotion depicted. He returned to Paris six months later when the Salons were opened to all artists–he had formerly been excluded from exhibiting because he was not an academician–and showed a number of self portraits, to no great success.

His laughing self portrait, known as *Le Moqueur*, was included in the 1793 Salon and exists in several versions, testifying to at least a modest popularity.

The interest in finding clear visual equivalents for emotional and psychological states can be traced back to the expression studies of Charles Le Brun, of course, but Ducreux's physiognomic experiments must have been sparked by the publication of Lavater's influential *Physiognomische Fragmente*... in 1775, itself testifying to the widespread interest in physiognomy and expression at the end of the *Ancien Régime*. Several of Ducreux's self portraits enact disturbing or painful emotions—distress, surprise, surprise mixed with terror—and provide a transition from the intense expressiveness of both Greuze's genre scenes and academic history subjects to the Romantics' concern with extreme emotional states.

WITH POLITICAL CONDITIONS deteriorating in Paris, many artists dependent on the court and aristocratic society left the country, at least temporarily. Henri-Pierre Danloux (1753–1809) followed Ducreux to London, arriving early in 1792. He set up shop in Leicester Square, in the heart of the French colony, and began to tailor his style better to suit English taste. One of his first clients was his fellow exile Rosalie Duthé, a beautiful singer and dancer at the Opéra, and the most celebrated courtesan of her day. Danloux's charming picture (FIG. 41)

FIG 41. Henri-Pierre Danloux. *Mademoiselle Rosalie Duthé*, c. 1792. Oil on canvas. 31¾ × 25½ inches. Karlsruhe, Staatliche Kunsthalle. Acquired from Colnaghi, 1984.

59

FIG 42. Louis Gauffier. *Frederick Augustus of Saxony*, 1793. Oil on canvas. 27 × 19¾ inches. Karlsruhe, Staatliche Kunsthalle. Acquired from Colnaghi, 1995.

of 1793, accounting for the view of St. Peter's in the distance and the inscription *Flor.^{ce}* on the monument. Gauffier's pellucid integration of sitter and surroundings anticipates Ingres's Roman portraits of a decade and a half later (see PLATE 19).

The close connections at court which had served Mme. Vigée-Le Brun so well before 1789 placed her in danger after the Revolution began and she too escaped to Italy. Famous throughout Europe, she was welcomed by art academies everywhere and never wanted for commissions. For twenty years she would travel the capitals of Europe painting courtiers and fellow exiles. The portrait of Hyacinthe-Gabrielle Roland (FIG. 43)—mistress of the Earl of Mornington, future Marquess of Wellesley and brother of the Duke of Wellington—was painted in Rome in 1791 while the sitter and her lover were on an Italian tour.

The portrait displays all the characteristics for which the artist was renowned: quick, fluent brushstrokes, vibrant colors, luminous fleshtones and a flattering though believable likeness. Many of Vigée-Le Brun's best portraits benefit from such disarming informality, and the portrait of Mlle. Roland is especially captivating in this regard. The painter highdepicts Mlle. Duthé about to hang a framed painting representing an allegorical figure of Hope looking out to sea at a departing ship. Her portrait was to be sent back to Paris to her lover, the banker Perregaux, who would understand its allusion to her desire to return home. Ironically, Mlle. Duthé, whose property was confiscated by the revolutionary government, wears the simple white dress and muslin scarf popularized by the Revolution.

Louis Gauffier (1762–1801) went to Rome when the Revolution broke out and remained there until he and his wife fled to escape the reprisals against French citizens which followed the execution of Louis XVI. Moving to Florence, where they joined a colony of expatriate French artists, Gauffier thereafter painted mostly small portraits of military men and diplomats who were stationed in Italy, as well as members of a cosmopolitan circle of Russian and English expatriates. His beautiful portrait of *Prince Augustus Frederick* (FIG. 42), sixth son of George III and Queen Charlotte, was begun in Rome in the winter of 1792 when the Prince was courting his future wife, and completed in Florence in the spring

FIG 43. Elisabeth-Louise Vigée-Le Brun. *Mademoiselle Roland*, 1791. Oil on canvas. 39 × 29½ inches. San Francisco, Fine Arts Museums of San Francisco. Acquired from Colnaghi, 1991.

PLATE 16. JOSEPH DUCREUX. *Self Portrait*, c. 1793. Oil on canvas. 35½ × 28⅛ inches.

FIG 44. Hubert Robert. *Camille Desmoulins (?) in Prison*, c. 1794. Oil on canvas. 12⅝ × 15⅞ inches. Hartford, The Wadsworth Atheneum; The Ella Gallup Sumner and Mary Catlin Sumner Collection.

lights the fall of a luxuriant wave of hair and the curve of an ample bosom to maximum effect. Her master in this was Rubens, from whose portrait of *Hélène Fourment in a Fur Coat* (c. 1640; Vienna, Kunsthistorisches Museum), Mlle. Roland's pose derives. Vigée-Le Brun's debt to Rubens was more profound; from him she learned how to endow the eyes of her sitters with intelligence and their flesh with pulsating life. It is this, as much as Mlle. Roland's *décolletage* and inviting smile, that charms and arouses.

In 1791, Grimm recounts, Empress Catherine the Great, who had repeatedly importuned Hubert Robert (1733–1808) to go to Russia, observed sarcastically that the famous painter of ruins was undoubtedly loathe to leave France just when he was surrounded by his favorite subject. Perhaps he should have gone, since his close relations with the aristocracy inevitably compromised him, and in October 1793 he was arrested for having failed to renew his citizen's card. He was incarcerated first at the former convent of Sainte-Pélagie, then moved to the former seminary of Saint-Lazare, where he painted and drew and —as a way of raising extra money to buy food— decorated earthenware plates which were sold for him in town by the guards. Hubert Robert's extraordinary little portrait of a fellow prisoner (FIG. 44) is unique in carefully detailing the interior of a revolutionary prison cell. Other artists made portraits in prison—David and Suvée, for example—but in none of these is there any indication of the sitter's surroundings.

The portrait has long been said to be of the radical journalist Camille Desmoulins but this is unlikely since he and Robert were not held in the same prison. Rather, it probably depicts Robert's prison mate, the poet Antoine Roucher, on the morning of his transfer from Sainte-Pélagie to Saint-Lazare. The poet's stately, distant pose gives the painting the quality of a *momento mori* and suggests that it could have been painted as a posthumous tribute to Roucher, who was guillotined on 24 July 1794, two days before the fall of Robespierre. Robert was luckier; he was released from prison a few weeks later.

Greuze's attitude toward the ideologies and institutions of the revolutionary government is difficult to assess. That he hated the Académie which had refused to accept him at the level of history painter, and had little success at court, would seem to have predisposed him to the cause of the radical reformers, and he did join the powerful Commune Générale des Arts led by David. He is said to have made depictions of a number of revolutionary events, and was among the first people to obtain a divorce as soon as the Revolution recognized the procedure.

Through all this he continued to paint and, in fact, produced some of his best portraits, working in a softer, brushier style than before. One such picture portrays Greuze's notary and patron, Duclos-Dufresnoy, and a second, possibly its pendant, is of Louis-François Robin (1756-1842), who became Greuze's notary after he assumed direction of Duclos-Dufresnoy's office on the rue Vivienne following the senior partner's retirement in 1791 (PLATE 17). Robin was well acquainted with the contentious Greuze, who was involved in a number of legal wrangles in the 1790s that called for a notary's services, in particular his divorce from the odious Mme. Greuze in August 1793.

Like many of Greuze's portraits from this period, *Robin* is painted on a walnut panel, a support the artist had rarely employed before the 1790s. Executed with a restricted palette and soft-focus technique, it exploits the advantage of its smooth panel support

PLATE 17. JEAN-BAPTISTE GREUZE. *Louis-François Robin*, c. 1794. Oil on panel. 26 × 21¾ inches.

which gives a translucency to the thinly painted areas and sets off the impasto of the sitter's white collar and salmon vest. As did Louis-Michel Vanloo and Vincent, Greuze employs the 'inspiration' type in this portrait representing the 37-year-old Robin, quill in hand, poised in thought. *Robin* is among the artist's most penetrating essays in the genre and a testament to Greuze's inspiration in a field in which, among his contemporaries, he is surpassed only by David and Goya.

WITH THE ADVENT of the Revolution, Jacques-Louis David's major history subjects from the 1780s were perceived, retrospectively, as calls to political change. He quickly became the Revolution's leading painter while, in fact, developing into a genuinely important figure in the political life of France. He led the attack on the Académie—the artistic Bastille, as he called it—which was abolished in 1793; was elected as a delegate from Paris to the Convention in 1792; and held seats on a number of increasingly virulent revolutionary committees. To the end of his life David was an absolute partisan of the Revolution who never disavowed his involvement in the Terror; he regarded his activities as a patriotic necessity to save the imperiled Republic.

From the early 1790s onward David's art was enlisted in the propaganda campaign for the Revolution. He organized many of the great Parisian festivals and designed costumes for officials of the Republic, but his crowning achievement for the revolutionary government was the series of three portraits of the "Martyrs of Liberty": *The Death of LePelletier de Saint-Fargeau* (destroyed), *The Death of Marat* (FIG. 45), and the unfinished *Death of Joseph Bara* (1794; Avignon, Musée Calvet).

Jean-Paul Marat was a radical journalist who rose to a leading position within the Jacobin party that ruled France during the Terror. On 13 July 1793, Charlotte Corday—a young woman who had arrived in Paris from Caen two days earlier with the express purpose of assassinating the self-styled "ami du peuple"—bought a knife, journeyed to Marat's house where she was admitted after several failed attempts to get in, and, entering Marat's apartment, stabbed him in his bath. Corday was arrested and guillotined four days later.

News of the murder soon reached the Jacobin Club of which David was then president. Calls went

FIG 45. Jacques-Louis David. *The Death of Marat*, 1793. Oil on canvas. 65 × 50½ inches. Brussels, Musées Royaux des Beaux-Arts de Belgique.

up for Marat to be buried in the Panthéon, and David was put in charge of orchestrating the funeral. He decided to exhibit the body on a dais in the church of the Cordeliers, and also agreed to create a painting to immortalize the death of this martyr to the Republic, as he had already done for LePelletier.

David's painting, completed by 14 October 1793, idealized Marat who was hideously ugly and bathed in order to soothe a chronic skin disease, but his corpse is presented very much as it was found and his fatal wound is on prominent display. Marat's hand grips a letter given him by Corday: "It is enough for me to be truly wretched to have a right to your kindness." On the crude wooden crate which served as Marat's desk a bank note covers a letter instructing that the money be given to a widow whose husband died serving the Revolution.

The painting is a masterpiece of austere design: geometric forms and deathly pallor, the haunting void of the picture's upper half illuminated by a mysterious, almost holy, light. The most enduring artistic image of the Revolution, *The Death of Marat* was also a religious icon for an atheistic world, a modern Descent from the Cross which called forth the

FIG 46. P. N. Legrand de Sérant. *A Kind Deed is Never Forgotten*, 1795. Oil on canvas. 24¾ × 31½ inches. The Dallas Museum of Art. Acquired from Colnaghi, 1989.

repressed religious impulses so often felt in the revolutionary parades and festivals. For its severity and asceticism it looks back to the Port-Royal paintings of Philippe de Champaigne, but also elevates 'propaganda portraiture' to a level of sophistication and effectiveness unequaled by any royal state portrait since Rigaud's *Louis XIV*.

Another propaganda portrait, though of a very different level of ambition and accomplishment, can be found in Pierre-Nicolas Legrand de Sérant's '*A Kind Deed is Never Forgotten*' (FIG. 46), exhibited in the Salon of 1796. Both a work of contemporary genre and group portraiture, it commemorates the selfless generosity of Joseph Cange—seen at center, wearing a bonnet—a poor errand boy at La Force prison who was touched by the misery of an aristocratic prisoner no longer able to communicate with his wife, and anonymously gave money to each of them. After 10 Thermidor, when the prisons were opened and the family reunited, the true source of the providential funds was revealed. In the painting, Cange is embraced by the aristocratic couple who have returned to the prison to express their gratitude. Behind them stands their maid, behind Cange his own family.

Cange's act of pity took place during the final days of the Terror and appealed to the imagination of a public hungry for hope amid a dark era's unbearable violence. Cange's story quickly spread, and inspired a string of poems, engravings and plays that turned the errand boy into a national hero. His celebrity was such that two years after the event, the incident still had enough resonance for Legrand to paint it.

FRANCE FOUND in Napoleon Bonaparte a new hero to worship, and David found in him both a hero and a new patron, whose grand aspirations dwarfed those of either Louis XVI or the Leaders of the Revolution, previously David's most important patrons. "What a beautiful head he has. It is pure, it is grand, it is as beautiful as the antique," David said of Napoleon in 1797. "Finally, here is a man to whom one would have raised altars in antiquity." If David was a man of intense but rather short-lived political passions, cooler heads were quite taken with Napoleon as well: Talleyrand would later say "His career is the most extraordinary that has occurred for one thousand years," and Chateaubriand, who denounced Napoleon's despotism, described him as "the mightiest breath of life which ever animated human clay."

David's first full-scale commission for the 30-year-old First Consul was an heroic allegory of Napoleon leading his troops in victory across the Alpine pass at the Great Saint Bernard (FIG. 47). The first version of the subject was commissioned by Charles IV of Spain, but Napoleon immediately ordered a second version for himself—David exhibited them side-by-side in his studio in 1801—and two more studio copies as well. The military triumph being commemorated took place on 20 May 1800 and led to the reconquest of northern Italy with the victory over the Austrians at Marengo. It appears to have been Napoleon's idea to be depicted "calm, on a fiery horse." In reality, the First Consul rode a mule, but this clearly did not accord with his conception of the Heroic. He also refused to pose for the portrait, shrewdly telling David, "It is the character of the countenance, what animates a person that it is necessary to portray... Certainly Alexander never

FIG 47. Jacques-Louis David. *Napoleon Crossing the Alps at the Grand-Saint-Bernard*, 1800. Oil on canvas. 102½ × 87 inches. Malmaison, Musée National.

posed for Apelles. No one knows if portraits of great men are likenesses. It suffices that their genius lives." David copied a mannequin dressed in the complete uniform that Napoleon had worn at Marengo, had his son pose in the uniform, and had his student François Gérard sit on top of a ladder in order to capture accurately the angle of his subject astride his rearing steed. The horse seems to be modeled after Falconet's equestrian statue of *Peter the Great*.

David's final composition is a triumph of myth-making. Soldiers dwarfed by the landscape can be seen in the distance trudging up a ravine in the mountain, while the self-possessed, resplendently attired Napoleon, saddled on a magnificent white stallion, points toward a distant snow-capped mountain where awaits his destiny and the destiny of France. The bleak landscape is rugged, the skies overhead turbulent and all of nature sublime. David resolves the tricky problem of how to show Napoleon 'calm' while his horse is 'fiery' by uniting man and beast in a whirl of wind-swept mane, tail and drapery that ascends toward the unseen goal. The painter has assimilated the lessons of the great equestrian portraits by Titian, Rubens and Velasquez and creates a more than worthy heir to them.

As the stallion rears on a stony ledge, its hooves are raised above rocks inscribed with the names of Bonaparte, Hannibal and Charlemagne, which establishes an historic pedigree for Napoleon in the invocation of the two great military heroes who had preceded him across the Great Saint Bernard. The allegorical message of the painting is clear. As Robert Rosenblum has eloquently defined it, "A great man has come from nowhere to fulfill an historical destiny, which is not his by genealogical right, but by virtue of his duplication of the great deeds of the past and by virtue of the almost supernatural energy and control that he promises as the great new leader of France." David would create many more images of the future Emperor, but none again would be so compelling, so exciting, or so optimistic.

The portrait of the *Katchef Dahouth* (FIG. 48) by Anne-Louis Girodet de Roucy-Trioson (1767–1824) received considerable attention when it was exhibited at the Salon of 1804, in part due to the renewed fascination in France for the exoticism of the Ottoman Empire, which followed upon the exploits of Bonaparte's Egyptian Campaign (1798–1801). The subject of the portrait was a 70-year-old governor of an Egyptian province and also, as the Salon *livret* tells us, a Christian Mameluke (a warrior-prince subject to the Ottoman Sultan) who must have been on a diplomatic mission to Paris when Girodet painted him.

Girodet was, after Ingres, the most original and eccentric painter to emerge from David's studio, capable of employing many divergent styles. In paintings like the glorious *Sleep of Endymion* (1791; Paris, Musée du Louvre) he feminized David's heroic neo-classicism with an alluring crepuscular chill, while the grand and violent *Revolt of Cairo* (1810; Musée National du Château) and, more modestly, the portrait of *Dahouth* have a virile vigor that seems to prefigure the Romanticism of Géricault and Delacroix a generation later.

PLATE 18. ROBERT-JACQUES-FRANÇOIS-FAUST LEFÈVRE. *Woman with a Lyre*, 1808. Oil on canvas. 31¾ × 27¼ inches.

FIG 48. Anne-Louis Girodet de Roucy-Trioson. *Mameluke Katchef Dahouth*, 1804. Oil on canvas. 57 × 44¼ inches. The Art Institute of Chicago. Acquired from Colnaghi, 1987.

The portrait also reflects the continuing impact on painters of Lavater's theories of physiognomy which particularly interested Girodet. The proposed relationship between physiognomy and human character led the artist to prefer models whose appearance seemed to him to reveal a specifically defined psychological quality. The degree of Girodet's success in appropriating Lavater's ideas in his paintings, and the way these ideas were already affecting the public discourse on human expression, is evident in the description of the Mameluke's portrait in a perceptive (if mildly racist) review of the 1804 Salon by the critic Boutard:

> ...not only the features, but also the age, the manners, the complexion of the personage... His long white beard and the shape of his clothes are not the only signs by which I can recognize his age and determine under what sky he was born. Even if only the torso of this portrait remained, one would still be able to realize...that this was the torso of an old man, of a phlegmatic temperament and brought up in the softness of Oriental life.

Robert Lefèvre (1755–1830), who studied with Regnault, exhibited from 1791 in the Salons to mild success until his portrait of *Napoleon Dressed as First Consul* (1804; destroyed) caused a sensation, to the point where the painter was falsely accused of having copied a portrait by David. From then on he was an astonishingly prolific and admired portrait painter. Protected by Vivant Denon, Lefèvre became official portraitist to the Imperial family and thereafter spent much of his time reproducing showy likenesses of its members for distribution as diplomatic gifts and decorations for municipal buildings. An almost industrial level of production—at least 37 copies of his portrait of *Napoleon in Imperial Costume* (1806) were ordered —took its toll on the quality of his painting, however, as he tried to execute all the replicas himself. Still, the ability to flatter has its rewards, and in 1816, after Napoleon's disgrace, Lefèvre was appointed First Painter to the King in the newly restored Bourbon monarchy.

Lefèvre's studio was also frequented by society ladies who wanted their likenesses painted with the same discreet flattery that the artist brought to his portraits of the Empress. An unknown sitter from 1808 (PLATE 18) is transparently draped like an ancient statue and strums a lyre in the guise of a Muse. This Empire version of a traditional allegorical portrait type bears a greater quality of naturalism than do the Muse portraits of Nattier, largely because it easily conforms to the contemporary fashion of dressing *à la grecque* and arranging one's hair in heavy curls imitative of hairstyles from the Flavian period of the Roman Empire.

The best genre painter of the First Empire was also one of its most active portraitists. Louis-Léopold Boilly (1761–1845), a self-taught painter from Lille, managed the transition from monarchy to Republic to Consulate and Empire with an ease matched by few other painters of such prominence, and he continued to enjoy popular success even during the Restoration and July Monarchy. His painting of *The Unveiling of David's 'Tableau du Sacre'* (FIG. 49) ostensibly commemorates the public debut of one of David's largest and most important Imperial commissions, but as in all of Boilly's genre scenes, what it really depicts are the characteristic or defining events in the public life of Paris during the early years of the 19th century. A crowd assembles in the Louvre to see Jacques-Louis David's image of Napoleon crowning

FIG 49. Louis-Léopold Boilly. *The Unveiling of David's 'Le Tableau du Sacre'*, c. 1810. Oil on canvas. New York, Private Collection.

NAPOLEON understood the importance of imbedding himself and his family in the national psyche if he was to found an Imperial dynasty, and he recognized the value of art as propaganda in furthering this aim. His family seemed happy to comply and all its members were frequently painted. Caroline Bonaparte (1782–1839), the Emperor's youngest sister and wife of Joachim Murat, King of Naples, commissioned a family portrait from François Gérard (1770–1837) in which she is surrounded by her four children (FIG. 50), reminiscent of Vigée-Le Brun's portrait of Marie-Antoinette *en famille*.

his wife Josephine as Empress, completed in November 1807 and exhibited, by special Napoleonic order, at the Louvre from February to March 1808: Boilly's masterpiece shows a crowd watching a painting of a crowd watching a crowning. No doubt it was largely because the coronation, which occurred in 1805, had been closed to the public that David's painstaking recreation of the event attracted such attention. However, it is not the sprawling canvas itself (which Boilly copied in David's studio) but the spectators' responses to it that constitute Boilly's real subject.

The unveiling of a major new work by David, the greatest and best-protected painter of the epoch, was, naturally, a major social occasion, and so it is appropriate that the audience be studded with fellow artists. This pantheon is recorded with care by Boilly: Hubert Robert looks out at us from directly beneath the figure of the Emperor; the white-haired Houdon stands beneath the left-hand curtain in the doorway; Boilly himself is in profile at the extreme right edge of the picture talking with the art critic F. B. Hoffman, who is emphatically offering his opinion. Less easily identified but also included are Mme. Vigée-Le Brun and François Gérard. David himself is only a symbolic presence. A charming evocation of the Parisian art world near the end of the Empire, this genre portrait serves as an informal valedictory for the Napoleonic era.

Completed by the spring of 1808, the portrait was intended as a gift for the Emperor to commemorate the Murat family's departure for the Kingdom of Naples, where they would take up residence as the royal family in September of that year. Gérard was

FIG 50 François Gérard. *Caroline Murat and her Children*, 1808. Oil on canvas. 84¼ × 66¹⁵⁄₁₆ inches. Private Collection. Acquired from Colnaghi, 1990.

paid the comparatively paltry sum of 12,000 *francs* for this grand manner portrait—in 1801 David had been paid 24,000 *francs* for the original *Napoleon Crossing the Great Saint Bernard* and 20,000 *francs* each for the replicas—which was exhibited at the Salon in 1808 and subsequently installed in Bonaparte's 'Salon de Famille' at Saint-Cloud, along with other full-length portraits of his sisters.

While Caroline's magnificent costume is copied from life, the Neapolitan background must have been Gérard's invention, since at the time the portrait was painted the Murats were still in Paris. The painstaking attention paid to the sumptuous variety of fabrics and textures—silks, satins, velvets, tapestry, embroidery, flesh, hair and flowers—makes it abundantly clear why Gérard was a favorite portraitist of the *arriviste* Emperor. But it is the painter's ability to capture the tender relationship between a young mother and her adoring children within the constraints of official portraiture which makes the picture such a success.

Caroline also employed the services of David's greatest pupil, Jean-Auguste-Dominique Ingres (1780–1864), who painted five pictures for the Murats, including one of the artist's masterpieces, the iconic *Grande Odalisque* (1814; Paris, Musée du Louvre), and a recently rediscovered portrait of Caroline at the window of her private audience chamber (PLATE 19). Ingres, who had been living in Rome since 1806, went to Naples in February 1814 to deliver to the Murats a troubadour painting that they had earlier commissioned, and while there he began to work on the small, full-length portrait of the queen. He returned to Rome in May to finish the portrait, which was not well received when it was sent to his patron, forcing Ingres to have the picture sent back to Rome for yet a third campaign to render the sitter's face and hat to her satisfaction. It is difficult now to see what it is that could have failed to please Caroline Murat. Tall and slim in a beautiful all-black ensemble—a high-waisted velvet pelisse, lace ruff and mantle, *giràndole* earrings and a hat trimmed in ostrich feathers—Caroline was probably in mourning for the Empress Josephine, who had died earlier that year. Behind her, a view across the shimmering bay of Naples centers on Vesuvius, whose billowing eruptions of smoke echo the coiling plumes of the queen's hat. Her chamber, we know from a contemporary watercolor, has been painstakingly recreated. She turns toward an unseen door to greet us as we enter and her expression is wry and lively.

Unfortunately for Ingres, the Murats' protectorate collapsed before he could be paid, leaving him in serious financial distress. As late at 1819 he had yet to be recompensed by the "Comtesse Laponi"—the name Caroline assumed after she fled Naples in 1815—for the two paintings that he had delivered. He was not the first painter to regret his dealings with Caroline Murat. Mme Vigée-Le Brun was commissioned to paint her in 1806 and remembered the encounter with rage nearly thirty years later. After complaining about the small fee she was paid, she writes,

> ...Mme. Murat arrived with two ladies in waiting who proceeded to dress her hair as I tried to paint her...Added to this inconvenience, she almost always broke our appointments, which meant my staying in Paris for the whole summer waiting, usually in vain, for her to appear, for I was eager to finish the painting; I cannot tell you how this woman tried my patience. Moreover, the gap between sittings was so long, that each time she did appear, her hair was dressed differently...The same thing happened with the dresses...

Of course, the artist bore little affection for the Corsican usurper or his family, as she make clear in her *Memoirs*,

> ...one day she happened to be in my studio and I said...in a voice loud enough for her to overhear: 'When I painted *real* princesses they never gave me any trouble and never kept me waiting.' Of course, Mme. Murat did not know that punctuality is the politeness of kings, as Louis XIV quite rightly remarked and *he*, at least, was no upstart.

Baron Gérard not only painted the Imperial family, but many members of their court. Constance Ossolinska Lubienska, whose bust-length portrait Gérard executed in Paris sometime between August 1813 and August 1814 (PLATE 20), was the daughter of the wealthy governor of Podlesie and married the son of a Polish Minister. In 1806 her husband joined Napoleon's Army on the Spanish campaign as a guide and interpreter, while his wife went to France

PLATE 19. JEAN-AUGUSTE-DOMINIQUE INGRES. *Caroline Murat*, 1814. Oil on canvas. 36¼ × 23⅝ inches.

FIG 51. Pierre-Paul Prud'hon. *The Empress Josephine*, 1805. Oil on canvas. 88¼ × 69 inches. Paris, Musée du Louvre.

to become a lady-in-waiting to the Empress Josephine. Their son, Napoleon, was born in Sedan in 1811, and after her husband's resignation from the army in 1814, the Lubienskis returned to their family mansion in Warsaw. Constance's transparent 'Roman' veil of silk gauze edged with gold, is painted with exceptional verisimilitude and billows in the wind that whips through the twilight lakeside landscape. This, the delicately painted flowers in her coiffure, and her expression of dreamy longing make the portrait a moody and prescient proto-Romantic image.

A quality of Romantic melancholy pervades the best known image of the Empress, as well (FIG. 51). Pierre-Paul Prud'hon (1758–1823) had already worked on projects for Josephine including the decoration of the ceiling of her salon on rue Chantereine and he had painted several well-received portraits of members of the Imperial family. Shortly after their coronation in 1805, Prud'hon was commissioned by Napoleon to paint an official portrait of the new Empress. The final composition of the painting does not seem to have come easily: Prud'hon made a number of false starts and there are several drawings and painted sketches of Josephine in various poses and settings.

Two decades earlier, Vigée-Le Brun had painted an informal portrait of Marie-Antoinette arranging flowers and dressed in a muslin gown and straw hat (1783; private collection), but little in the field of royal portraiture prepared the way for a portrait as unconventional and casual as Prud'hon's painting of Josephine. The Empress is depicted alone, resting languorously on an outcropping of rock in the gardens of her house at Malmaison, an estate that she had purchased in 1799 and whither she retreated when her marriage was dissolved in 1809. Her elongated form arabesques gracefully along the rocks in a rhythm evocative of the statuary of Canova, which Prud'hon so admired. She wears the red Imperial robe over her fashionable muslin tunic *à la grecque*, but she is oblivious to our gaze and seems absorbed in a private reverie. A neoclassical urn informs us that we are in a park not far from the reach of society, but the wild and brooding landscape appears almost primeval. Prud'hon's bituminous paint, mysterious lighting and modulated, Correggesque brushwork create a somber seductivity that is the visual analogue of a passage from Chateaubriand.

Pupil, collaborator and companion of Prud'hon, Constance Mayer (1775–1821) was an established portrait painter in her own right when she entered his studio in 1802. The usual distinction between master and assistant seems to have been fluid in their *ménage* and their separate contributions to the multi-figured allegories and mythologies that were exhibited under either one or other of their names is difficult to disentangle. Even in portraiture, Prud'hon is known to have sometimes supplied preparatory studies to Mayer, as was the case with her portrait of Sophie Lordon (PLATE 21). Painted shortly before Mayer's suicide, it is one of her most accomplished portraits, and was much admired when it was posthumously exhibited in the Salon of 1822. The creamy application of paint, gentle *sfumato* and soft coloration all bear the marks of Prud'hon's influence, but the slight upward tilt of the sitter's face is a characteristic of Mayer's portraiture just as the sentimental and gentle quality ascribed to the sitter's disposition is a reminder that Mayer first studied with Greuze. Mlle. Lordon was the daughter of Pierre Jerôme, a pupil and friend of Prud'hon.

PLATE 20. FRANÇOIS GÉRARD. *Constance Ossolinska Lubienska*, c. 1814. Oil on canvas. 25¾ × 20⅝ inches.

FIG 52. Jacques-Louis David. *Vicomtesse Vilain XIIII and her Daughter*, 1816. Oil on canvas. 37½ × 30 inches. London, The National Gallery. Acquired from Colnaghi, 1994.

AFTER NAPOLEON'S final defeat at Waterloo and the permanent restoration of the Bourbon monarchy, Jacques-Louis David was forced into exile. In January 1816, following the passage of the law against regicides, David and his wife left for Brussels where he would remain for the rest of his life. He produced several brilliant mythological paintings such as *Cupid and Psyche* (1817; Cleveland Museum of Art) and *The Farewell of Telemachus and Eucharis* (1818; Malibu, The J. Paul Getty Museum), splendid but disturbing experiments in imbuing ideal subjects with a strong realism which baffled his contemporaries and met with little critical success. He moved in a circle of expatriate exiles that included Emmanuel-Joseph Sieyès, Baron Alquier, Joseph Bonaparte's wife and two daughters, and Ramel de Nogaret, and painted portraits of many of them.

A portrait of the *Vicomtesse Vilain XIIII with her Daughter* (FIG. 52) was among the first works executed by David after his arrival in Brussels on 27 January 1816. Philippe Vilain XIIII had rallied early to Napoleon and pursued a brilliant career as the Mayor of Basel and of Ghent, receiving the title of *Comte de L'Empire Français* in 1811; at the time of David's arrival in Belgium he was a member of the Estates-General, voting with the Liberal party. His wife, Sophie de Feltz (1780–1853), held important court positions under both the First Empire and later in Brussels. In her capacity as lady-in-waiting to Napoleon's second wife, the Empress Marie-Louise, Vicomtesse Vilain XIIII held the King of Rome at his christening. It is not known how the couple came to commission the portrait, but it would have been surprising if David had not met such ardent Bonapartists almost immediately after his arrival in Brussels.

Several letters written by the sitter to her husband in The Hague, where he was attending the Estates-General, have recently been discovered; not only do they reveal much new information about this particular portrait, but they shed light on David's practice and methods as a painter of portraits. The first letter was begun in Basel on the morning of 13 May 1816, and taken up again that evening in Brussels where Sophie had traveled to begin her sittings for David. Three days later she wrote:

I am beginning to think that my portrait will be quite good, but I must admit that the whole thing is extremely boring. The day before yesterday, the [first] sitting lasted from 11:00 for 3:00 and was for the head and eyes; yesterday's sitting lasted from 11:00 to 2:45 for the nose and cheeks. Today he [David] will do the chin and the mouth. He wanted a day for repainting, but I begged him to not waste any time. He understood... Nonetheless, I fear that he will still be working on it until Wednesday...

Sophie's letter of the following day is less illuminating, although she makes it clear that David was painting the portrait in this studio in the rue de L'Évêque, and a passing comment reveals her growing irritation with the sittings:"... I will dine again at the [illegible] on Sunday because I have to stay here for this wretched David..." Undoubtedly her exhaustion and pique were aggravated by the fact that she was at the time three months pregnant with her second daughter. Saturday's letter (18th May) conveys

PLATE 21. CONSTANCE MAYER. *Sophie Fanny Lordon*, 1820. Oil on canvas. 23½ × 19¼ inches.

FIG. 53. Jacques-Louis David. *Madame Ramel de Nogaret*, 1820. Oil on canvas. 23⅜ × 18¾ inches. Private Collection. Acquired from Colnaghi, 1989.

the demands made on his sitters by David's perfectionism:

> I beg you to write me still at this address since I am as yet taken up with David who has still to do my body. Yesterday, he made me wait and dress from 11:00 until 3:00, only to paint my hair. I suggested that to make me dress was a whim on his part, but he insisted that it was necessary for the general effect, and I can assure you that it was extremely boring. Yesterday, during the sitting, Mesdames de Mercy [d'Argenteau]... Lalain and Eulaile came to see me and found that the portrait looked exactly like me. If it is a success and if it gives you pleasure, my effort, my boredom, and my extreme fatigue will at least have found their reward. But I predict that I will only be able to leave at the very earliest on Wednesday [22nd May].

It is difficult not to take a certain pleasure in the incongruous spectacle of the taciturn David allowing a claque of society matrons to watch him at work. Sophie's final letter is dated 5 July 1816, more than a month later, and was written from the country. Recounting to her husband a recent trip to Brussels, Sophie added:

> [Louise, who posed with her] was delighted with the portrait which seemed to me even more beautiful than the last time I saw it. I agreed with Madame David that I would send for the painting in two weeks, but that the price was for her to decide...

Mme. Vilain XIIII's enthusiasm for the portrait was well deserved. As Antoine Schnapper recently wrote, it is "one of the most beautiful portraits of the epoch. The quality of line, the natural and tender play of the hands, the frank realism of the faces... eloquently attest that David remained a prodigious painter until his death."

The Vilain XIIII family were prominent locals and new acquaintances when David painted them in 1816; M. and Mme. Ramel de Nogaret (PLATE 22 and FIG. 53), painted four years later, were close friends of the artist. Dominique-Vincent Ramel de Nogaret (1760–1829), an attorney from Montolieu, near Carcassonne, who was elected deputy to the Estates-General, was among the representatives who pledged the Oath of the Tennis Court on 20 June 1789: he is to be seen on the far left in David's drawing of the event, and it may be from that time that his relationship with David first dates. Ramel served in the Constituent Assembly and was elected to the Convention, where he played a leading role in drafting the Constitution of the Year II, and voted for the death of Louis XVI. During the Directory he was one of the Five Hundred and succeeded, in February 1796, to the Ministry of Finance, where he initiated significant reforms, notable among which was the reconstruction of the French fiscal system, and the introduction of the *franc*. Having effectively retired during the First Empire, he was persuaded to become prefect of Calvados during the Hundred Days of Napoleon's return. With Bonaparte's ultimate disgrace and the passage of the law against regicides, Ramel and his wife, like the Davids, left France for exile in Brussels. After the painter's death in 1825, when the Bourbon government refused to allow his body to be interred on French soil, it was Ramel who secured a cemetery plot for the family

PLATE 22. JACQUES-LOUIS DAVID. *Ramel de Nogaret*, 1820. Oil on canvas. 23½ × 18¾ inches.

and it was he who gave the funeral oration. Ramel married Ange-Pauline-Charlotte Panckoucke shortly after withdrawing from public life. She was the grand niece of Charles-Joseph Panckoucke, the publisher of the *Encyclopédie*.

The small, intense bust-length portraits of the Ramels are among the most penetrating of David's career. In his early seventies when he painted them, David's talents suffered no decline: although less carefully finished than David's earlier portraits, *M. and Mme. Ramel* are remarkably, almost disturbingly, direct.

The couple is depicted without idealization, stern and determined with few illusions and little trace of their former cosmopolitanism. Anita Brookner has written of the Brussels portraits that they "have a resolutely provincial character. Dowdy, fussy and uncompromising, they are an unmistakable feature of Restoration painting considered in its widest aspect." These portraits, she continues, "have the closed prudence of a small bourgeois society with its own ideas of significant appearance." In *Mme. Ramel* David renounced the fine finish and stylishness of his Paris works and sought a new model in the kind of painting that he found in and around Belgium and the North–recreating the simple, startling immediacy encountered in the works of Mabuse, the Flemish Mannerist. With a rigorous astringency of technique that assumes a moral dimension, David has rendered Mme. Ramel's powerful and honest face and, in summary but evocative strokes, his sitter's striking lace and silk bonnet and collar and her heavy black silk bodice with its shimmering blue-grey highlights. M. Ramel's modest contraposto and diagonal placement to the picture plane makes his portrait slightly less austere and unforgiving than his wife's. His open jacket front and the virtuoso brushwork in his hair also lends the sitter a more accommodating air. Nevertheless, the unblinking and tight-focused intensity of these busts seems to harken back to the Renaissance portraiture of Corneille de Lyon, while their uncompromising realism—shared by the younger Géricault—moves away from the academic perfection and idealism of David's earlier work and reaches far into the nineteenth century, to Courbet and beyond.

THE FIRST HALF of the nineteenth century in France–a period in which the return to European peace, domestic security and growing prosperity led to an unprecedented demand for the portrayal of sitters from the middle class and above—might be described as the age of the bourgeois portrait. The reestablishment of regular Parisian salons, whose admission was no longer restricted to members of the Académie, also saw a steady growth in the number of portraits and a corresponding irritation on the part of Salon critics that artists were turning too readily to portraiture for 'ready money'! Théophile Gautier, in a review of the Salon of 1847, could barely conceal his exasperation with public taste:

> Portraits are the only aspect of artistic production whose presence is widely felt in bourgeois life today. The innocuous vanity of having our image reproduced and encased in a superb frame; our desire to bequeath a likeness to our loved ones that we assume they will hold dear; and, perhaps most important, our subconscious longing to preserve from time's

FIG 54. Théodore Géricault. *Laure Bro*, c. 1821–24. Oil on canvas. 18 × 22 inches. Private Collection.

PLATE 23. LOUIS-LÉOPOLD BOILLY. *Madame Vincent*, 1820. Oil on canvas. 16½ × 13 inches.

inevitable destruction an impression of how we once looked—all these reasons help explain why the uncultivated man, who neither commissions art nor collects paintings, will happily part with considerable sums of money to have his portrait painted.

For certain artists, whose specialty lay in other fields, portraiture could provide both a stable and substantial income. Louis-Léopold Boilly, the first painter of modern life, is thought to have executed no fewer than 4,500 portraits during his fifty year career, completing his small bust length canvases, often meticulously described, in less than two hours. He was capable of more ambitious portraits in which his unsurpassed virtuosity of technique combined with an unexpectedly Romantic approach to nature to render his sitters with an affecting solemnity. A basket of flowers in her lap—whose bloom, of short duration, is a poignant reminder that beauty must also fade—the sitter in Boilly's portrait of 1820 (PLATE 23) meets our gaze with some hesitancy, her tightly curled coiffure and swanlike neck indebted to Ingres's *Portrait of Mlle. Rivière* (Paris, Musée du Louvre) which Boilly would have seen at the Salon of 1806. In keeping with Boilly's more ambitious portraits of women, the sitter—identified on the stretcher as a Madame Vincent, 'friend of the artist'—is shown at ease in the protective ambient of a verdant park, a natural surrounding that is both domesticated and melancholic.

Almost exactly contemporary with this gentle testimony of friendship, and attired in a similar dress of white muslin, with an almost identical Italian straw bonnet placed to one side, Géricault's *Portrait of Laure Bro* (FIG. 54) presents a far more brooding and arresting image. Meeting our gaze head on, with a wry but not unkind skepticism, Géricault's landlady—the wife of a prominent Bonapartist—is at once decorous and voluptuous. Although, at one level, it might be assumed that the sitter has just arrived and placed her bonnet and veil on the table beside her, Géricault's delight in her costume and the various accoutrements of her dress has a distinctly erotic edge to it. The diaphanous muslin, through which her breasts are almost visible; the silk gloves, one still to be

FIG 55. Eugène Delacroix. *Madame Henri-François Reisener*, 1835. Oil on canvas. 29⅛ × 24⅞ inches. New York, The Metropolitan Museum of Art.

removed, hinting at a fetishism worthy of Klinger; the mysteriously floating gauze curtain with its glimpse of rural Paris in the distance; the languid draping of her bonnet and veil which gently mirror her own pose, recumbent yet alert. It is in details such as these that Géricault creates a portrait of such intimacy that we hesitate before stepping forth into the darkened room.

Like Géricault, Delacroix—who as a student had modeled for one of the figures in the *Raft of the Medusa* and whose early essays in Romanticism seemed sanctioned by the encouragement that the older artist had received—restricted his portraiture to a relatively confined circle of family members and personal associates. Exhibited in the Salon of 1833— at the same time as Ingres's *Monsieur Bertin* (Paris, Musée du Louvre)—Delacroix's more modest portrait of *Doctor François-Marie Desmaisons* (PLATE 24) nonetheless shares the attributes of a similarly commanding and confident personality, albeit rendered far more informally. Painted out of doors in a turbulent, if unidentifiable, setting, the 28-year-old doctor,

PLATE 24. EUGÈNE DELACROIX. *Doctor François-Marie Desmaisons*, 1832. Oil on canvas. 26½ × 21¼ inches.

thumb tucked behind his unbuttoned waistcoat, gazes past us, alert if self-absorbed. The sitter was a relatively close friend of Delacroix's—the artist had celebrated the feast of Saint Nicholas in his home in December 1830—but there is little indication of any deep personal engagement on the artist's part. And although Delacroix painted this portrait shortly after he returned from six months in North Africa, the work bears not the slightest influence of his Moroccan sojourn, since it is primarily indebted in its assertive and painterly handling of flesh and fabrics to the portraiture of Sir Thomas Lawrence, whom Delacroix had met in London in the summer of 1825.

If Lawrence presides over the portrait of *Dr. Desmaisons*, Constable is the artistic godfather of Delacroix's splendid portrait of his maternal aunt by marriage, Madame Henri Riesener (born Félicité Longrois, c.1787–1846), painted three years later (FIG. 55). Widow of a mediocre but fashionable portrait painter who had made his fortune in Russia and had returned to Paris in 1820 "laden with diamonds and furs for his wife," there is little in the elegant but respectable appearance of Delacroix's beloved aunt to suggest that Félicité Longrois had enjoyed an early success at Napoleon's court, where, after a brief liason with the Emperor, she was married off to a portraitist almost twenty years her senior, much to the relief of the Empress Josephine who signed her marriage contract in June 1807.

A cultivated and affectionate matriarch, who translated Byron's *Childe Harold* with her nephew and whom Delacroix professed to love as a mother, the portrait of *Madame Riesener* is one of the artist's most affectionate works. Her jet black hair crowned by a bonnet of white lace, her neck encased by a starched ruff that would not be out of place in a portrait by Rembrandt, Delacroix's comfortable aunt gazes almost sardonically at the viewer, a hint of a smile barely perceptible. Her widow's black enlivened by a brilliantly colored foulard tucked under her belt at the waist, a thin gold chain of a type used for eyeglasses or timepieces falling from her shoulders, *Madame Riesener* is one of the masterpieces of bougeois portraiture of the July Monarchy, as well as a fitting testimony to one of a "petit nombre de personnes" who were infinitely dear to the artist.

From Delacroix's aunt to Courbet's father (PLATE 25): although the social and economic position of the sitters and the aspirations of the artists could not be more different, a shared tenderness and respect characterizes both of these exceptional works. Eléanor-Régis-Jean-Joseph-Stanislas Courbet (1798-1882), a wealthy landowner who was 'handsome but exceptionally foolhardy', affects the striking "Assyrian" profile that his son inherited in such good measure, while sporting the prominent side whiskers that he would maintain well into old age. That Courbet may have inherited his rustic dandyism from his father is also suggested by the embroidered duck egg waistcoat that appears from underneath the hunter-green jacket. Probably painted in Ornans during one of the brief trips home that Courbet made during his first years in Paris, this forthright and confidently executed early work—which compares well with Millet's uncompromising portraits of friends and family members from the same decade—may also have been intended to reassure his father of his chosen vocation. Régis had intended that his son move to Paris in order to study law.

Born the same year as Courbet, but an artist who stood for the values of finish, propriety and respectability despised by the Realists, Louis-Edouard Dubufe crafted his elegant, lilting double portrait (PLATE 26) at about the same time that Courbet painted his admirable effigy of his father. With Nazarene simplicity yet fantastically observed details of coiffure, costume and jewelry, Dubufe states his *Ingriste* allegiances, pays homage to his teacher Paul Delaroche, while proclaiming a precocious talent for society portraiture to equal his father's. By the 1850s, this second generation portraitist from 'Dubufe and Company,' in Bruno Foucart's witty phrase, had established a lucrative and successful portrait practice on both sides of the English Channel. Jules Janin, spokesman of the Romantics who sat to 'le petit Dubufe' in 1851, noted bitterly 'how strange it was that such a small talent could make so much money.' In contrast to his more familiar mature production—with Winterhalter, Dubufe was the chronicler of the court and financial elites of Second Empire Paris—Dubufe's early double portrait offers an authentic, if greatly stylized, response to two well-bred adolescent sitters who have yet to be identified. So proficient is this painting that when it was engraved in 1840 it was attributed to the artist's father, Claude-Marie (1790–1846), the July Monarchy's most successful portraitist.

PLATE 25. GUSTAVE COURBET. *Portrait of the Artist's Father*, 1844. Oil on canvas. 28¾ × 23⅜ inches.

FIG 56. Jean-Auguste-Dominique Ingres. *La Princesse de Broglie*, 1853. Oil on canvas. 47¾ × 35¾ inches. New York, The Metropolitan Museum of Art; The Lehman Collection.

WHAT DUBUFE ASPIRED TO all his life, Ingres accomplished with an apparent ease that concealed long and painstaking effort. Although it is his sinuous, glassy-finished portraits that we most revere, Ingres dedicated himself to history painting and resented the time that portrait painting stole from him. "Damned portraits," he complained in 1847. "They are so difficult to do that they prevent me from getting on with greater things that I could do more quickly." Unable indefinitely to refuse commissions of portraits for a handful of his most persistent patrons, he reluctantly embarked upon a series of society portraits extending from the *Comtesse d'Haussonville* (New York, The Frick Collection) completed in 1845, to *Madame Moitessier* (London, The National Gallery) dated 1856, which are today regarded as the crowning glory of Ingres's long career.

The *Princesse de Broglie* (FIG. 56) was begun in 1851 and finished two years later—fast for Ingres, who took seven years to complete his portrait of *Baronne Betty de Rothschild* (1848; Paris, Guy de Rothschild Collection) and made Mme. Moitessier wait fourteen years before taking delivery of her's. So exhausting and frustrating had the process of portrait painting become for Ingres, with the endless experiments in pose and numerous preparatory studies that accompanied them, that he vowed the *Princesse de Broglie* would be the last of his aristocratic portraits, and it was in fact the last to be begun, if not completed. "A portrait of a woman! Nothing in the world is more difficult, it can't be done…It's enough to make one weep," he once exclaimed.

Pauline Eléonore de Galard de Brassac de Béarn, the Princesse de Broglie (1825–1860), was the sister-in-law of the Comtesse d'Haussonville. Her pose was worked out in a beautiful nude study in Bayonne in which Ingres minutely analyzed the underlying anatomical structure of the figure which would, in the end, be concealed under the sitter's magnificent blue silk hoop skirt. The details of her costume—gold pendant necklace, drop earrings, marabou plumes, ropes of pearls, kid gloves, evening wrap—are mesmerizing in the studied perfection with which they are recreated by Ingres's brush, but it is the Princesse's enigmatic expression—reticent, melancholic, her almond eyes seeming to look past or through us–that is most arresting and memorable. The incomparably graceful line of her throat, curve of her shoulder, silhouette of her form—these are the unique characteristics of Ingres's portraiture which, as Baudelaire recognized, imposes an abstract quality of ideal form on a microscopically observed material reality rarely equaled since the art of Van Eyck: "The drawing of M. Ingres is the drawing of a man with a system. He believes that nature must be corrected, amended…"

With its glacial palette of grey, white, gold and frost blue, its attention to form and abstraction of line conveyed emphatically through sloping shoulders and curving, boneless arms, the *Princesse de Broglie* brings to portraiture a hyper-graceful and sophisticated abstraction not seen in French painting since the mannerism of the sixteenth-century School of Fontainebleau: Our journey, in one sense, has now come full circle.

PLATE 26. LOUIS-EDOUARD DUBUFE. *Portrait of Two Sisters*, c. 1840. Oil on canvas. 58½ × 44⅝ inches.

INGRES WAS ONE of the last living representatives of a generation of painters who had trained in the studio of David, himself chiefly responsible for reviving the classical tradition that had been formalized by the Académie Royale des Peinture et Sculpture in the middle of the seventeenth century and was founded on the artistic principles of Poussin and Le Brun. With Ingres's death in 1867, that tradition seemed to die with him. Just three years earlier, the 24-year-old Claude Monet (1840–1929) had painted a small oil study of his friend, the marine and landscape painter, *Johan Barthold Jongkind, smoking a pipe* (PLATE 27). Dark, brooding, rapidly sketched and rough in its handling, it is painted in conscious emulation of the recent work by the yet little-known figure painter Edouard Manet (1832–1883), which Monet would have seen for the first time in a dealer's exhibition in the spring of 1863. Despite its youthful crudeness, Monet's portrait is a powerful painting and an acute, convincing likeness. With his emphatic brushwork, strong tonal contrasts and unidealized naturalism, Manet provided a daring alternative to the sweet Salon painting of Monet's teacher Charles Gleyre, and Manet's work of the early 1860s opened a door for Monet's young colleagues in Gleyre's shop: Renoir, Sisley, and Bazille. Over the next three or four years, Monet's palette would lighten, his command of figure drawing would become more assured and, working outside of the studio, he would learn to integrate figures into the landscape with greater confidence, as in the audacious portrait of his childhood friend *Victor Jacquemont* (c. 1868; Zurich, Kunsthaus). A new tradition was developing, the beginning of a Golden Age that would lead French painting and the French portrait in dramatically new directions; although the history of Impressionist and Post-Impressionist portraiture is yet to be told, it is a story for another book and another exhibition.

PLATE 27. CLAUDE MONET. *Johan Barthold Jongkind*, c. 1864. Oil on canvas. 17½ × 13½ inches.

Catalogue

FRANÇOIS CLOUET
? 1522–1572 Paris

PLATE I

Françoise Brézé, duchesse de Bouillon

Oil on panel
12¼ × 9¼ inches
31.5 × 23.5 centimeters
The reverse of the panel bears the seal of the Halley-Duchesne de La Sicotière families

Lent by a private collector

Of the 551 drawings by Jean and François Clouet and their assistants acquired by Catherine de'Medicis, 336 are now in the museum at Chantilly. Moreau-Nélaton was the first to recognize and publish, *Françoise Brézé, duchesse de Bouillon*, as a painting based upon a drawing in the collection at Chantilly. The drawing itself not only bears her name at the top, but also has notations of the colors used in the present painting. The drawing and the painting have the letter "F" worked into the chain which crosses the shoulders and upper chest of the Duchesse, an insignia which the artist undoubtedly used to identify the sitter.

While it is recorded that Catherine de'Medicis ordered or acquired the drawings mentioned above, there is no mention of her having acquired any of the paintings. One may conjecture that this portrait of the *Duchesse de Bouillon* was purchased by a member of her family, possibly her parents, Diane de Poitiers and Louis Brézé, Grand sénéchal de Normandie.

Diane de Poitiers, duchesse of Valentinois (1499–1556)—the favorite of François I, although she was some fifteen years older than he—became the mistress of Henri II. She was not only the favorite of the king, but dominated the court with her brilliance and beauty. Living in the Château d'Anet, she beautified it with the talents of the greatest architects of the time, and employed such artists as Jean Goujean and Jean Pilon. Françoise was betrothed to Robert IV de la Marck, duc de Bouillon and Prince of Sedan in 1539. The descendants of her younger sister, Louise, joined the family with the royal line when one of her great-granddaughters, Marie Adelaide de Savoie, married Louis, duc de Bourgogne, who would become Louis XV of France. Their descendants included Louis XVI, Louis XVIII, and Charles X, the last of the Bourbon line.

The drawing has been dated between 1543 and 1553. It is listed by Irene Adler in her *catalogue raisonné* of Clouet's drawings and paintings, as the earliest of the 13 painted portraits by François Clouet known today. Several other portraits exist which were not mentioned by Professor Adler and the other earlier experts. One of these, the *Portrait of Elizabeth of Valois* is in the Museum in Toledo, Ohio. Of the 13 portraits by Clouet, *Françoise Brézé, duchesse de Bouillon* appears to be the only female portrait still in private hands.

PROVENANCE

Halley-Duchesne de La Sicotière (ca. 1760)
Baron Bertrand de Schickler (d. 1910)
Private collection, England
Mr. & Mrs. Stanley S. Wulc, Rydal, Pennsylvania (mid-1960s)
[Christie's London, June 29, 1973, lot 59]
[Christie's London, December 8, 1989, lot 83]
Trust of a noble English family
Private collection

LITERATURE

E. Moreau-Nélaton, *Le Portrait à la Cour des Valois. Crayons Français du XVIe Siècle conservés au Musée Condé à Chantilly*, I, p. 111, pl. LXXXVIII, fig. 67
E. Moreau-Nélaton, *Les Clouets et leurs Emules*, 1924, II, p. 17 and fig. 206; III, p. 16, no. 88
L. Dimier, *Histoire de la Peinture de Portrait en France au XVIe siècle*, I, 1924, p. 50, and II, 1925, p. 124, no. 492.
A. Fourreau, *Les Clouets*, 1929, p. 50
I. Adler, *Die Clouet Versuch einer Stilkritik*, Jahrbuch der Kunsthistorischen Sammlungen in Wien, III, 1929, pp. 243, no. 16 and 246, no. 1

EXHIBITED

Paris, Bibliothèque Nationale, 1907, no. 521 (as unknown French 16th-century artist, *Portrait of Eleanore of Austria*)

FRANÇOIS QUESNEL THE ELDER
Edinburgh 1543–1619 Paris

PLATE 2

Portrait of a Lady

Oil on canvas
33¾ × 24 inches
85.5 × 61 centimeters
Inscribed: *De la/Femme de M.re Sieur/Del/g ou b)ennes Seigneur de/Villes(eine)...?*

Colnaghi

Born in Edinburgh where his father painted for James V of Scotland, François Quesnel is first mentioned in the French royal accounts in about 1572 when he was paid for the models of coins distributed to the crowd on the occasion of the entrance of Charles I and Elizabeth of Austria into Paris. He achieved contemporary renown for his portraits of members of Henry III's court and the favorites of Henry IV "in the new manner of painting in pastel ('crayon') where the heads are depicted slightly smaller than life on white paper, rather than the grey sheets of the past, with pencil, red chalk, vermillion wash and lake" (Guillet de Saint-Georges, writing about the Dumoustiers). Quesnel's popularity was such that in Michel de Marolles's words, "...de François tout le monde est semé,/Qui dépeignit la cour en ce genre estimé..." His brother, Nicolas, also executed portraits.

Quesnel's fame proved transitory, fading away even before his death in 1619. In modern times, Quesnel's artistic personality was reconstructed by L. Dimier (1926) who attributed to him a number of drawings in the Cabinet des Estampes in the Louvre, fifty sheets from the 1909 Wickert Sale, as well as others formerly in the Fontette Collection. Dimier based his findings at first on comparison between an engraving of Henriette d'Entragues by de Leu after Quesnel and a drawing of Henry IV's mistress in the Louvre group, and later between the whole series and a signed drawing of a child in Angoulême.

François Quesnel rarely painted in oil. His portraits in that medium, such as *Mary Ann Waltham* (monogrammed FQ and dated *1572*) at Althorp and the *Madame de Cheverny* at Versailles, tend to be smaller than the Colnaghi picture and on panel rather than canvas. However, this *Portrait of a Lady* shows both the strengths and weaknesses of Quesnel's art as described by Dimier: "... in a number of his most accomplished works, a happy employment of his natural talents makes up for a certain lack of technical skill. The fine finish spread, as it were, over these sheets, the flattering color, the clever use of light and shade which at times seems mannered, gives them a scintillating charm. Each of the parts contributes to the subtle play of colors. The brows and lips give off a radiance that imparts a unity of tone to the faces. The eyelids are suffused with light; the hair has a pleasing lustre. For the rest, the pencil strokes fall happily into place, and the noses and ears are drawn with a special delicacy and grace."

On the evidence of costume, this *Portrait of a Lady* was painted early in the 1580s. Anne Dubois de Groer has compared this picture to a drawing of a lady in the Wickert Sale (Dimier, pl. 53) in 1909.

FRANS POURBUS THE YOUNGER
Antwerp 1569–1622 Paris

PLATE 3

Head Studies of Three French Magistrates

Oil on canvas
15 × 22⅝ inches
38.1 × 57.5 centimeters

Colnaghi

Following a tradition which dated back to the middle of the sixteenth century, the municipal authorities of Paris commissioned Frans Pourbus the Younger, "peintre de la Reine" (Marie de'Medicis) and the leading international portraitist of his day, to paint two large canvases to be placed over the chimney-pieces in the assembly hall of the Hôtel de Ville. Dézallier d'Argenville stated that they showed: "... the provosts of the guilds and magistrates of this town (Paris) kneeling at the feet of the infant Louis XIII who is seated on a throne; the other one represents the majority of that prince. Marie de'Medicis is placed behind her son in one of the pictures." He also added that the two paintings combined "truth to nature and beautiful coloring with a noble simplicity in the treatment of the draperies, ravishing expressions and perfect likenesses."

The first canvas was executed in about 1614, and the second at a slightly later date. Both remained in their original positions until late in the seventeenth century when they were put above the doors on either side of the right-hand chimney-piece, then dominated by Rigaud's full length *Portrait of Louis XIV* (destroyed). A 1687 engraving by Noël Cochin the Younger shows this new arrangement of the pictures. Pourbus's paintings, like all the others, were removed from the Hôtel de Ville in August 1792. The earlier of the two would seem to have been destroyed, while the second canvas was cut up into fragments which were later bought by Vivant Denon. He sold three of these

to Labensky, director of the Hermitage, who was in Paris between 1808 and 1810. A fourth fragment appeared in 1921 at the Cardon Sale in Brussels, and is now in a private Belgian collection.

J. Wilhelm (1963) associated the Labensky/Hermitage fragments (one is now in the National Museum, Warsaw) and the section in Brussels with a preparatory drawing by Pourbus for the second Hôtel de Ville canvas, inscribed and dated 1618 by Mariette in the eighteenth century and now in the Louvre. He also identified a number of the magistrates and nobles in the four fragments, including the Chancellor Nicolas Brulart de Sillery, the Keeper of the Seals, Guillaume du Vair, and the Duc de Luynes. Their presence indicates that the second picture could not have been painted before the assassination of the Queen Mother's Italian favorite, Concini, on 24 April 1617. In fact, the second chimney-piece in the assembly room was not finished until June 1618.

None of the magistrates in the Colnaghi study appear in the fragments published by Wilhelm. They may, therefore, have featured in the destroyed 1614 canvas, showing the infant King with the Queen Mother. It is likely, given Dézallier d'Argenville's description, that the two pictures were similar in composition, the chief difference being the civic authorities depicted in each of them. In the Colnaghi canvas, the *gravitas* of the heads and their careful progression, as it were, towards a central figure are similar in style and arrangement to the 1618 drawing and the related fragments. The sensitive rendering of the world-weary faces with their expressive eyes is characteristic of works in Pourbus's more intimate manner, such as the *Self Portrait* and the *Pierre de Francheville* in the Uffizi, Florence. The Colnaghi picture is an early example of the use of the sketch as an aid for a finished portrait. In this case, the number of the personages to be depicted made this necessary.

PROVENANCE
Galerie du Lac, Vevey, by 1982
Private collection, Switzerland

LITERATURE
J. Wilhelm, "Pourbus, peintre de la municipalité parisienne", in *Art de France*, 1963, II, pp. 114–23

HYACINTHE RIGAUD
Perpignan 1659–1743 Paris

PLATE 4

Portrait of a Parisian Alderman

Oil on canvas
55¾ × 44½ inches
140.2 × 110.3 centimeters

Colnaghi

This magnificent *Portrait of a Parisian Alderman* epitomizes Rigaud's extraordinary ability to capture a "speaking" likeness and render the evanescent beauty of rich materials. Dézallier d'Argenville (1762) noted that "when he (Rigaud) painted velvet, satin, taffeta, fur or lace, one had to touch them to realize they were not the real thing. Wigs and hair, which are so difficult to paint, were but a game for him; the hands in his paintings are particularly divine." He also stated that "Rigaud's portraits were such perfect likenesses that upon seeing them from a distance, one entered into conversation, in a sense, with the figures they depicted."

Dominique Brême has examined this portrait and confirms that it is a fully autograph work by Hyacinthe Rigaud. He dates it to about 1700.

PROVENANCE
Private collection, Paris

LITERATURE
To be included in the forthcoming *catalogue raisonné* of Rigaud's painting being prepared by Dominique Brême

NICOLAS DE LARGILLIERRE
Paris 1656–1746 Paris

PLATE 5

Portrait of a Gentleman

Oil on canvas
54 × 41½ inches
137 × 105.5 centimeters

Colnaghi

This superb painting is similar in format, size and style to several works by Largillierre dated c. 1720, notably the *Portrait of the Comte de Noirmont* in the Museu Nacional de Arte Antiga, Lisbon (reproduced fig. 23c, p. 138, in M.N. Rosenfeld, *Largillierre and the Eighteenth-Century Portrait*, Montreal, 1982) and the *Portrait of Monsieur de Puiséjour*, in the Barzin collection, Paris (fig. 23d, p. 139, Rosenfeld, *op. cit.*). Largillierre—like many 18th-century portrait painters—developed and employed a standardized repertory of poses and figure types from which his clients could choose when commissioning their portraits, as is evident when comparison is made between the Barzin collection's *Monsieur de Puiséjour* and Colnaghi's *Portrait of a Gentleman*. The configuration of the sitters, the

poses of the hands, the drapery billowing behind the figures, and even the placement of the fluted columns are identical in both portraits; only the sitter's costumes and accessories differ and, of course, their faces are completely individualized. As Rosenfeld has pointed out, it does not detract from Largillierre's originality that he worked in this manner; his paintings are still the most penetrating and realistically characterized portraits of any French artist working in the first half of the 18th century.

Dominique Brême, who is completing the *catalogue raisonné* of Largillierre's paintings begun by Georges de Lastic, has examined the Colnaghi portrait and confirms that it is a fully autograph work by Largillierre of which there is no known replica or copy. He supports a dating of c. 1720 and observes that the "audacious use of color"—saturated wine red, sapphire blue and salmon pink—is characteristic of the final period of the artist's career.

The identity of the sitter in Colnaghi's *Portrait of a Gentleman* remains a mystery. Although it has been suggested that it might portray Louis-François de Pérusse, comte des Cars, "lieutenant pour le roi au haut et bas Limousin" under Louis XIV, this identification has little to recommend it other than provenance. It seems unlikely that Largillierre—an artist who specialized in portraits of members of the rich merchant class and minor aristocracy—would have portrayed such an illustrious member of the nobility with a degree of informality and familiarity usually reserved for his depictions of fellow artists. Indeed the rhetorical gestures and romantically undone shirtfront—as well as the dense velvety application of paint — are similar in Largillierre's celebrated portrait of his friend, the sculptor Nicolas Coustou (Berlin, Gemäldegalerie) of five years earlier.

PROVENANCE
Ducs des Cars, Rouen

LITERATURE
To be included in the forthcoming *catalogue raisonné* of Largillierre's paintings being prepared by Dominique Brême

JEAN-BAPTISTE SANTERRE
Magny-en-Vexin 1651–1717 Paris

PLATE 6, FIG. 22

Portrait of a Woman and *Portrait of an Artist, thought to be Santerre*

Oil on canvas
32¼ × 25½ inches, each
82 × 65 centimeters, each

Santerre was a pupil of François Lemaire and Bon de Boulogne, and was received as an academician in October 1704. He was known in his own day as a painter of portraits, often in the allegorical tradition. A fine example of Santerre's work in the grand manner is the *Portrait of Marie-Adelaide de Savoie, duchesse de Bourgogne* (signed and dated *1709*), now at Versailles. His fame depended on his few religious and historical canvases. In 1704 he exhibited *Susanna and the Elders* in the Louvre as his diploma piece. Its chilly neo-cinquecento atmosphere was to exert an influence on later artists, such as Vien and Falconet, whose small marble statues of bathers are strikingly similar in feeling. In 1709 he executed a *St. Theresa in Ecstasy* for the royal chapel at Versailles to a universal outcry because of its erotic overtones.

Like many of his contemporaries, Santerre was open to a variety of influences, from the Italian colorists to Dutch and Flemish artists. This pair of portraits shows him working in the naturalistic vein of Rembrandt, as is especially evident in the woman's likeness. The iridescent colors of her gown and striped head-dress are found in *A Young Girl Beckoning* (signed and dated *1703*) in a private collection (FIG. 21). The identification of the artist with Santerre himself is based on a strong similarity of likeness with the *Self Portrait* at Versailles, where he is, however, considerably younger than in the Colnaghi picture.

JACQUES AUTREAU
Paris 1657–1745 Paris

PLATE 7

Madame de Tencin Serving Chocolate

Oil on canvas
28¼ × 35⅝ inches
72 × 90.5 centimeters

Colnaghi

Little is known of Autreau's years as a poverty-stricken painter. It was only after 1717 when Autreau gave up painting for a career in the theater that he would achieve a degree of success and recognition. During the last 20 years of his life he composed 15 works for the stage, and it is for these three-act comedies—witty tales of love which prefigure the comedies of Mari-

vaux and Beaumarchais—that Autreau maintains a small posthumous fame.

The few known facts of Autreau's life can be quickly summarized: born in Paris in 1657, the son of a wine merchant, he was identified at the time of his father's death in 1686 as a "maître peintre." He married a woman with the surname Boucher and had a son who also became a painter. Despite his modest success as a playwrite in 1720s and '30s he remained poor (cheated out of his share of the profits, he complained) and by 1737 he was reduced to asking the Prime Minister, Cardinal de Fleury, to admit him into the Hospice des Incurables, where he died in obscurity eight years later.

The corpus of extant paintings by Autreau is very small, consisting of just one tiny *Self Portrait* (8¼ × 6¼ inches) in Versailles and the present composition, which exists in three versions. It is not surprising that Autreau—a painter whose identification with the literary circle at the Café Laurent was so strong that he changed careers and joined its ranks—should choose as his subject several of the most prominent members of the *monde littéraire* in Paris, or that this playwrite-to-be should depict figures in a manner which evokes characters on the stage. The picture portrays, gathered in the informally arrayed library of Mme. de Tencin's *hôtel* on the rue Saint-Honoré (which she and her brother had occupied since c. 1710), three friends preparing to take breakfast and engaged in an animated discussion centering on a manuscript which one of them holds. At far left in a high blond wig and brocade vest, is Bernard Le Bovier de Fontenelle (1657-1757), nephew of Corneille, and himself one of the leading philosophers, poets and playwrights of his time, whose career spanned almost the whole of both Louis XIV's and Louis XV's reigns. Seated beside him, and dressed in a red cloak, is Houdar de La Motte (1672–1731), a close friend of Autreau and a distinguished poet who, early in his career, had composed libretti for operas. Finally, standing to the right and dressed in black, is Joseph Saurin, a mathematician and *habitué* of the Café Laurent who seems to check off the points in the argument on his fingers. Little trace seems to remain of Autreau's obscure friend.

In 1707 Fontenelle, La Motte, Saurin and Autreau had all become embroiled in a spirited battle—*chansons* and anonymous sonnets were their weapons—with the poet Jean-Baptiste Rousseau who had attacked the character of all the regulars of the Café Laurent, and in particular La Motte. The war ended when La Motte (against the advice of Fontenelle and Saurin) reconciled with Rousseau, shortly before the group was to have staged a public demonstration and sung a vicious denunciation of the poet (penned by Autreau) while standing on the Pont Neuf. The close personal bonds between the artist and his three sitters helps explain the unusual informality and animation which informs this curious group portrait and the prominence given to the pages which La Motte holds.

Entering through a doorway along the back wall is the mistress of the house, the self-styled "Mme." de Tencin who wears a simple morning robe and bonnet and carries a silver platter with brioches. Even in a century noted for its remarkable women, Claudine-Alexandrine-Guérin de Tencin (1682–1749) was outstanding. Although renowned for a string of celebrated lovers—among whom were the Duc de Richelieu, the Regent and Fontenelle—her contribution to French intellectual life was her illustrious salon to which for nearly 40 years she lured the great men of France. Her protégé Marivaux was in constant attendance, as was Prévost (author of Manon Lescaut) and, on occasion, Montesquieu. Only the salons of Mme. du Deffand and Mme. Geoffrin could claim such luminaries.

Although the Colnaghi *Madame de Tencin Serving Chocolate* has recently resurfaced, Autreau's other versions of the composition were identified in 1967 by Nick Childs ("Jacques Autreau," *The Burlington Magazine*, Vol CIX, June 1967, pp. 335-337) in a highly informative article which forms the basis for any subsequent discussion. One version, in the London Library, bears a manuscript note in an 18th-century hand which reads: "Fontenelle, La Mothe et Saurin, disputent sur une matière philosophique. Md. Tencin, deguisée en servante, leur sert une collation." Above this in a different 18th-century hand are five lines of verse followed by "Autreau pinxit et sculpsit, Anno 1716." A further note identifies it as having passed through the sale of the collection of the Comte de Vence in 1761. The other version is in Versailles, where as recently as 1980, it was misattributed to Robert Levrac-Tournières.

An anonymous late 18th-century manuscript note in the Municipal Library at Lyon describes the composition in great detail under the title "Dejeuné en chocolat donné et servi par Mme de Tencin." The note continues : "On croit que ce tableau de deux pieds et demi de largeur sur deux pieds de hauteur, a été peint vers 1710 par Jacques Autreau, peintre et poète. Il a appartenu a Mme de Tencin; de ça il a passé a M. de Boze, a M. L'Abbé Leblanc, et aujourd'hui a M. l'Abbé Berthelemy." As the note specifies LeBlanc but not the Comte de Vence or La Faye as a prior owner of the painting, it clearly refers to a different picture than that now in London Library. However, the dimensions given in the Leblanc sale (22 × 30 inches) differ from those of all extant versions and it seems possible that it is yet a fourth, still unlocated, version, perhaps even a missing prototype for the group. Could Autreau have painted one version for each sitter?

PROVENANCE
Edmond Filleul (1818–1907), Montargis
By descent until 1991

Jean Marc Nattier
Paris 1685–1766 Paris

PLATE 8

Louise-Anne de Bourbon-Condé, called Mlle. de Charolais

Oil on canvas
43¾ × 57½ inches
114 × 146 centimeters
Signed and dated at lower left: *Nattier pinxt. 1731*
Inscribed on reverse: *Trentham Catalogue/22* and *Mad.lle de Charolois, Sister of the Duc de Bourbon./J.M. Nattier, Pinxt.*

Lent by a private collector

The third daughter of Louis III Bourbon-Condé, duc de Bourbon and Louise-Françoise de Bourbon (Mlle. de Nantes), the legitimized daughter of Louis XIV and Madame de Montespan, and great granddaughter of the *Grande Condé*, Mlle. de Charolais was born at Versailles on 23 June 1695. Like her sisters, she was famous for her beauty. Toussaint claimed that "Nature appeared to have used up all Her gifts when favoring the Princesses [Mlle. de Clermont, Mlle. de Sens, Mlle. de Vermandois and the Princesse de Conti] of this family". Mlle. de Charolais possessed an enchanting character: "proud and sweet, melancholy and joyful, indolent and vivacious, and at times capricious; aware of her position, sincere in her sentiments; loving pleasure she turns night into day and day into night". This magnificent portrait represents Mlle. de Charolais in all her brilliance. When describing her, Toussaint noted that, although she was more than thirty, her radiant beauty remained undimmed.

Along with her friend the Comtesse de Toulouse, Mlle. de Charolais formed part of Louis XV's intimate circle. As a young man, the king often spent time at Rambouillet, the great country estate belonging to the Comte de Toulouse. Here, away from the rigours of court life, he hunted by day, and at night relaxed at table or over cards.

Mlle. de Charolais was secretly married to the Prince de Dombes, second-born of the Duc du Maine. Reasons of state, however, prevented them from making their union public. According to Voy's *Vie privée de Louis XV*, the Princess produced a child almost every year. However, for form's sake, it was always put about that she was unwell during the last six weeks of her pregnancies, when members of the court paid visits to enquire after her health.

Nattier executed some of his best work for the Bourbon-Condé family. He painted two likenesses of Mlle. de Clermont, Keeper of the Queen's Houshold. One shows her as the nymph of the mineral waters at Chantilly (1729–30; Chantilly, Musée Condé) and the other in her bath as a Turkish sultane (1733; London, The Wallace Collection). His likeness of Louise-Henrietta de Bourbon-Condé, duchesse d'Orléans as Hébé is in Stockholm.

An unsigned replica of this portrait of *Mlle. de Charolais*, belonging to Arthur L. Nicholson, was sold at the American Art Association, New York, on 18 May 1933 (Lot 17). An oval likeness of the Princesse with a guitar appeared in the Lassalle Sale at the Hôtel Drôuot in December 1901.

PROVENANCE

Dukes of Sutherland, Trentham
[Trollope, 17 July 1907, 210 gns]
[Galerie Sedelmeyer, Paris]
J. Pierpont Morgan, Wall Hall, Aldenham, Herts, by 1910;
[his sale, Christie's, London 31 March 1944, Lot 137, 1,800 gns]
Private collection

LITERATURE

F.-V. Toussaint, *Anecdotes curieuses de la cour de France sous le règne de Louis XV*, Paris, 1908
P. de Nolhac, *Nattier*, Paris, 1910, p. 226

Maurice-Quentin de La Tour
St. Quentin 1704–1788 St. Quentin

PLATE 9

Jacques Dumont le Romain

Pastel on paper
25½ × 21 inches
648 × 533 millimeters

In the Salon of 1742, Quentin de La Tour exhibited five pastels of very different types. As the catalogue descriptions reveal, he evidently intended to show the range of portraiture possible in his chosen medium, from the formal glamour of *Mme. la Presidente de Rieux* "en habit de bal", to the informality of *Mlle Salle* "habillée comme elle est chez elle". The present portrait of Jacques Dumont called Le Romain lies between the two, informal in pose yet quite monumental in ambition.

Jacques Dumont (1701–1781) was from a long line of artists who were primarily sculptors. Despite Dumont's powerful sculptor's hands, so admirably described here engaged in the gentle art of music, he was primarily a painter and engraver. Having traveled early to Rome, he adopted the sobriquet Le Romain. A successful painter of religious and mythological works, he also painted genre and the occasional portrait. His *Publication of the Peace of*

1749 was an important commission for the Paris Hôtel de Ville. Received as an academician in 1728, he became a Professor in 1736 and later rose to the rank of Honorary Director.

Another, more formal likeness of Dumont by La Tour was exhibited in the Salon of 1748 and offered to the Académie (now in the Louvre). This was a belated fulfillment of the Académie's request in 1737 for two works from La Tour, specified as portraits of Jean Restout and François Le Moyne, to ensure his election as an academician. A portrait of Restout (now lost) was exhibited in the Salon the following year, no doubt an informal warm-up to the more serious version required of him by the Académie which was not completed to La Tour's satisfaction until 1746. The second subject was more of a problem. Only months after La Tour received the Académie's commission, Le Moyne committed suicide. Jean-Baptiste Vanloo was chosen as the new subject. Almost immediately, however, Vanloo moved to London where he remained until 1742, when ill health forced his return to his home town of Aix. The inaccessibility of Vanloo made progress on La Tour's requirements impossible and it is likely that by exhibiting the present portrait of Dumont in 1742, La Tour had hoped to suggest to the Académie an alternative. The death of Vanloo in 1745 forced the issue and, using the informal portrait of Dumont as a model, La Tour completed a larger pastel of his friend in the same low viewpoint format as that of Restout and submitted it to the Académie in October 1750.

A *préparation* of the head of Dumont in black and white chalk on blue paper was purchased by the Cleveland Museum of Art in 1983. In many details (especially the form of the turban and the way that it cuts behind the sitter's right ear) the drawing is closer to the Louvre pastel than the present one. However, as the Louvre version appears to be the later of the two (certainly in its completion), the Cleveland sketch, so evidently drawn from life, must have been made in preparation for the present pastel and then reused without revisions for the other painting.

Our thanks to Christopher Robinson for preparing this entry.

PROVENANCE
[Paul Cailleux, Paris (by 1922)]
[Ffoulkes et Co., Paris (by 1928)]
Sir Robert Abdy, Paris
Camille Plantevignes, Paris (by 1935)
Mon. Rossignol, Paris

LITERATURE
La Renaissance de l'Art Français et des Industries de Luxe, December 1921, ill.
L'Illustration, June 1921
E. Fleury, "Two Newly-Discovered La Tours," *The Burlington Magazine*, January 1922, pp. 26–31, ill.
A. Besnard and G. Wildenstein, *La Tour, La Vie et l'Oeuvre de l'Artiste*, Paris, 1928, no. 117, ill.

EXHIBITED
Paris, Salon, 1742, no. 130
Paris, Musée du Louvre, *Salle des Pastels de Saint–Quentin*, 1922
Paris, *L'Art Français au Service de la Science*, April/May 1923, no. 23
Paris, Galerie Cailleux, *Un Choix de Pastels des Maîtres du XVIII Siècle*, June 1923, no. 6
Copenhagen, Palais de Charlottenberg, *Exposition de l'Art Français au XVIII Siècle*, 1935, no. 275

JEAN-BAPTISTE PERRONNEAU
Paris 1715–1783 Amsterdam

PLATE 10

Jean-Baptiste Antoine Le Moyne

Pastel on paper
17 × 13¾ inches
431 × 350 millimeters
Signed *Perronneau* in black chalk at the lower right. Inscribed (according to Vaillat and Ratouis de Limay) *Ce pastel a été fixé par Loriot* on the reverse

Colnaghi Drawings

Jean-Baptiste Perronneau, a pupil of Charles Natoire and the engraver Laurent Cars, began his career as an engraver, but soon abandoned this in favor of working as a portraitist in oils and pastel. *Agréé* at the Académie in 1746, Perronneau made his Salon debut the same year, and continued to exhibit regularly until 1779. He traveled widely throughout Europe, working in Holland, Spain, Germany, Italy and Prussia. In France, however, his pastel portraits remained overshadowed by those of his older contemporary, Maurice-Quentin de La Tour, who had established the vogue for this medium. Nonetheless, Perronneau's pastels, the earliest of which date from around 1743, were greatly admired for their freshness and vitality, and for the skill with which the artist captured the personality of his sitters.

This charming pastel is a portrait of Jean-Baptiste Antoine Le Moyne (1742–1781), the eldest son of the sculptor Jean-Baptiste Le Moyne the Younger. Antoine Le Moyne, judge and *conseiller du roi*, died at the age of 39 in Port-au-Prince, where he held the post of lieutenant in the Admiralty. Exhibited at the Salon of 1747, this pastel is a superb example of Perronneau's skill as a portraitist and of his virtuoso handling of this delicate medium. Perronneau also produced a pastel portrait of the elder Le

Moyne's third wife, Jeanne Dorus, which was exhibited at the Salon of 1753.

Another pastel portrait by Perronneau of a different young boy, dated 1747 and formerly in the Albert Lehmann collection, has in the past been identified as the drawing exhibited at the 1747 Salon. However, the features of the sitter in the Colnaghi drawing accord well with those in a later, engraved portrait of Jean-Baptiste Antoine Le Moyne, after a drawing by Louis Vigée.

The large and impressive collection of paintings, drawings and tapestries assembled by Camille Groult, kept in his *hôtel particulier* on the avenue Malakoff in Paris, included several pastel portraits by Perronneau. "Nothing could be more charming." observed the Goncourt brothers, "than [Perronneau's] portrait of a little boy that belongs to M. Groult."

PROVENANCE

Camille Groult, Paris, by c.1885;
 by descent to Pierre Bordeaux-Groult, Paris

LITERATURE

E. and J. de Goncourt, *L'Art and Dix-huitième Siècle*, Paris 1880–4, vol. 2, "La Tour," note 28

A. Flament, 'La collection Groult', *L'Illustration*, Paris, 18 January 1908, p. 54

L. de Fourcaud, 'Le pastel et les pastellistes français au XVIIIe siècle', *La Revue de l'art ancien et moderne*, September 1908, p. 230, note 1

H. MacFall, *The French Pastellists of the Eighteenth Century*, London, 1909, p. 111

L. Vaillat and P. Ratouis de Limay, *J-B. Perronneau: sa vie et son oeuvre*, Paris, 1909, pp. 11, 86–87, cat. no. 11, pl. 18

EXHIBITED

Paris, Salon, 1747, no. 125 ('*Un Portrait au Pastel, du Fils de M. le Moyne, Sculpteur ordinaire du Roy, âgé de cinq ans*')

Paris, Galerie Georges Petit, *Société des pastellistes Français: Exposition rétrospective*, April 1885, no. 75 (lent by Camille Groult)

Louis-Gabriel Blanchet
Paris 1705–1772 Rome

PLATE 11

Portrait of a Gentleman

Oil on canvas
29¼ × 24¼ inches
74.2 × 61.6 centimeters
Signed and dated lower left: *G. Blanchet 1752* inscribed at right: *Rome*

Lent by a private collector

Blanchet, who is sometimes described as having been born at Versailles, was the son of a *valet de chambre* of one Monsieur Bloin, who was himself the *valet de chambre* to Louis XIV.

He began his studies at the Académie Royale and was awarded second prize, after Subleyras, in a competition of 1727. He is recorded in Rome in 1728, where he spent five years as a *pensionnaire* at the French Academy, and does not appear to have ever returned to France. He had strong ties to Subleyras, with whom he shared lodgings in 1737, and their drawings are very close in style. While in Rome, Blanchet was the portrait painter to the court of the Stuart family.

Though religious and history paintings by Blanchet survive, his career was devoted to portrait painting and his work was popular among British and French expatriates living in Rome. The Duc de Saint-Aignan owned no less than seven of his paintings including the double portrait of the Reverends Jacquier and Leseur, now at the museum in Nantes.

The identity of the sitter in our portrait eludes identification. Elegantly dressed and placed within a painted niche, the sitter holds a volume inscribed "Belidor" on the spine. Belidor was the author of several essential volumes on artillery and warfare. The volume by Belidor and the rocky fortress-like wall out of which the sitter leans, suggests that the sitter may himself have been some type of technical engineer and, perhaps, a protégé of Belidor.

Louis Tocqué
Paris 1696–1772 Paris

PLATE 12

Nikita Akimfievitch Demidoff

Oil on canvas
87 × 56½ inches
220 × 142.5 centimeters

Colnaghi

In 1757 Louis Tocqué was appointed court painter to the Tsarina Elizabeth of Russia, a position he was to hold for a little more than two years. He met with great success in St. Petersburg, where he painted likenesses of the Tsarina and important members of the Imperial circle, including this magnificent full-length portrait of *Nikita Akimfievitch*

Demidoff (1724–1787). A state councillor and Court Chamberlain, Demidoff was a cultured man who traveled widely and corresponded with Voltaire. His *Journal du Voyage...*, a record of his visits to Germany, England, Italy and France, was published in Moscow in 1787.

The sitter's grandfather laid the foundations of the family's fabulous industrial wealth. A humble artisan from Tula, Nikita Demidoff (1656–1725) owed his rapid rise to fortune to a chance encounter with Peter the Great. During a march through the Tula district, the Tsar noticed that his German-made pistol was not working properly. Although reluctant, the Emperor was persuaded to entrust its repair to Demidoff, who enjoyed a local reputation as a gunsmith. Within two days, he not only returned the original in perfect condition, but also an excellent replica, which cost very little to produce. Overjoyed, Peter the Great appointed Demidoff Imperial gunsmith. He also gave him a hundred rubles and extensive land in the Urals, rich in precious minerals, such as silver and malachite. In 1699 Demidoff built the first Russian ironworks at Nevansk.

The Demidoffs achieved international celebrity in the first half of the nineteenth century. In 1822 the sitter's son, Nicholas, settled in Florence, where he founded hospitals and other charitable institutions. He also commissioned a magnificent villa outside the city, which he planned to fill with works of art. The Grand Duke of Tuscany, impressed by munificence on such an impressive scale, conferred the title of Count of San Donato on Demidoff before his death in 1828. Nicholas's artistic ambitions were fulfilled by his second-born. Dividing his time between Paris and Florence, Anatole Demidoff (1812–70) was to become, along with the 4th Marquess of Hertford, one of the most conspicuous collectors of his time. He was created Prince of San Donato in the 1830s. His extravagant buying at auction and scandalous private life served as a model for the Count Olensky in Edith Wharton's *Age of Innocence*.

A three-quarter length variant of this *Portrait of Nikita Akimfievitch Demidoff* is in the Museum of Fine Arts, Moscow.

PROVENANCE

Nikita Demidoff, St. Petersburg;
thence by family descent to Anatole Demidoff, Prince of
 San Donato, Villa San Donato, Florence;
thence by family descent to Princess Abamelek-Lazarew,
 Villa Demidoff, Pratolino, by 1929
H.R.R. Prince Paul of Yugoslavia, by 1968
The British Rail Pension Fund

LITERATURE

A. Doria, *Louis Tocqué*, Paris, 1929, p. 104, no. 77, fig. 27
G.W. Lunderg, *Roslin*, Malmo, II–III, 1957, p. 61, under
 no. 328

EXHIBITED

London, Royal Academy, *France in the Eighteenth Century*,
 1968, no. 662, ill. (cat. by Denys Sutton)
Leeds castle, Kent, on loan, 1980-95

JEAN-MARC NATTIER
Paris 1685–1766 Paris

PLATE 13

Mademoiselle Marsollier

Oil on canvas
23¼ × 20 inches
61.5 × 50.5 centimeters
Signed and dated at center left: *Nattier/pinxit 1757*

Lent by a private collector

This elegant bust-length portrait shows Mlle. Marsollier, one of the great heiresses of mid-eighteenth century France. Nattier painted her as a young girl with her mother in 1749. This double portrait was exhibited at the Salon of 1750, and is now of in The Metropolitan Museum of Art, New York. Although we know little of the sitter's life, Mlle. Marsollier's mother was born to a minor court official and a famous beauty. She had married an extremely rich silk merchant on the condition that she was never obliged to set foot in her husband's shop. She always avoided the rue Saint-Honoré where the showroom was located. As a result of these foibles, the lady was nicknamed "*la duchesse de velours*". She made her husband buy a post at court as secretary to the king and the title of Count de Saint-Pierre in order to remove the stain of trade from the family name.

PROVENANCE

The Marquis de Reroman
The Marquis Dafosse, Château de Saint-Pierre-du-Fresne,
 Calvados,
[Wildenstein and Co., Paris]
Albert H. Wiggin, New York; by family descent to
Muriel Wiggin Selden
Lynde Selden, New York
[Sale, Parke Bernet, New York, 4 April 1973, lot 149, ill.]
Private collection, California
Private collection, New York

LITERATURE

To be included in the forthcoming *catalogue raisonné* of
 Nattier's paintings being prepared by the Wildenstein
 Foundation, no. 325

JEAN-HONORÉ FRAGONARD
Grasse 1732–1806 Paris

PLATE 14

Portrait of a Singer Holding a Sheet of Music

Oil on canvas

32 × 25½ inches

81 × 65 centimeters

Lent by a private collector

This magnificent painting is one of the series of portraits by Fragonard that are commonly called *figures de fantaisie*. Its earliest provenance is uncertain but it has been thought to be the picture described as a "young lady, seen half-length..; she holds a sheet of music in her hand...height 29 *pouces*, width 24 *pouces* (30⅞ × 25½ inches)" which appeared in the Roettiers sale in January 1778. The *Singer's* earliest firm provenance cannot be established until 1882 when it was exhibited in Bordeaux together with another 'fantasy portrait', the so-called *Actor,* both at that time owned by the curator of the Musée des Beaux-Arts in Bordeaux, Emile Vallet. Since then the two paintings have been paired and have come to be regarded as pendants. However, if this was indeed the painting which appeared in the Roettiers sale it was sold alone. Furthermore, when the *Singer* was copied in pastel by the amateur artist comte Almaric de Brehan in 1773 it was paired with the portrait of the *Abbé de Saint-Non* which later entered the Louvre with three other 'fantasy portraits' belonging to Dr. Louis La Caze.

The pastels provide a *terminus ante quem* of 1773 for the *Singer.* Further contemporary sources which document this or indeed any of the *figures de fantaisie* are frustratingly few. Moreover, scholars are not even unanimous as to how the group should be comprised: some include the *Portrait of a Man* (Art Institute of Chicago) and the *Cavalier Seated by a Fountain* (Barcelona, the Cambo collection) even though the former is not a portrait and the latter is larger and of a different compositional format than the group of fifteen half-length figures whose dimensions correspond to this picture.

Fragonard is not known to have had a practice as a portrait painter and although he painted other single figure pictures, such as *The Vestal* (private collection), the only paintings other than the *figures de fantaisie* to be traditionally identified as portraits are those of family members such as the *Portrait of Fanfan* (Lawrence, Spencer Museum of Art).

It seems, however, that around 1769 Fragonard embarked on a series of rapidly executed half-length portraits of men and women dressed in ruffs, plumed hats, and cloaks: 'fancy dress' costumes which, despite their echoes of Rubens, contemporaries termed "Spanish". Such pictures had been popularised by the *Concert Espagnol* and the *Lecture Espagnol* commissioned from Carle Vanloo by Madame Geoffrin in 1754.

As with the "Spanish" scenes painted by Vanloo, the majority of the sitters in the fantasy portraits are portrayed with generic accoutrements—swords, books, music or instruments—which convey a spirit of courtliness without appearing to have any more particular allegorical function.

Some of the subjects of the *figures de fantaisie* have now been identified, including the Abbé de Saint-Non, Diderot and, perhaps most interestingly, the two portraits of members of the Harcourt family. The latter have no provenance earlier than that of the family of the purported sitters, which might suggest that at a moment in his career Fragonard accepted a few portrait commissions. Perhaps the most likely explanation for the series is that of Pierre Rosenberg, who suggests that the entire group was painted for Fragonard's own pleasure to decorate a gallery in his apartment in the Louvre.

The extraordinary modernity of the *figures de fantaisie* and their tremendous power to convey the excitement of the creative process is perhaps best summed up by Rosenberg who noted: "Fragonard never let himself be dominated by the model; on the contrary the model served only as a pretext for the painting. This was a very modern attitude but then it was not until the end of the nineteenth century that it became the essential in a work of art, understood and practised by all".

PROVENANCE

[?Sale, Paris, 13 January 1778 (Roettiers coll.), no. 20]
[?Sale, Paris, 30 November 1778 (Dulac and Lachaise coll.), no. 218]
[?Sale, Paris, 2 April 1794 (Godefroy coll.), no. 24]
Emile Vallet, Bordeaux, by 1882
[Sale, Paris, 25 January 1884 (Vallet coll.), no. 14, ill.]
acquired by Gaucher for F.F. 25,000 for Baron Alphonse de Rothschild
Baron Édouard de Rothschild
Thence by descent within the family

LITERATURE

R. Portalis, *Honoré Fragonard: Sa Vie, son oeuvre*, 2 vol., Paris, 1889, ill. as an engraving between pp. 280 and 281
P. de. Nolhac, *J.-H. Fragonard, 1732–1806*, Paris, 1906. p. 112
J. Wilhelm, "Fragonard eut-il un atelier?" *Médicine de France*, no. 25 1951, p. 26
L. Réau, *Fragonard*, Brussels, 1956, pp. 119, 182
G. Wildenstein, *The Paintings of Fragonard*, Aylesbury, 1960, p. 246, pl. 42, p. 16
C. Sterling, *Portrait of a Man (The Warrior), Jean-Honoré Fragonard: An Unknown Masterpiece by Fragonard,*

Williamstown, 1964, n.p., fig. 11

D. Wildenstein and G. Mandel., *L'Opera Completa di Fragonard*, Milan, 1972, p. 97, no. 263, ill.

J.-P. Cuzin, *Jean-Honoré Fragonard, Life and work*, New York, 1988, pp.102, 108, 113, 117, 120, 122 ill. fig 135, cat. no. 181

M. D. Sheriff, *Fragonard, Art and Eroticism*, Chicago, 1990, p. 183

EXHIBITED

Bordeaux, *Exposition de la Société Philomatique*, 1882, no. 2461

Paris, Grand Palais; New York, The Metropolitan Museum of Art, 1987–88, *Fragonard*, cat. by Pierre Rosenberg, pp. 255, 258, 286–7, ill. no. 138

ELIZABETH-LOUISE VIGÉE-LE BRUN
Paris 1755–1842 Paris

PLATE 15

Portrait of the Artist's Mother

Oil on canvas, oval
24½ × 20½ inches
62.5 × 52 centimeters

Lent by a private collector

Vigée-Le Brun recounts in her *Mémoires* that early in her career she painted three portraits of her mother: the first, in pastel, represented her as a sultana and is now lost; the second, a bust-length view of the sitter seen from behind, and formerly given to Watteau, was correctly identified by Joseph Baillio in 1982 ("Quelques peintures reattribuées a Vigée Le Brun", *Gazette des Beaux-Arts*, XCIX, January 1982, pp. 13–26), and is now known only from a photograph; and the present painting. Until it reappeared at auction in 1985, this portrait was believed to have been destroyed at the end of the 19th century and its composition was known through copies made for descendants of the painter's brother.

In her *Mémoires*, the artist includes the present portrait in a list of works painted between 1768 and 1772, almost certainly a slip of her memory, as both the style of the painting and the appearance of the sitter suggest a date closer to 1775–78, as has been suggested by Joseph Baillio. Vigée-Le Brun also painted a portrait of her younger brother, Étienne Vigée, dressed as a schoolboy, a painting now in the Saint Louis Art Museum: it is a charming but considerably less accomplished picture and must date from several years earlier than the portrait of the artist's mother.

It too is listed by Vigée-Le Brun as having been painted between 1768–1772, yet an examination of the canvas reveals that it is signed on the lower left and dated *1773*. It should be remembered that the painter's *Mémoires* were composed more than a half-century after these earliest works were painted and she was sometimes relying on memory in preparing the book.

The sitter, Jeanne Maissin (1728–1800), was a hairdresser and the daughter of a *marchand-laboureur* from Rossart in the province of Luxembourg. She married the portraitist Louis Vigée (1715–1767) in 1750 and the couple had two children, the painter and her brother Étienne (1758–1820), a playwrite and poet of some distinction. Jeanne remarried seven months after the death of Louis Vigée in 1767. Her second husband, Jacques-François Le Sèvre (1724–1810), was a goldsmith who moved the family to an apartment on rue Saint-Honoré facing the Palais Royal. Jeanne Maissin died on 9 April 1800 in Neuilly.

My thanks to Joseph Baillio for his assistance in preparing this entry.

PROVENANCE

Mme. Vigée-Le Brun; bequest to her niece,
Caroline de Rivière, *née* Vigée, 1842;
 by descent in the family through the second half of the 19th century
Comtesse de La Ferronnays, Paris
[Her sale, Paris, 1897, lot 18 (5800 ff)]
Private collection, France, until 1985
[Sale, Sotheby's, Monaco, 22 June 1985, lot 179]
[Stair Sainty Matthiesen, New York, until 1985]
Private collection, New York

LITERATURE

E. L. Vigée-Le Brun, *Souvenirs,* Paris, 1835–37; republished in 2 vols., ed. by Claudine Herrman, Paris, 1984, vol. 1, pp. 26 (note 3), 38; vol. 2, p. 331

P. de Nolhac, *Mme. Vigée-Le Brun*, Paris, 1908, p. 138

W. H. Helm., *Vigée-Le Brun: her life, works and friendships*, London, 915, p. 197

H. T. Douwes Dekker, *Mme. L.E. Vigée-Le Brun, catalogue des portraits en huile et pastel retrouvés*, Paris, 1978, no. 095

To be included in the forthcoming *catalogue raisonné* of Vigée-Le Brun's paintings being prepared by Joseph Baillio

Joseph Ducreux
Nancy 1735–1802 Paris

PLATE 16

Self Portrait

Oil on canvas
35½ × 28⅛ inches
74.2 × 61.6 centimeters

Lent by a private collector

Ducreux is today best known for his series of self portraits in which he explores physiognomy—the theory that facial expressions are a guide to the understanding of human personality. This was a topic of great interest in France during the *Ancien Régime*, sparked by the publication in 1775 of Johann Kaspar Lavater's famous *Physiognomische Fragmente*. . . . The mastery of drawing and painting heads showing various emotions was an important aspect of an artist's training in the 18th century. Ducreux made a specialty of these *têtes d'expression* using himself as the subject. He painted himself in diverse attitudes and expressions: yawning, laughing, surprised and, as here, mocking.

While in London (January–August 1791), Ducreux published a series of three self portrait etchings, each inscribed with the emotion depicted. These were quite popular in the city of Hogarth and Rowlandson. The prints were widely distributed and made their way to Paris where Ducreux's contemporaries were surprised at his departure from the society portraits for which he had been known. From 1791 to 1793 Ducreux exhibited many of his expressive self portraits at the Salon where they were not greatly successful. "His interest in physiognomy" writes J. Adhemar "marked Ducreux as a man of the *Ancien Régime*, the age of Rousseauean sensibility and enthusiasm, the age of popular theater and theatrical gesture." In this respect, Ducreux's works were inconsistent with the Davidian stoicism that marked the history paintings most popular during the revolutionary years.

There exist several versions of *Le Moqueur*, one of which is in the Louvre. G. Lyon, author of the only monograph on the artist, thinks that our painting is the one that Ducreux exhibited at the Salon of 1793, under the title *Un moqueur qui montre du doigt*. Although the dimensions do not exactly match those listed (the Salon *livret* indicates the dimensions as 3 *pieds* 2 *pouces* × 2 *pied* 1/2 *soit*, or about 100 × 81 centimeters) it is certainly conceivable that, in the years between the Salon exhibition and the appearance in 1874 of our painting at the Boittelle sale, it may have lost a few centimeters. A version of the composition appeared at the sale of Joseph Ducreux's own collection in 1865; the dimensions were not recorded. The present painting was, for many years, in the collection of M. Boittelle, a noted collector of French painting who was a prefect of police under the Empire; he was especially fond of Ducreux's works and owned many of them.

PROVENANCE

Possibly collection of the artist
[Paris, Hôtel Drôuot, 14–15 January 1865, lot 3 (sold for 290 francs)]
M. Boittelle
[His sale, Paris, Hôtel Drôuot, 2 April 1874, no. 15 (as *Portrait célèbre du peintre connu et gravé sous le nom de Moquer*)]
[M. Boittelle sale, Paris, Hôtel Drôuot, 13 March 1891, no. 7, (sold for 1,000 francs)]
[Anonymous sale, Paris, Hôtel Drôuot, 9 June 1909, no. 10, illustrated (bought M. Sortais for 20,000 francs)]
Yznaga del Valle, Paris by 1935
Costa de Beauregard, until 1989
[Colnaghi]

LITERATURE

C. Lyon, *Joseph Ducreux (1735–1802) Premier Peintre de Marie-Antoinette*, Paris, 1958, pp. 152, 172 and p. 273 note 6, (Catalogue of Self-Portraits no. 14)
C. Monnier, *Inventaire des Collections Publique Françaises: Pastels XVIIe et XVIIIe siècles, Musée du Louvre*, Paris, 1972, cited under no. 48

EXHIBITED

Paris, Salon, 1793, No. 240 as *Un moqueur qui montre du doigt* ('3 pieds, 2 pouces de haut sur 2 pieds, 1/2 de large')
Copenhagen, Palais de Charlottenborg, 1935, *Exposition de l'Art Français au XVIIIe Siècle*, no. 60
New York, Colnaghi, 1989, *1789: French Art During the Revolution*, no. 18

JEAN-BAPTISTE GREUZE
Tournus 1725–1805 Paris

PLATE 17

Louis-François Robin

Oil on panel
26 × 21¾ inches
67 × 55.3 centimeters

Colnaghi

Louis-François Robin (1756–1842) became Greuze's notary after the retirement of his former notary (and avid patron), Duclos-Dufresnoys in 1791. Robin assumed direction of Duclos-Dufresnoys's office on the rue Vivienne and ran it until his retirement in 1816. He would certainly have been well-acquainted with the contentious Greuze, who often had need of a notary's services in the 1790s, as he was involved in numerous legal wrangles—including a particularly nasty suit against his brother's wife, and his own divorce from the odious Mme. Greuze in August 1793. In a letter from Greuze to a M. Cavaignac, dated 25 March 1793, the artist is seen evidently trying to set up a meeting between Cavaignac and Robin.

The date on Greuze's letter to Cavaignac—1793—corresponds perfectly with the style of the painting, which is characteristic of Greuze's portraiture during the Revolution. Like many of his portraits from this period, it is painted on a walnut panel—a support he had rarely employed before the '90s. It is composed with the same restricted palette and soft-focus, brushy technique as his portrait of *Jean-Nicolas Billaud-Varenne* (Dallas Museum of Art), itself datable to 1793. Edgar Munhall's comments about the Billaud-Varenne portrait are equally applicable here: "The schema of the portrait is similar to other of Greuze's terse, bust-length portraits of the 1780s and 1790s. In many of these, as here, the artist exploited the advantages of a smooth panel support, that gives a translucency to the thinly painted or stippled areas of the background, flesh and wig, against which he played off the creamy impasto of the collar and bow."

Dr. Colin Bailey has kindly brought to our attention a similar portrait representing Duclos-Dufresnoys in a private French collection. Painted on a panel of identical dimensions to our picture, it depicts the notary sitting at his desk looking from left to right. The existence of a portrait of Robin's former partner suggests that the two were painted as pendants.

Munhall observed that the Robin portrait conforms to the 'inspiration' type widely employed in the later 18th century, notably by Fragonard in his celebrated 'figures de fantaisie.' Representing the sitter at his desk, quill in hand, poised in thought, is an appropriate formula for the depiction of a notary, a profession of considerable esteem and importance in the 18th century.

PROVENANCE

[Sale, Paris, Hôtel Drôuot, 29 February 1872, lot 6 (6,400 ff, "Portrait d'un homme de loi")
Robin family, and by descent until 1992]

LITERATURE

J. Martin and C. Masson, *Catalogue raisonné de l'oeuvre peint et dessiné de J.B. Greuze,* Paris, 1908, no. 1297 (as "Homme de loi")

EXHIBITIONS

Paris, Société philanthropique (held at the École des Beaux-Arts), *Portraits du Siècle,* 1885, no. 123 (as of an unknown sitter, lent by M. Robin)

ROBERT-JACQUES-FRANÇOIS-FAUST LEFÈVRE
Bayeux 1755–1830 Paris

PLATE 18

Woman with a Lyre

Oil on canvas
31¾ × 27¼ inches
78.7 x 69.3 centimeters
Signed and dated at centre left: *Rob.t Lefevre./fecit 1808*

Colnaghi

Lefèvre's contemporaries considered his portraiture equal to that of David and Gérard. Protected by Denon, Lefèvre was employed by Napoleon and his immediate family. Apsley House possesses a fine group of these imperial likenesses; they include those of the Emperor himself (1812), Josephine (1806), Joseph Bonaparte and Pauline Borghese (1806). During his diplomatic mission to Paris in 1805, Pius VII sat to both David and Lefèvre. After the Restoration, Lefèvre, untainted by the accusation of regicide, became First Painter to Louis XVIII.

The young sitter in this elegant portrait is fashionably dressed *à la grecque*. Her transparent white gown is draped with a cashmere shawl. This elegant accessory had been introduced to Europe from India by the English in the late eighteenth century. These shawls were both functional, being extremely warm, and chic because, according to *La Belle Assemblée* of 1808, they could be arranged on the figure "like the drapery of our Greek statues". They played an important part in Madame Récamier's famous "atti-

tudes," The sitter's hair, suitably antique and annointed with an *huile antique* to achieve the cedilla-like curls of front and side locks below the bandeau, was a style adopted by French ladies of fashion.

The lyre, attribute of the Muses of lyric poetry, dance and song, was another classical prop in vogue early in the nineteenth century. In 1808 Madame Vigée-Le Brun painted Madame de Staël with one as *Corinne* in the portrait in the Musée d'Art et d'Histoire, Geneva. By the 1820s, such posturing had gone out of style, and was open to ridicule, as indicated by Balzac's withering description of Madame de Bargeton in *Lost Illusions*. A caricature of Madame de Staël in the provinces, the lady in question never hesitated to pick up her lyre at the least occasion, holding forth to the astonished nobility of Angoulême. The lyre in the Colnaghi portrait probably alludes to the sitter's musical accomplishments because there is also a spinet in the background.

JEAN-AUGUSTE-DOMINIQUE INGRES
Montauban 1780–1867 Paris

PLATE 19

Caroline Murat

Oil on canvas
36¼ × 23⅝ inches
92 × 60 centimeters
Signed and dated at lower left: *Ingres P.* xit *Roma 1814*

Lent by a private collector

When Joachim Murat passed through Rome in 1808 on his way to take possession of the Kingdom of Naples, he bought a large painting of a nude woman, called *La Dormeuse de Naples*, from Ingres who at that time was a struggling pensioner of the French Academy. In 1814, Caroline Murat (1782–1839), Queen of Naples and Napoleon's most intelligent sister, commissioned Ingres to paint a companion (*La Grande Odalisque*, now in the Louvre) to be hung alongside the *Dormeuse* in the couple's private apartments in the Royal Palace, and a small full-length portrait of herself. At about the same time, Ingres also executed his first historical genre scenes—*The Betrothal of Raphael* (Baltimore, Walters Art Gallery) and *Paolo and Francesca* (Chantilly, Musée Condé)—for the queen.

Ingres went to Naples in February 1814 to work on this portrait. While there, he made a number of preparatory drawings, now in the Musée Ingres in Montauban, and sketches of various members of the Murat family for a small conversation piece. He returned to Rome in May to finish the portrait which did not meet with immediate success when sent to Naples. In a letter to his friend Mazois, an architect in the service of the Murats, he complained that he was now obliged to rework the face and hat for the third time, asking Mazois to bring the picture back with him to Rome. He also stated that because of this "*contretemps*" he had not as yet been paid for the pictures, and, as a result, had run out of money.

Whatever hopes Ingres had placed in the Murats were soon dashed by the rapid course of international events. On 23 May 1815, Caroline Murat was forced to seek refuge on board an English ship at anchor in the Bay of Naples after a popular uprising against the French, and on 13 October of the same year, Murat himself was executed in Calabria after an abortive attempt to regain his lost kingdom. As late as 1819, Ingres had still not been paid for the two pictures as an exchange of letters between de Mercey, the Parisian agent of the Countess of Lipona, as Caroline Murat now called herself, and August de Coussy, Murat's former secretary, testifies.

This portrait of *Caroline Murat*, along with the *Dormeuse*, disappeared from the Royal Palace after the return of the Bourbons in 1815. It was bought by Count Gropello in about 1850. The picture was published by Mario Praz (1964) as the work of an anonymous artist showing Maria Amelia di Borbone, daughter of Ferdinand IV of Naples and Maria Carolina of Austria, who married Louis Philippe, duc d'Orléans and future King of the French, in Palermo in 1809. Praz stated that she was in mourning for her mother who died in Vienna in 1814. In 1988 H. Naef recognized it as Ingres's lost portrait of Caroline Murat. Cleaning revealed the signature which had been hidden by dirt and a heavy coat of varnish.

Ingres portrayed Caroline Murat in the large window recess of her private audience chamber, giving onto a terrace with a magnificent view of the Gulf of Naples with Vesuvius and Sorrento in the distance. The reveals were lined with mirrors to reflect the movement of water and sky. The walls of the room itself were hung with silvery-white satin above a red dado. According to contemporaries, the draperies served to set off the queen's fresh coloring. The furnishings were an enchanting mixture of the luxurious knick-knacks of the period and rare antiquities. Correggio's *Ecce Homo* and *School of Love,* now in The National Gallery, London, were also displayed there.

PROVENANCE

Commissioned by Caroline Murat early in 1814
Bought c. 1850 by the Count of Gropello in
 Terlizzi in Puglia;
 thence by family descent
[Galerie Chauveau, Brussels by 1963]
Private Collection, Belgium
[Galerie D'Arenberg, Belgium, 1988]
Private collection

LITERATURE

A. Magimel, *Oeuvres de J.A.D. Ingres, gravées au trait sur acier par Achille Réveil, 1800–1851*, Paris, 1851, under no. 102

H. Delaborde, *Ingres, sa vie et ses travaux, sa doctrine, d'après les notes manuscrites et les lettres du maître*, Paris, 1870, no. 143

H. Lapauze, *Les dessins d'Ingres au Musée de Montauban*, Paris, 1901, I, pp. 235 & 248, notebook IX, folios 65–66 and notebook X, folios 22–27

H. Lapauze, *Le Roman d'amour de M. Ingres*, Paris, 1910, p. 267ff

H. Lapauze, *Ingres, sa vie et son oeuvre (1780–1867), s'après des documents inédits*, Paris, 1911, pp. 148, 150–52

G. Wildenstein, *The Paintings of J.A.D. Ingres*, London, 1954, p. 178, no. 90

M. Praz, *La filosofia dell'arredamento*, Milan, 1964, p. 195 ill.

R. Rosenblum, *J. A. D. Ingres*, London, 1967, p. 50

B. Radius & B. Camesasca, *L'opera completa di Ingres*, Milan, 1968, p. 95, no. 77

Rome, Villa Medici, 1968, *Ingres in Italia*, cat. by J. Foucart, p. XXI and no. 45

H. Naef, *Die Bildniszeichnungen von Ingres*, Berne, 1977, I, pp. 379–97

F. Nathan, *Ingres*, Milan, 1980, p. 177, no. 93

Tokyo, National Museum of Western Art; Osaka, National Art Museum, 1981, *Ingres*, no. 72

H. Naef, "Un chef-d'oeuvre retrouvé: Le portrait de la reine Caroline Murat", *Revue de l'Art*, V. 88, 1990, II, pp. 11–20

Rome, Villa Medici; Paris, Espace Electra, *Le Retour à Rome de Monsieur Ingres*, 1993, cat. by G. Vigne, no. 50

L. Bulit, "Nouvelles découvertes de documents sur Ingres et Murat", *Cavalier et Roi, bulletin des Amis du Musée Murat*, Bastide, January 1993, no. 24, pp. 8–10

G. Vigne, *Ingres*, London, 1995, p. 112, fig. 82, p. 332, transcription of Notebook X.

FRANÇOIS-PASCAL-SIMON, BARON GÉRARD
Rome 1770-1837 Paris

PLATE 20

Constance Ossolinska Lubienska

Oil on canvas
25¾ × 20⅝ inches
65.5 × 52.5 centimeters

Colnaghi

Constance Ossolinska (1782–1869) was the daughter of Joseph Gaetan Lemnau (1764–1834), Comte Ossolinski, the wealthy governor of Podlesie, who married Marianne Zalewska in 1781. In 1805, Constance married the son of the minister Feliks Lubienski Tomasz, and moved into the hôtel Bielinski-Lubienski in Warsaw. In 1806 Tomasz Lubienski joined Napoleon's armies as a guide and interpreter. While he was involved in the Spanish campaign, his wife, Constance, went to France to become lady-in-waiting to the Empress Josephine whom she accompanied to Strasbourg and Plombières in 1809. Their son, Napoleon, was born in Sedan in 1811, just before General Tomasz departed for the Russian campaign. On his return to Paris in 1813, Tomasz was made brigadier-general; he would resign from the army in June 1814 with the rank of maréchal de camp. In August 1814, the Lubienski family left for Poland and returned to their family mansion in Warsaw. General Tomasz became Polish Chief of Staff in 1831, having been named Senator of the Kingdom of Poland in 1829.

The portrait of Constance would appear to have been painted in Paris between August 1813 and August 1814, given the model's traveling costume and the wreath of flowers in her hair. There is a pentimento in the positioning of her left hand which brings to mind Gérard's *Portrait of Arthur Potoski* of 1819 (a copy is in the Warsaw museum).

PROVENANCE

Lubienski Collection, Warsaw
[Galerie Neupert, Zurich]
Baszanger Collection, Geneva, until April 1950
Private collection, France
[Sold, Christie's, London, April 21, 1989, lot 70]

LITERATURE

H. Gérard, *Oeuvre du Baron François Gérard*, vol. III, Paris, 1857-58

Baron Gérard (nephew of the artist), *Lettres adressées au Baron François Gérard...précédée d'une notice sur la Vie et les Oeuvres de François Gérard...*, 2nd ed., 1886, II, p.412

R. Lubienski, *General Tomasz Lubienski,* 1899, I, pp. 30–31

A. Ryszkiewcz, *Francusko-Polskie Zwiaski Artystyczne,* 1967, pp. 142–43 and fig. 62

EXHIBITED

New York, Colnaghi, *1789: French Art During the Revolution,* 1989, no. 33

MARIE-FRANÇOISE-CONSTANCE LA MARTINIÈRE, called CONSTANCE MAYER
Paris 1775–1821 Paris

PLATE 21

Sophie Fanny Lordon

Oil on canvas
23½ × 19¼ inches
60 × 49 centimeters
Signed and dated at lower left: M.*elle* Mayer/Pinxit 1820

Colnaghi

A pupil of Suvée and Greuze, Constance Mayer entered Prud'hon's studio in 1802. A close friendship developed between the two, lasting until Mayer's suicide in 1821. A constant artistic collaboration went hand in hand with their romantic attachment. Prud'hon provided drawings and sketches for her ambitious mythological and genre paintings, such as *The Sleep of Venus and Cupid* (1806) in The Wallace Collection, *The Happy Mother* (1811) and *The Abandoned Mother* (1810) in the Louvre.

According to J. Doin (1911), Mlle. Mayer, saddened by attacks on Prud'hon's art in the journals of the period, turned to portraiture, choosing her subjects from Prud'hon's intimate circle. Sophie Lordon's father, Pierre Jérôme, was a pupil and close friend of the artist. He exhibited in the Salon between 1806 and 1838, the year of his death. Sophie (b. 1804) married Auguste Duquerre in 1824. As was his habit, Prud'hon provided Mlle. Mayer with a preparatory study for this portrait. It was exhibited posthumously in the Salon of 1822.

PROVENANCE

By descent in the family of the sitter;
Madame Levasseur by 1911

LITERATURE

J. Doin, "Constance Mayer (1775–1821)", in *Revue de l'art ancien et moderne,* January 1911, p. 145, ill. on p. 143

EXHIBITED

Paris, Salon, 1822, no. 920

JACQUES-LOUIS DAVID
Paris 1748–1825 Brussels

PLATE 22

Ramel de Nogaret

Oil on canvas
23½ × 18½ inches
60.5 × 47.5 centimeters
Signed and dated at lower left: *L. DAVID/BRUX. 1820*

Lent by a private collector

After the restored Bourbon Monarchy passed a law banishing regicides, David went into exile. He tried to settle without success in Rome, and finally went to Brussels where he and his wife arrived on 27 January to be met later by a number of old friends. The new Kingdom of the Netherlands, comprising Holland and Belgium, showed such hospitality to the exiles that the French ambassador was recalled to Paris for a short time in 1817.

David continued to work on history paintings and portraits in Brussels. His sitters, of whom Ramel was a typical example, were mostly drawn from exiled regicides who, like himself, had rallied to the Emperor in 1814. David also painted a number of important local people, including the Vicomtesse Vilain XIIII, who had been lady-in-waiting to Empress Marie-Louise, and François-Antoine Rasse, prince de Gavre.

An able functionary of the Revolution, Dominique-Vincent Ramel de Nogaret was born at Montolieu in the Haut-Languedoc in 1760. He came from a rich middle-class family of textile manufacturers. In 1785 he became a royal attorney in Carcassone, and represented his region at the Estates-General in 1789. Ramel sat on the left in the Constituent Assembly. In June 1791 he was sent to Brittany to help sedate royalist disorder after the flight of the king from Paris. In the same year he became president of the Tribunal of Carcassonne, returning to Paris in May 1793 to take part in the Convention. Ramel voted for the death of Louis XVI on the condition that the sentence be ratified by popular vote, but then rejected any idea of a pardon for the king. Much of Ramel's time was spent trying to find a solution for the grave financial crisis which threatened the economic ruin of France. It was this silent work which helped him to ride out the Terror, although the Incorruptibles put him among "the aristocrats and cheats".

In 1795 Ramel was dispatched to Holland to bring order to the Army and consolidate the Revolution there. His proclamation to the Dutch people, inciting them to accept the glorious freedom offered by the French, was

issued on 19 March 1795. As a result, the goods of the "former Prince of Orange" were confiscated, a number of pictures sent to Paris, and Dutch Flanders signed away to France by the Batavian Republic. In 1796 Ramel was appointed Finance Minister. His major achievement was the reintroduction of financial stabilty with a currency based on gold and silver instead of the paper notes which had caused inflationary havoc during the preceding years. However, some of his measures caused the ruin of those who had invested in the public debt and led to the accumulation of wealth by speculators. Accusations that he had enriched himself and directed the nation's finances as "one would write a novel" induced Ramel to resign in July 1799. Dispassionate modern opinion judges him to have been one of the best Finance Ministers in modern France.

Ramel did not take part in public affairs under the Empire. He did, however, accept the office of prefect of Calvados during the Hundred Days. As a result, he too retreated to Brussels where he renewed his old friendship with David. When the artist died and the French government refused to allow him to be buried in France, it was Ramel who helped David's family acquire a plot in a Brussels cemetary, and gave the funeral address.

PROVENANCE

By descent in the family of the sitter, until 1995

LITERATURE

Notice sur la vie et les ouvrages de M. J.-L. David, Paris, 1824, p. 67

A. Mahul, *Annuaire nécrologique, ou complément annuel et continuation de toutes les biographies, ou dictionnaires historiques...*, Année 1825, Paris, 1826, no. XLI, p. 141

Th. A., *Vie de David, Premier Peintre de Napoleon*, Brussels, 1826, pp. 212 and 242, Paris edition, 1826, p. 166

P. A. Coupin, *Essai sur J.-L. David, peintre d'histoire, ancien membre de l'Institut, officier de la Légion d'honneur*, Paris, 1827, p. 57

E. J. Delécluze, *Louis David, son école et son temps. Souvenirs*, Paris, 1855, p. 368

J. L. J. David, *Le peintre Louis David, 1748–1825*, Paris, 1880, I, P. 650

Ch. Saunier, *Louis David. Biographie critique*, Paris, 1904, p. 119

Ch. Saunier, "David et son école aux Palais des Beaux-Arts de la Ville de Paris (Petit Palais)", in *Gazette des Beaux-Arts*, May 1913, p. 279

Kl. Holma, *David, son évolution et son style*, Paris, 1940, no. 156

A. Schnapper, *David témoin de son temps*, Fribourg, 1980, p. 288

A. Schnapper, *David*, New York, 1982, pp. 286–87

Paris, Musée du Louvre and Versailles, Musée National du Château, 1989, *Jacques-Louis David, 1748–1825*, cat. by A. Schnapper, pp. 513–14.

EXHIBITED

Paris, Ecole des Beaux-Arts, *...deuxième exposition de Portraits du siècle au profit de la société Philanthropique*, 1885, no. 64

Paris, Palais des Beaux-Arts [Petit Palais], *David et ses élèves*, 1913, no. 64

Château de Sceaux and then Brussels, Palais des Beaux-Arts, *Ile-de-France-Brabant*, 1962, no. 180, ill.

LOUIS-LÉOPOLD BOILLY
La Bassée 1761–1845 Paris

PLATE 23

Madame Vincent

Oil on canvas

16½ × 13 inches

42 × 33 centimeters

Signed and dated: *1820*. Inscribed on the stretcher: *Mme Vincent amie de Boilly*

Colnaghi

Although Boilly is today prized for his remarkable genre scenes painted in *le goût hollandais*, he also specialized in *trompe l'oeil* and portraiture. It was the latter that paid the bills and formed the basis of the artist's career. He is said to have painted over 4,500 portraits and Boilly himself claimed that he could paint a small bust-length portrait in two hours. From the start of his career, around 1778, until the turn of the century, Boilly only rarely painted portraits in a format other than bust-length on a canvas measuring 8⅝ × 6⅝ inches, many hundreds of examples of which are known today. It is the rare three-quarter length (*Lucille Desmoulins*, 1791; Paris, Musée Marmottan) or full-length portrait (*Robespierre*, c. 1789; Lille, Musée des Beaux-Arts,) which proves the exception.

Around 1800, however, Boilly began to vary his portrait format. While continuing to paint the small-scale busts, he introduced larger full and three-quarter length portraits in which he placed his sitters, for the first time, in landscape settings. *The Portrait of Antoine-Thomas-Laurent Goupil* (location unknown), the famous group *Portrait of the Christophe Philippe Oberkampf Family before the Joüy Factory* (Private Collection), and the beautiful pair of an unknown man and woman in the Musée des Beaux-Arts, Lille, are all examples of this new type.

Our *Madame Vincent* joins this group. Besides the format and setting, new too is the porcelain finish and the crisp drawing. Great attention is paid to small details of jewelry, costume, tailoring and to the accessories which mark social rank. Our *Madame Vincent* is depicted in all the

nervous refinement expected of an upper bourgeoise of the early Romantic era.

Harisse, in his *catalogue raisonné,* calls our portrait simply "Jeune Femme", and the identity of the sitter continues to resist identification despite the tantalizing inscription on the stretcher which reads *Mme. Vincent amie de Boilly.* A collector named Vincent, about whom little is today known, owned a significant number of Boilly's paintings, and these were dispersed at his sale on 24 January 1877. Unfortunately, no picture matching the description of our portrait appears to have been in his collection, and nothing is known of his wife. Could our *Madame Vincent* be she?

PROVENANCE

M. Kinen, Paris (as of 1898)
André Veil, Paris
René Fribourg, New York
[René Fribourg collections sale, Part II, Sotheby's, London, June 26, 1963, lot 71B]
Dr. J. Singer (1963–64)
Private collection, until 1989

LITERATURE

Henry Harisse, *L.L Boilly, Peintre, Dessinateur et Lithiographe—sa Vie et son Oeuvre,* Paris, 1898, cat. no. 83

EUGÈNE DELACROIX
Charenton-Saint-Maurice 1798–1863 Paris

PLATE 24

Doctor François-Marie Desmaisons

Oil on canvas
26½ × 21¼ inches
65 × 54 centimeters

Colnaghi

Moreau was the first to identify the sitter in the 'Portrait de M.D.. . ' that was exhibited at the Salon of 1833 as Dr. Desmaisons, and to date it to 1832, but published no further particulars. Robaut gave the Doctor's initial as L. (wrongly, it seems), adding that Desmaisons was not only Delacroix's physician but had been his friend since 1814. He also illustrated his entry for this portrait, which he had never seen, with a small engraving based on a copy done about 1853 by A. Revenaz. The original portrait did not come to light until 1967, and was published in 1970 by L. Johnson who held, on the basis of the genealogy of the former owner, that the sitter can only have been François-Marie Desmaisons, Doctor of Medicine, who was born at Chambery, Savoy, on 19 July 1804 and died in Paris on 21 July 1856. Since both his parents died at Chambery and their three children were born there, it seems unlikely that he was a close friend of Delacroix's by 1814, as stated by Robaut. That he was a friend by 1830 is, however, certain because in December of that year Delacroix celebrated the Feast of Saint Nicholas in his Paris home (letter dated 6 December 1830).

Unlike the other portraits Delacroix exhibited at the 1833 Salon, the sitter is shown in the open air, placed against a cloudy sky that is charged with a Lawrence-like atmosphere; Delacroix also used that artist's subtly blended flesh tints. This placing, combined with a low horizon, imparts an air of detached observation and a certain *hauteur* to the Doctor. The right hand, with thumb tucked into the armhole of the waistcoat, invests him with a further note of confident authority, while also breaking up the dark mass of the suit by introducing light tones of flesh and white linen. The expression on the face seems at once penetrating, compassionate, ironical and slightly disenchanted.

PROVENANCE

Possibly in possession of the sitter from 1832–33 until his death without issue in 1856 (alternatively, he may have given it to his mother, recovering it after her death on 19 June 1852);
thence by descent to his brother, Baron Jean-Jacques-Pierre Desmaisons, his sole heir who died without issue at Aix-les-Bains in 1873;
thence by family descent to his nephew, Charles Reymond, Turin;
thence by descent Maria Buffa di Perrero, Turin, Charles Reymond's granddaughter
[Galerie Heim, Paris]
Private collection, America

LITERATURE

T. Gautier, 'Salon de 1833', in *France littéraire,* VI, 1833, p. 151
C. Laviron and B. Galbaccio, *Le Salon de 1833,* Paris, 1833, pp. 98f
A. Moreau, *E. Delacroix et son oeuvre,* Paris, 1873, pp. 173 and 234
A. Robaut, *L'Oeuvre complet de Eugène Delacroix,* Paris, 1885, p. 103, no. 375
A. Joubin, ed., *Correspondance générale d'Eugène Delacroix,* Paris, 1935–38, I, p. 364, n. 1, V, p. 171, n. 1
L. Johnson, "Delacroix et les Salons/Documents inédits en Louvre" *Revue du Louvre,* XVI, 1966, pp. 221 and 229, n. 14
L. Johnson, "Four Rediscovered Portraits by Delacroix", *The Burlington Magazine,* CXII, 802, January 1970, pp. 8f, fig. 7
L. Johnson, *The Paintings of Eugène Delacroix,* Oxford, 1986, III, p. 37, no. 218, IV, pl. 39

EXHIBITED

Paris, Salon, 1837, no. 634, as "*Portrait de M D.*"

GUSTAVE COURBET
Ornans 1819–1877 Tour de Peitz

PLATE 25

Portrait of the Artist's Father

Oil on canvas:
28¾ × 23⅜ inches
73 × 59.5 centimeters
Stamped lower left: *Atelier Gustave Courbet*
Stretcher bears wax seal: *Atelier Gustave Courbet*

Régis Courbet (1798–1882) was a wealthy landowner with an independent, if somewhat eccentric, turn-of-mind. He pursued countless ideas and inventions which proved of little pratical use, a typical example being a five-wheeled carriage. Francis Wey wrote that "the head of the Courbet family . . . was a handsome man, but exceptionally and ostentatiously foolish". Courbet painted a second portrait of his father at the age of seventy-six. Régis Courbet also figures in a number of his son's most ambitious compositions, such as *After Dinner at Ornans* (Lille, Musée des Beaux-Arts), *Funeral at Ornans* (Louvre), *Peasants of Flagey* (Besançon, Musée des Beaux-Arts) and *Returning Huntsmen* (Ornans, Musée Gustave Courbet). A watercolor portrait of Régis Courbet, datable to c. 1848, is in the Reeves Collection, Dallas Museum of Art.

For many years, this portrait of *Régis Courbet* was thought to date from 1844 because of a mis-reading of Riat's list of portraits painted in that year. This mentions "A Belgian baron" and "His Father". The latter refers, however, to the baron's father and not Courbet's. This is confirmed by a letter in the Bibliothèque Nationale, Paris, in which Courbet informed his parents that he had recently painted likenesses of a Belgian baron who was a major in the cavalry and his father. It is more likely that this picture was executed in about 1840 because it can still be placed within the classical tradition of portraiture. The sober composition, bare background and the sitter's self-conscious pose look back to David and Ingres, while the unflinching realism of the actual image points the way to Courbet's future as an artist.

PROVENANCE

Juliette Courbet (1831–1915), Paris
By family descent to Mmes de Tastes and Lapierre
[Sale, Atelier Gustave Courbet, Paris, 19 July 1919, bt.
 M. Bernheim Jr., FF. 8,000]
[Galerie Durand-Ruel, Paris]
Georges René Laederich, Boulogne sur Seine
Private collection

LITERATURE

C. Riat, *Gustave Courbet Peintre*, Paris, 1906, p. 34
A Fontainas & L. Vauxcelles, *Histoire générale de l'Art français de la Revolution à nos Jours*, Paris, 1922, ill. p. 95
G. Kahn, *L'Art et les Artistes*, no. 80, October 1927, ill. p. 12
C. Leger, *Courbet*, Paris, 1929, ill. p. 12
C. Leger, *Courbet*, Paris, 1948, ill. p. 194
G. Mack, *Gustave Courbet*, New York, p. 33, plate 1
A. Chamson, *Gustave Courbet*, Paris, 199, color plate 19
R. Fernier, *Gustave Courbet, Peintre de l'Art vivant*, Paris, 1969, no. 8, ill. on p. 19
R. Fernier, *La vie et l'oeuvre de Gustave Courbet*, Geneva, 1977, I, p. 30, no. 50, ill. p. 31
G. Boudaille, *Gustave Courbet*, Paris, 1981, no. 21, ill. p. 31
J. J. Fernier, *Courbet et Ornans*, Paris, 1989, ill. p. 51

EXHIBITED

Paris, Galerie Bernheim Jeune, *Courbet*, 1919, no. 22
Paris, Musée Carnavalet, *Chefs-d'oeuvre des collections parisiennes*, 1952-53, no. 19
London, Marlborough Gallery, *Gustave Courbet*, 1953, no. 2
Venice, XXVIIª Biennale, *Courbet*, 1954, no. 2
Lyon, Palais Saint-Pierre, *Gustave Courbet*, 1954, no. 2
Paris, Petit Palais, *Gustave Courbet*, 1955, no. 7
Philadelphia Museum of Art, *Gustave Courbet 1817–1877*, 1959–60, no. 4
Ornans, Hôtel de Ville, *Gustave Courbet*, 1962, no. 4
Berne, Kunstmuseum, *Gustave Courbet*, 1962, no. 3
Paris, Galerie Claude Aubry, *Courbet dans les collections privées françaises*, 1966, no. 3
Rome, Académie de France, *Gustave Courbet*, 1969–70, no. 1
Paris, Galerie Daber, *Courbet 1819–1877*, 1975, no. 1
Paris, Grand Palais, *Courbet*, 1977–78, no. 1,

LOUIS-EDOUARD DUBUFE
Paris 1819–1883 Versailles

PLATE 26

Portrait of Two Sisters

Oil on canvas
58½ × 44⅝ inches
149 × 114 centimeters
Signed at lower right: *Edouard Dubufe*

Colnaghi

Edouard Dubufe was the second representative of an artistic dynasty which spanned the nineteenth and early years twentieth centuries. E. Delécluze in *Les Beaux-Arts en 1855* wrote: "the empire of the portrait is divided between M. Edouard Dubufe and M. Winterhalter, two

men of talent. The latter, whose brush is quick and lively, goes straight to heart of the matter and obeys the dictates of fashion without flinching. The crinoline, the bustle, and even the pannier which threatens the rest of us, do not frighten him or cause him a moment's hesitation. For his part, the wise M. Edouard Dubufe dissimulates the more exaggerated forms of dress, and gives his pretty sitters the likeness which they desire. In fact, he has taken up society portraiture with remarkable skill . . . Edouard Dubufe is in vogue and deserves his success." F. Bac in *La cour des Tuileries sous le Second Empire* gives a more caustic view of the rivalry between Winterhalter and Dubufe: "Literally overwhelmed, Wintherhalter can not satisfy the demand for his work, and is forced to ask his clients to wait for three years. When informed of this delay, the ladies exclaim with considerable good sense, 'Three years! Good heavens, whatever shall we look like then! We really can not wait that long!' So, with death in their hearts, they run as one to M. Dubufe's studio, knowing full well they will not get the same treatment. He flatters with other means, but flatters nevertheless. Thus, M. Dubufe acquires more clients."

This *Portrait of Two Sisters* is a charming example of keepsake art, and must, therefore, have been executed around 1840. This date is confirmed by the costumes of the young girls.

LITERATURE

E. Bréon, ed., *Claude-Marie, Edouard et Guillaume Dubufe/Portraits d'un siècle d'élégance parisienne*, Paris, nd., ill. p. 115

CLAUDE MONET
Paris 1840–1929 Giverny

PLATE 27

Johan Barthold Jongkind

Oil on canvas
17½ × 13½ inches
45 × 34 centimeters

Lent by a private collector

Monet first met Jongkind (1819–1891), the Dutch marine and landscape painter who worked in France for forty years, in the autumn of 1862 in his native Normandy. Years later, Monet would recount that one day he stopped to sketch a cow in a field near Caux. The animal, however, kept moving about, and the artist was forced to keep pace with it. A giant of a man who witnessed the comic scene tried to stop the cow at the risk of being blinded by its horns. The man turned out to be an English enthusiast of things French and a friend of Jongkind whose art he admired. He invited Monet to join them for lunch the following Sunday at a country inn. Mme. Lecadre, Monet's aunt, furnished a different version of meeting between the two artists. In a letter of 30 October 1862 to Amand Gautier, she wrote that her nephew had made Jongkind's acquaintance while sketching on the Normandy coast, and that the older man had offered Monet advice on his *plein-air* technique. Monet later recalled that Jongkind made as many as fifteen or twenty watercolor studies a day, using the most promising for finsihed oil paintings which the younger man did not particularly admire. In fact, Monet had written to Boudin in February 1860 with youthful insouciance: "Our only good seascape painter, Jongkind, is dead as an artist; he is completely mad . . ." However, this harsh judgement did not prevent Monet from using Jongkind's pictures of this period as a basis for his own early compositions, such as the *Headland of the Hève River at Low Tide* (1865) in the Kimbell Art Museum, Fort Worth.

Boudin and Jongkind joined Monet at Honfleur in July 1864. It was an idyllic summer. Monet wrote to Bazille: "Boudin and Jongkind are here; we are getting on marvelously. I regret very much that you aren't here, because in such company there's a lot to be learned and nature begins to grow beautiful; things are turning yellow, grow more varied; altogether it's wonderful..." Jongkind and Monet continued to work together throughout September. It is, therefore, likely that he painted this rapid sketch-like portrait of his friend at this time.

This portrait of *Johan Barthold Jongkind* is related to a series of small likenesses of relatives and friends which date to this moment in the artist's career. They include the portrait of *Dr. Lanclanché* in The Metropolitan Museum of Art, New York, and *A Standing Man* in a private collection. In stylistic terms, they represent an early reaction by Monet to Manet whose pictures he had seen in March 1863 at the Martinet Gallery in Paris.

PROVENANCE

Michel Monet, Giverny
[Wildenstein and Co., London]
[F. and P. Nathan, Zurich, 1967]
Private collection

LITERATURE

C. M. Mount, "A Monet Portrait of Jongkind", *The Art Quarterly*, Winter 1958, pp. 382–89, figs. 1 and 2

D. Wildenstein, *Claude Monet*, Lausanne/Paris, 1974, no. 44, p. 136, ill.

EXHIBITED

Recklinghausen, Kunsthalle, *Verkannte Kunst*, 1957

Selected Bibliography

The following works were consulted by the author in writing the introductory essay. Catalogue entries contain full bibliographic citations.

BOOKS AND ARTICLES

A. Ananoff and D. Wildenstein, *François Boucher*, Paris, 1976

C. Baudelaire, *Selected Writings on Art and Literature*, London, 1972. English translation by P.E. Charvet

F. Beaucour, Y. Laissus and C. Orgogozo. *The Discovery of Egypt*, Paris, 1990

J. Belleudy, *J. S. Duplessis*, Chartres, 1913

A. Besnard and G. Wildenstein, *La Tour*, Paris, 1928

A. Blunt, *Art and Architecture in France, 1500 to 1700*, London, 1953, 4th ed. 1981

A. Blunt, *Nicolas Poussin,* The A.W. Mellon Lectures in the Fine Arts, Washington, and London, 1967, 2 vol.

A. Blunt, *The Paintings of Nicolas Poussin. A Critical catalogue*, London, 1966

B. Brejon de Lavergnée, 'Some new pastels by Simon Vouet: portraits of the court of Louis XIII', *The Burlington Magazine*, 1982, pp. 689-93

A. Brookner, *Greuze: The Rise and Fall of an Eighteenth-Century Phenomenon*, London, 1972

A. Brookner, *David*, London, 1980

G. Brunel, *Boucher*, Paris, 1986

A. Bury, *Maurice-Quentin de la Tour*, London, 1971

J .Cayeux, *Hubert Robert*, Paris, 1989

A. Châtelet, and J. Thuillier, *French Painting from Fouquet to Poussin*, Geneva, 1963

C. Colomer, *Hyacinthe Rigaud, 1659–1743*, Perpignan, 1973

P. Conisbee, *Painting in Eighteenth-Century France*, London, 1981

P. Conisbee, *Chardin*, Oxford, 1986

W.R. Crelly, *The Paintings of Simon Vouet*, New Haven and London, 1962

T. E. Crow, *Painters and Public Life in Eighteenth-Century Paris*, New Haven and London, 1985

J.P. Cuzin, *Fragonard, Life and Work* New York, 1988.

E. Dacier, *Gabriel de Saint-Aubin, peintre, dessinateur et graveur*, Paris, 1929-31

A.-J. Dézallier D'Argenville, *Abrégé de la vie des plus fameux peintres*, Paris 1745–52

D. Diderot, *Diderot an Art—I, II*, New Haven and London, 1995, English translation by John Goodman

L. Dimier, *Histoire de la peinture française du retour de Vouet à la mort de Le Brun (1627 à 1690)*, Paris and Brussels, 1926–1927, 2 vol.

L. Dimier, ed., *Les Peintres Français du XVIII siècle*, Paris, 1928–30.

A. Doria, *Louis Tocqué*, Paris, 1929

B. Dorival, *Philippe de Champaigne, 1602 - 1674: la vie, l'œuvre et le catalogue raisonné de l'œuvre*, Paris, 1976, 2 vol.

L. Dumont-Wilden, *Le Portrait en France*, Brussels, 1909

L. Eitner, *Géricault, His Life and Work*, London, 1983

R. Fermier, *La vie et l'œuvre de Gustave Courbet: Catalogue raisonné*, 2 vols., Lausanne, 1977

The Fine Arts Museums of San Francisco, *French Paintings 1500–1825*, San Francisco, 1987. Cat. by Pierre Rosenberg and Marian C. Stewart

A. Fourreau, *Les Clouets*, Paris, 1929

C. Gabillot, *Hubert Robert et son temps*, Paris, 1895

C. Gabillot, *Alexis Grimou*, Paris, 1911

M. Gareau, *Charles Le Brun, First Painter to King Louis XIV*, New York, 1992

E. and J. de Goncourt, *French Eighteenth-Century Painters*, London, 1948. English translation by Robin Ironside. First published in Paris in 3 vols. in 1880-4

R.L. Herbert, *David: Brutus*, New York, 1972

L. Johnson, *The Paintings of Eugene Delacroix, A Critical Catalogue*, 6 vols. Oxford, 1981–89

G. de Lastic, 'Propos sur Nicolas de Largilière. En marge d'une exposition', *Revue de l'Art*, no 61, 1983, pp. 73-82

T. Lefrançois, *Charles Coypel 1694–1752*, Paris, 1994

M. Levey, *Painting and Sculpture in France 1700–1789*, New Haven and London, 1993

G. Levitine, *Girodet-Trioson: An Iconographical Study*, New York, 1978

G. Lyon, *Joseph Ducreux*, Paris, 1958

P.J. Mariette, *Abécédario de P.J. Mariette*, ed. P. de Chennevières, and A. de Montaiglon, Paris, 1851–60

J. Matthey, *Antoine Watteau, peintures réapparues*, Paris, 1959

P. Mellen, *Jean Clouet, Complete Catalogue of the Drawings, Miniatures and Paintings*, London, 1971

A. Mérot, *Eustache Le Sueur (1616–1655)*, Paris, 1987

A. Mérot, *Poussin*, London, 1990

A. Mérot, *French Painting in the Seventeenth Century*, New Haven and London, 1995

J. Montagu, *The Expression of the Passions: the Origin and Influence of Charles Le Brun's 'Conference sur L'expression générale et particulière'*, New Haven and London, 1994

C. M. Mount, "A Monet Portrait of Jongkind", *The Art Quarterly*, Winter 1958

L. Nikolenko, *Pierre Mignard, the portrait painter of the Grand Siècle*, Munich, 1983

P. Nolhac, *Nattier*, Paris, 1925

R. de Piles, *Cours de peinture par principes*, Paris, 1708, Edited by J. Thuillier, Paris, 1989

D. Posner, *Antoine Watteau*, London, 1984

A. Potiquet, *Jean-Baptiste Santerre*, Paris, 1876

T. Puttfarken, *Roger de Piles' Theory of Art*, New Haven and London, 1985

L. Réau, *Historie de la peinture française au XVIIIe siècle*, Paris and Brussels, 1925–26

A. Ribiero, *The Art of Dress: fashion in England and France 1750 to 1820*, New Haven and London, 1995

W. Roberts, *Jacques-Louis David, Revolutionary Artist*, Chapel Hill, 1989

M. Roland Michel, *Watteau, An Artist of the Eighteenth Century*, London, 1984

J. Roman, *Le Livre de raison du peintre Hyacinthe Rigaud*, Paris, 1919

R. Rosenblum, *Ingres*, New York, 1967

R. Rosenblum and H.W. Janson, *19th-Century Art*, New York, 1984

A. Schnapper, *David*, New York, 1982

A. Schnapper and E. Bouyé, *Jacques-Louis David, Portrait of Ramel*, Paris (Maître Binoche auction catalogue), 18 October 1995

M.D. Sheriff, *Fragonard, Art and Eroticism*, Chicago, 1990

S.L. Siegfried, *The Art of Louis-Léopold Boilly*, New Haven and London, 1995

C. Sterling and H. Adhémar, *Musée national du Louvre, Peintures. École française, XIVe, XVe et XVIe siècles*, Paris, 1965

J. Thuillier and A. Châtelet, *French Painting: From Le Nain to Fragonard*, Geneva, 1964

J. Thompson, "Jean-Baptiste Greuze", *The Metropolitan Museum of Art Bulletin*, Winter 1989/90

L. Vaillet and R. Ratouis de Limay, *J.B. Perronneau, sa vie et son œuvre*, Paris, 1923

E.-L. Vigée-Le Brun, *The Memoirs of Elizabeth Vigée-Le Brun*, Bloomington, 1989. English translation by Siân Evans. First published in Paris in 3 vols in 1835-7

G. Vigne, *Ingres*, New York, 1995

D. Wakefield, *French Eighteenth Century Painting*, London, 1984

The Wallace Collection, *Catalogue of Pictures III, French Before 1815*, London, 1989, cat. by John Ingamells

D. Wildenstein, *Claude Monet, Vie et Œuvre*, Lausanne, 1974

G. Wildenstein, *Le Peintre Aved*, Paris, 1922

G. Wildenstein, *The Paintings of Ingres*, New York, 1954

C. Wright, *The French Painters of the Seventeenth Century*, Boston, 1985

The Wrightsman Collection, *Volume V, Paintings and Drawings*, New York, 1973, cat. by Everett Fahy and Francis Watson

EXHIBITIONS

1963
Versailles, Musée national du château. *Charles Le Brun (1619–1690) peintre et dessinateur.* Cat. by Jennifer Montagu and Jacques Thuillier.

1968
London, Royal Academy of Art. *France in the Eighteenth Century.* Cat. by Denys Sutton.

1974
Paris, Hôtel de la Monnaie. *Louis XV: un moment de perfection de l'art français.*

1974–75
Paris, Grand Palais; Detroit Institute of Arts; New York, The Metropolitan Museum of Art. *French Painting 1774–1830: The Age of Revolution.* Cat. by Frederick J. Cummings, Antoine Schnapper and Robert Rosenblum.

1975–76
Toledo Museum of Art; Art Institute of Chicago; Ottawa, The National Gallery of Canada. *The Age of Louis XV: French Painting 1710–1774.* Cat. by Pierre Rosenberg.

1976–77
Hartford, Wadsworth Atheneum; San Francisco, Palace of Legion of Honor; Dijon, Musée des Beaux Arts. *Jean-Baptiste Greuze 1725–1805.* Cat. by Edgar Munhall.

1978
London, Royal Academy of Art. *Gustave Courbet: 1819-1877.* Cat. by Hélène Toussaint, et. al.

1979
Paris, Grand Palais; The Cleveland Museum of Art; Boston, Museum of Fine Arts. *Chardin 1699-1779.* Cat. by Pierre Rosenberg.

1982
Fort Worth, Kimbell Art Museum. *Elizabeth Louise Vigée Le Brun.* Cat. by Joseph Baillio.

1982
Montreal Museum of Art. *Largillierre and the Eighteenth-Century Portrait.* Cat. by Myra N. Rosenfeld.

1982
Paris, Grand Palais; New York, The Metropolitan Museum of Art; The Art Institute of Chicago. *France in the Golden Age.* Cat. by Pierre Rosenberg.

1983
Atlanta, The High Museum of Art. *The Rococo Age.* Cat. by Eric M. Zafran.

1984–85
Baltimore Museum of Art; Boston, Museum of Fine Arts; Minneapolis Institute of Arts. *Regency to Empire: French Printmaking 1715–1814.* Cat. ed. by Victor I. Carlson and John W. Ittman.

1985
Washington, D.C., National Gallery of Art; Paris, Grand Palais; Berlin, Schloss Charlottenburg. *Watteau 1684–1721.* Cat. by Margaret Morgan Grasselli and Pierre Rosenberg.

1985
Paris, Hôtel de la Monnaie. *Diderot et l'art de Boucher à David, Les Salons: 1759–1781.* Cat. ed. by Marie-Catherine Sahut and Natalie Volle.

1985
New York, The Frick Collection. *Ingres and the Countesse d'Haussonville.* Cat. by Edgar Munhall.

1985–86
New York, Stair Sainty Matthiesen; New Orleans Museum of Art; Columbus Museum of Art. *The First Painters of the King. French Royal Taste from Louis XIV to the Revolution.* Cat. by Colin B. Bailey.

1986–87
New York, The Metropolitan Museum of Art; Detroit Institute of Arts; Paris, Grand Palais. *François Boucher 1703–1770.* Cat. by Alastair Laing.

1986–87
Houston, Museum of Fine Arts. *A Magic Mirror: The Portrait in France 1700-1900.* Cat. by George T.M. Shackelford and Mary Tavener Holmes.

1987
New York, Stair Sainty Matthiesen. *François Boucher: His Circle and Influence.* Cat. by Guy S. Sainty and Alan Wintermute.

1987
Paris, Musée du Luxembourg; Rome, Villa Medici. *Subleyras 1699–1749.* Cat. by Olivier Michel and Pierre Rosenberg.

1987–88
Paris, Grand Palais; New York, The Metropolitan Museum of Art. *Fragonard.* Cat. by Pierre Rosenberg.

1988
Paris. *Claude-Marie, Edouard et Guillaume Dubufe. Portraits d'un siècle d'élègance parisienne.* Cat. ed. by E. Bréon.

1989
New York, Wildenstein and Co. *The Winds of Revolution.* Cat. by Joseph Baillio.

1989
New York, Colnaghi. *1789: French Art During the Revolution.* Cat. ed. by Alan Wintermute.

1989
Musée de Valence. *Hubert Robert et la Révolution.* Cat. by Catherine Boulot, Jean de Cayeux and Hélène Moulin.

1989–90
Paris, Musée du Louvre and Versailles, Musée national du château. *Jacques-Louis David 1748–1825.* Cat. by Antoine Schnapper and Arlette Sérullaz.

1990
New York, Colnaghi. *Claude to Corot: The Development of Landscape Painting in France.* Cat. ed. by Alan Wintermute.

1990–91
Paris, Grand Palais. *Vouet.* Cat. by Jacques Thuillier.

1990–91
London, Dulwich Picture Gallery. *Courage and Cruelty.* Cat. by Jennifer Montagu and Nicola Kalensky.

1991
New York, The Frick Collection. *Nicolas Lancret 1690–1743.* Cat. by Mary Tavener Holmes.

1991–92
Paris, Grand Palais. *Géricault.* Cat. by Sylvain Laveissière and Régis Michel.

1992–93
Paris, Grand Palais; Philadelphia Museum of Art; Fort Worth, Kimbell Art Museum. *Loves of the Gods.* Cat. by Colin B. Bailey.

1993
Montreal Museum of Fine Arts; Rennes, Musée des Beaux-Arts; Montpellier, Musée Fabre. *Century of Splendour.* Cat. by Michel Hilaire, Jean Aubert and Patrick Ramade.

1994–95
Paris, Grand Palais; New York, The Metropolitan Museum of Art. *Origins of Impressionism.* Cat. by Gary Tinterow and Henri Loyrette.

1994–95
Zurich, Kunsthaus; Tübingen, Kunsthalle. *Degas Portraits.* Felix Bainmann and Marianne Karabelnik, eds.

1994–95
Paris, Grand Palais. *Nicolas Poussin 1594–1665.* Cat. by Pierre Rosenberg and Louis-Antoine Prat.

1995
London, Royal Academy of Art. *Nicolas Poussin 1594–1665.* Cat. by Richard Verdi.

1995
Musée national des Granges de Port-Royal. *Philippe de Champaigne et Port-Royal.* Cat. by Claude Lesné and Philippe Le Lezour.

Index

Figures are shown in italics

Adam, Lambert-Sigisbert 44
Albani, Francesco 25
Alquier, Baron 74
Angiviller, Charles-Claude de Flahaut de la Billarderie, Compte d' 50
Argenville, Dézallier d' 16, 90, 91, *29*
Arnauld, mère Catherine-Agnès 24, *15*
D'Artois, Comte 50
Augustus of Saxony, Frederick 60, *42*
Autreau, Jacques 34, 90, PLATE 7
Aved, Jacques-André-Joseph 40, 56, *27*
Balzac, Honoré 102
Barry, Madame du 50
Barbarini, Cardinal 18, 19
Batoni, Pompeo 44, 46
Baudelaire, Charles 84
Bazille, Frederick 84
Beaubrun, Henri and Charles 23
Beaumarchais, Pierre Auguste Caron de 93
Belidor 96
Belle, Alexis-Siméon 40
Benedict XIV, Pope 44
Bellori, Giovanni Pietro 20
Berhan, Comte Jean-René-François Alamaric de 98
Bernini, Giancarlo 25
Berry, Duc de 52
Bertin, M. 80
Bertin, Nicolas 32
Billarderie, see Angiviller 50
Billaud-Varenne, Jean-Nicolas 101
Blanchet, Louis-Gabriel 46, 96, PLATE 11
Bloin, Monsieur 96
Boilly, Louis-Léopold 68, 69, 79, 80, 105, 106, PLATE 23, *49*
Boitelle, M. 100
Bonaparte, Caroline see Murat
Bonaparte, Josephine 69, 70, 72, 103, *51*
Bonaparte, Marie-Louise 74, *104*
Bonaparte, Napoleon 42, 65, 66, 68, 69, 70, 72, 74, 76, 101, *47*
Borghese, Pauline 101
Boro, Alessandro del 19, *10*
Boucher, François 40, 41, 48, 50 *28, 33*
Boucher, Jean 24
Boucher, Mlle. (wife of Autreau) 93
Boucher, Madame de 41, *28*
Boudin, Eugène 108
Bouillon, Duchesse de 11, 89, PLATE 1
Boullongne, Bon de 32
Boullongne, Louis de 31, 41
Boulogne, Valentin de 16
Bourbon, Louis III Bourbon-Condé duc de 38 94
Bourdon, Sébastien 21, 23, 24, *12*
Bretèche, M. de la 54, 56

Brézé, Françoise, duchesse de Bouillon 11, 89, PLATE 1
Brézé, Louis 11, 89
Bro, Laure 78, 80, *54*
Broglie, La Princesse de, Pauline Eléonore de Galard de Brassac de Béarn 84, *56*
Buckingham, Duke of 22
Byron, Lord George Gordon 82
Camargo, La, Marie-Anne de Cupis de 36, 42, *24*
Cange, Joseph 65
Canova, Antonio 72
Carracci, Annibale 16
Caravaggio 16
Carriera, Rosalba 41
Correggio 102
Cars, Laurent 42, 95
Cars, Louise-François de Perusse, Comte des 92
Casanova 48
Catherine the Great, Empress of Russia 62
Cavaignac, M 101
Champaigne, Sister Catherine de Sainte-Suzanne 24
Champaigne, Philippe de 16, 21, 23, 24, 29, 30 65, *14, 15*
Chardin, Jean-Baptiste-Siméon 40, 42, 44, *26*
Chantelou, Paul Fréart de 20
Charles I of Austria 90
Charles I of England 22, 28
Charles VIII of France 10
Charles VII of France 11
Charles IX of France 14
Charles X of France 89
Charles IV of Spain 65
Queen Charlotte 60
Charolais, Mlle, de, Louise-Anne de Bourbon-Condé 38, 94 PLATE 8
Chartres, Duchesse de 57
Chateaubriand 65, 72
Chevalier, Étienne 10, *2*
Cheverny, Madame de 90
Chevreuse, Duc de 14, *6*
Choiseul, Le Comte de 50, *34*
Choiseul, Chevalier de 50, *34*
Christina, Queen of Sweden 21
Clermont, Mlle. de, Marie-Anne de Bourbon 38, 94
Cleves, Joos van 11
Clouet, François 11, 12, 14, 89, PLATE 1, *4*
Clouet, Jean 10, 28, *3*
Clouets, the 14
Cochin, Charles-Nicolas 38
Cochin, Noel the Younger 90
Colbert, Jean-Baptiste 22
Concini, Concino 91
Conti, Princesse de 94
Corday, Charlotte 64
Corneille, Jean-Baptiste 93
Courbet, Gustave 78, 83, 107, PLATE 25
Courbet, Régis 82, 83, 107, PLATE 25

Coussy, Auguste de 102
Coustou, Guillaume 32
Coustou, Nicolas 92
Coypel, Charles-Antoine 37, 25
Coypel, Noel 32
Crozat, Madame 40, *27*
Danloux, Henri-Pierre 59, *41*
David, Jacques-Louis 21, 57, 58, 59, 62, 64, 65, 66, 68, 69, 74, 76, 77, 78, 86, 101, 104, 105, 107, PLATE 22, *39, 45, 47, 53, 52*
Deffand, Madame du 9, 93
Delacroix, Eugène 66, 80, 81, 82, 106, PLATE 24, *55*
Delaroche, Paul 82
Delyen, Jacques-François 31, 32, *20*
Demidoff, Anatole, Prince of San Donato 97
Demidoff, Nicholas, Count of San Donato 97
Demidoff, Nikita 97
Demidoff, Nikita Akimfievitch, 46, 49, 96, PLATE 12
Denon, Vivant 68, 90, 101
Desforges, Pierre-Jean-Baptiste Chouard, called 58, 59, *40*
Desjardins, Martin 29
Desmaisons, Doctor François-Marie 80, 81, 82, 106, PLATE 24
Desmoulins, Camille 62, *44*
Desmoulins, Lucille 105
Diderot, Denis 50, 52, 54, 56, 58, 98, *36*
Dombes, Prince de 94
Doria, Giancarlo 18
Dorus, Jeanne 96
Drouais, François-Hubert 41, 50, 56, *34*
Dubufe, Claude-Marie 82
Dubufe, Louis-Edouard 82, 84, 85, 107, 108, PLATE 26
Ducreux, Joseph 54, 59, 61, 100, PLATE 16
Dufresnoy, Duclos 62, 101
Dumont, Jacques le Romain 42, 94, 95, PLATE 9
Dumoustiers, the 10, 12, 90
Duquerre, Auguste 104
Dupillé, Jacques-André 37
Duplessis, Joseph-Siffred 56, *37*
Dyck, Sir Anthony van 16, 21, 22, 23, 28, 30, 31
Elizabeth of Austria 90
Elizabeth, Tsarina of Russia 96
Elle, Louis 21
Entragues, Henriette d' 90
Estreés, Gabrielle d' 12
Eugenius IV, Pope 9
Eyck, Jan van 9, 23
Falconet, Étienne-Maurice, 92
Felibién, 18, 31
Fiorentino, Rosso 11
Fleury, Cardinal 93
Fontenelle, Bernard le Bouvier de 34, 93
Fouquet, Jean 9, 10, 11 *2*
Fra Angelico 9

Fontainebleau, school of 11, 25, 28
Fragonard, Jean-Honoré 52, 53, 54, *54*, 98, PLATE 14
Francheville, Pierre de 91
François I of France 9, 10, 11, 89, *3*
François II of France 12
Freret-Déricour, Madame 56, *37*
Gainsborough, Thomas 36
Gauffier, Louis 60, *42*
Gautier, Armand 108
Gautier, Théodore 78
Gavre, François-Antoine Rasse, Prince de 104
Gentileschi, Orazio 18
Geoffrin, Madame 41, 52, 93, 98
Gérard, Baron François-Pascal-Simon 42, 66, 69, 70, 101, 103, PLATE 20, *50*
Géricault, Théodore 66, 78, 80, *54*
Girodet de Roucy-Trioson, Anne-Louis 42, 66, 68, *48*
Gleyre, Charles 86
Goncourts, the 41, 96
Goncourt, Edmond de 54
Gonzaga, Cardinal Valente 44
Goya, Francisco 64
Guerin, Baron Pierre-Narcisse 47
Godefroy, Auguste-Gabriel 40, *26*
Godefroy, Charles 40
Goubaud, Antoine 30
Goujean, Jean 89
Goupil, Antoine-Thomas-Laurent 105
Greuze, Jean-Baptiste 50, 52, 59, 62, 63, 64, 72, 101, 104, PLATE 17, *35*
Greuze, Madame 101
Grimm, Baron Melchior von 50, 62
Grimou, Alexis 32
Gropello, Count 102
Gros, Baron 42
Groult, Camille 96
Guimard, Mlle. 54
Hals, Frans 23, *54*
Harcourt, Duc d' 54, 98
Haussonville, Comtesse d' 84
Hayman, Francis 36
Henri III of France 14, 90
Henri IV of France 4, 18, 90
Holbein, Hans the Younger 10, 11
Houdon, Jean-Antoine 54
Huilliot, Pierre-Nicolas 31
Ingres, Jean-August-Dominique 21, 28, 50, 60, 66, 70, 71, 84, 86, 102,107, PLATE 19, *56*
Jacquemont, Victor 86
Jacquier, Reverend 96
James V of Scotland 14, 90
Janin, Jules 82
John II the Good of France 9, *1*
Jongkind, Johan Barthold 86, 87, 108, PLATE 27
Katchef Dahouth 66, 68, *48*

III

La Caze, Dr. Louis 98
La Hyre, Laurent de 19, 21
La Martinière, Marie-Françoise-Constance, see Mayer, Constance
La Motte, Houdar, de la 34, 93
La Tour-Maurice Quentin de 9, 41, 42, 59, 94, 95, PLATE 9, *29, 30*
Lajoue, Jacques de 36
Lalande, Jerome 54
Lallemand, Jean-Baptiste 23
Lanclanche, Dr. 108
Lancret, Nicolas 36, *24*
Largillierre, Nicolas de 9, 28-31, 34, 46, 91, PLATE 5, *19*
Lavater, Johann Kaspar 59, 68, 100
Lavoisier, Antoine-Laurent and his wife 58, *39*
Lawrence, Sir Thomas 82
Le Brun, Charles 21, 22, 24, 25, 28, 30, 37, 41, 59, 86, *13*
Le Brun, Jean-Baptiste-Pierre 57
Le Juge, Elizabeth, neé de Gouy 30, *18*
Le Juge, Jean 30, *18*
Le Moyne, Francois 95
Le Moyne, Jean-Baptiste Antoine 44, 95, PLATE 10
Le Moyne, Jean-Baptiste 44, 95
Le Pautre, Pierre 30
Le Sèvre, Jacques-François 99
Le Sueur, Eustache 18, 19, 21, *9*
Le Cadre, Madame 108
Lefèvre, Robert-Jacques-François-Faust 67, 68, 101, PLATE 18
Legrand de Sérant, Pierre-Nicolas 65, *46*
Le Pelletier, 64
Leseur, Reverend 96
Lely, Sir Peter 30
Lèpicie, Bernard 36, 40
Létin, Jacques de 16
Limbourg Brothers 9
Longrois, Félicité 82
Lordon, Pierre Jerome 104
Lordon, Sophie 72, 75, PLATE 21
Louis XI of France 10
Louis XIII of France 16, 18, 21, 23, *8*
Louis XIV of France 22, 25, 26, 56, 57, 65, 70, 90, 93, 94, *17*
Louis XV of France 32, 38, 40, 41, 48, 50, 52, 89, 93, 94
Louis XVI of France 50, 52, 56, 60, 65, 76, 89, 104
Louis XVIII of France 89
Lubienska, Constance Ossolinska 70, 72, 73, 103, PLATE 20
Luynes, Duc de 91
Lyon, Corneille de 9, 12, 14, 78
Mabuse, Jan Gossaert called 78
Maissin, Jeanne 56, 57, 99, PLATE 15
Maine, Duc de 94
Maine, Duchesse de 34
Manet, Edouard 86, 108
Manon Balletti 48
Marivaux, Pierre Carlet de, Chamblain de 93
Monville, Abbé de 25
Marat, Jean-Paul 64, *45*
Marck, Robert IV de la 89

Marie-Antoinette, Queen of France 50, 57, 58, 59, 69, 72, *38*
Marino 18, 19
Marolles, Michel de 90
Marsollier, Mademoiselle 48, 57, 97, PLATE 13
Mayer, Constance 72, 104, PLATE 21
Mazois, François 102
Medicis, Catherine de' 10, 89
Medici, Marie de' 14, 23, 90
Mellin, Charles 19, *10*
Melun Diptyck *2*
Memling, Hans 23
Mignard, Pierre 20 24, 25, 28, 32, *16*
Moitessier, Madame 84
Molière 25, 28
Monet, Claude 86, 87, 108, PLATE 27
Montespan, Madame de 94
Montesquieu, Robert, Marquis de 93
Montmorency, Anne de 12, *5*
Montsoreau, Countess of 31, 34, *19*
Mori, Antonio 16
Murat, Caroline 69, 70, 71, 102, PLATE 19, *50*
Murat, Joachim 69, 102
Nanteuil, Robert 41
Natoire, Charles 42, 95
Nattier, Jean-Marc Frontispiece, 9, *2*, 38, 40, 50, 51, 46, 48, 68, 94, 97, PLATES 8, 13
Netscher, Gaspard and Theodore 30
Nicholas V, Pope 9
Nogaret, Madame Ramel de 76, 78, *53*
Nogaret, Dominique-Vincent, Ramel de 74, 76, 77, 78, 104, 105, PLATE 22
Noirmont, Comte de 91
Oberkampf, Christophe Philippe 105
Orléans, Duc d' 34
Orléans, Jean-Philippe Chevalier d' 38
Orléans, Louise-Henrietta de Bourbon-Condé, Duchesse d' 94
Ossolinski, Joseph Gaetan Lemnau, Count 103
Oudry, Jean-Baptiste 44
Panckoucke, Ange-Pauline-Charlotte see Nogaret, Mme Ramel de
Pater, Jean-Baptiste 36
Perreal, Jean 10
Perronneau, Jean-Baptiste 42, 43, 44, 95, PLATE 10
Peter the Great, Tsar of Russia 66, 97
Picart, Bernard 40
Pigalle, Jean-Baptiste 52
Piles, Roger de 28, 31
Pilon, Jean 89
Pius VII, Pope 101
Pointel 20
Poitiers, Diane de 11, 12, 89
Pompadour, Madame de 41, 42, 48, 50, *33*

Potoski, Arthur 103
Poussin, Nicolas 18, 19, 20, 21, 22, 23, 24, 25, 37, 86, *11*
Pozzo, Cassiano dal 18, 20
Pourbus, Frans the younger 9, 14, 90, 91, PLATE 3, *6*
Prévost d'Exiles, Abbé Antoine François 93
Primaticcio, Francesco 11
Provence, Comte de 50
Prud'hon, Pierre Paul 72, 104, *51*
Puiséjour, Monsieur de 91
Quesnel, François the Elder 12, 14, 90, PLATE 2
Quesnel, Pierre 14
Racine, Jean 28
Raoux, Jean 32, 34, 38
Raphael 24
Récamier, Madame 101
Regnault, Jean-Baptiste 68
Régnier, Nicolas 16
Reisener, Henri-François 80, 82, *55*
Rembrandt van Rijn 23, 32, 34, 92
Guido, Reni 18, 25
Renoir, Pierre-Auguste 86
Restout, Jean 95
Richelieu, Cardinal 16, 20, 21, 23, 93
Rieux, Madame la Presidente de 94
Rigaud, Hyacinthe 9, 28-31, 34, 46, 48, 56, 57, 65, 90, 91, PLATE 4, *17, 18*
Rivière, Mlle. 80
Robert, Hubert 62, 69, *44*
Robespierre, Maximilien-François-Marie-Isidore de 62, 105
Robin, Louis-François 62, 63, 64, 101, PLATE 17
Roettiers, sale 98
Roland, Hyacinthe-Gabrielle 60, 62, *43*
Roque, Antoine de la *23*, 36
Rothschild, Baronne Betty de 84
Roucher, Antoine 62
Rousseau, Jean-Baptiste 34, 93
Rubens, Sir Peter Paul 16, 22, 25, 54, 62, 66, 98
Saint-Aignon, Duc de 96
Saint-Aubin, Gabriel de 46, 48, 56, *32*
Saint-Simon 28
Saint-Non, Abbé de 98
Saint-Pierre, Comte de 97
Salle, Mademoiselle 94
Santerre, Jean-Baptiste 32, 92, PLATE 6, *21, 22*
Saurin, Jacques 34, 93
Savoie, Marie-Adélaïde de, Duchesse de Bourgogne 32, 92
Séguier, Pierre, Chancellor 22, 25, *13*
Sens, Mademoiselle de 94
Sévigné, Madame de 28
Sieyès, Emmanuel-Joseph 74
Sillery, Nicolas Brulart de, Chancellor 91
Sisley, Alfred 86
Spoed, Jean-Jacques 41

Staël, Madame de 102
Stuart, Mary 12
Subleyras, Pierre-Hubert 44, 45, 46, 56, 96, *31*
Suvée, Joseph-Benoît 62, 104
Talleyrand-Perigord, Charles-Maurice de 65
Tencin, Claudine de 34, 92, PLATE 7
Testelin, Henri 23
Testelin, Louis 23
Tischbein, Johann Heinrich 36
Titian, 11, 19, 24, 66
Tocqué, Louis 46, 49, 56, 96, PLATE 12
Tomasz, Feliks Lubienski 103
Touchet, Marie 12
Toulouse, Comtesse de 94
Tournières, Robert Levrac 32, 34, 93
Toussaint Louverture 94
Troy, François de 32, 34
Troy, Jean-François de 40
Vair, Guillaume de 91
Vallet, Emile 98
Valois, Elizabeth de 89
Vanloo, Carle 50, 58, 98
Vanloo, Jean-Baptiste 95
Vanloo, Louis-Michel 52, 54, *36*
Velásquez, Diego 22, 66
Vermandois, Mademoiselle de 94
Vien, Joseph-Marie 58, 92
Vigée-Le Brun, Elizabeth-Louise 9, 55, 56, 57, 58, 60, 62, 69, 70, 72, 99, 102, PLATE 15, *38, 43*
Vigée, Étienne 56, 99
Vigée, Louis 56, 96, 99
Vignon, Claude 16
Vilain XIIII, Philippe 74
Vilain XIIII, Vicomtesse de, née Sophie de Feltz 74, 104, *52*
Vincent, François-André 54, 58, 59, 64, *40*
Vincent, Madame 79, 105, 106, PLATE 23
Vinci, Leonardo da 11
Vivien, Joseph 41
Voltaire 9, 42, 97, *29*
Vouet, Simon 16, 18, 19, 21, 22, 24, 41, *7, 8*
Waltham, Mary Ann 14, 90
Watteau, Jean-Antoine 34, 35, 36, 99, *23*
Wharton, Edith 97
William IV of Holland 40
Winterhalter, Franz Xaver 82, 107, 108

112